THE ANATOMY *of* *the* SEA

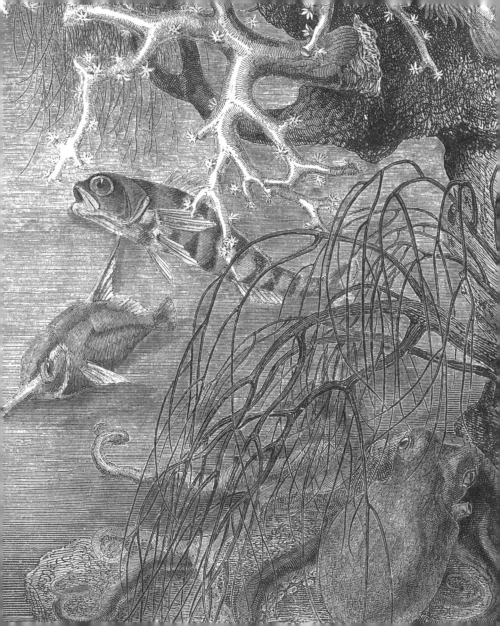

THE ANATOMY *of* *the* SEA

Over 600 Creatures of the Deep

By Dr. David Ponsonby & Professor Georges Dussart

CHRONICLE BOOKS
SAN FRANCISCO

First published in the United States in 2005
by CHRONICLE BOOKS LLC

Copyright © 2005 THE IVY PRESS LIMITED

Library of Congress Cataloging-in-Publication
Data available.

ISBN: 0-8118-4633-4

Manufactured in CHINA
Cover design by AYA AKAZAWA

Distributed in Canada by RAINCOAST BOOKS
9050 Shaughnessy Street
Vancouver, British Columbia V6P 6ES

10 9 8 7 6 5 4 3 2 1

CHRONICLE BOOKS LLC
85 Second Street
San Francisco, CA 94105

www.chroniclebooks.com

This book was created by
THE IVY PRESS LTD
The Old Candlemakers, West Street,
Lewes, East Sussex BN7 2NZ, U.K.

Creative Director PETER BRIDGEWATER

Publisher SOPHIE COLLINS

Editorial Director JASON HOOK

Senior Project Editor REBECCA SARACENO

Design Manager SIMON GOGGIN

Design JANE LANAWAY

Picture Researcher LORRAINE HARRISON

Contents

Introduction

For a period of two hundred years after 1700, biology began its adventure as a major field of science. Building on the framework of classification developed by the Swedish anatomist Carolus Linnaeus (1707–1778), the structural relationships between organisms were defined by anatomists such as Georges Cuvier (1769–1832) in France and Richard Owen (1804–1892) in England. This was also the period when exploration gradually became more scientifically motivated. Important voyages were undertaken by the botanist Joseph Banks (1743–1820), who traveled to Australia with Captain James Cook, the German scientist Alexander von Humboldt (1769–1859), and the naturalist Charles Darwin (1809–1882). These naturalist-explorers ranged over land and water, bringing back both living and preserved specimens, or descriptions of specimens.

In this great age of anatomical description, the ability to draw was an essential skill. Although extremely proficient, the

explorers' observations were not always perfect. For example, Cuvier mistook the reproductive organ of a squid for an animal in its own right. Elsewhere, in an error of taxonomy, the ancient filter-feeding group, the brachiopods, were classified with the clams, even though the two groups have entirely different origins and histories.

Eventually, an immensely detailed anatomical archive was built up, and authors such as the Rev. J. G. Wood popularized this record with publications such as *The Illustrated Natural History*, published in 1863. Another of Wood's publications sold 100,000 copies in a week. These works focused strongly on anatomy, reflecting the scientific developments and interests of the time. In this context, anatomy was an essential foundation for later biochemical and molecular studies.

The anatomical record emphasizes marine creatures—perhaps hardly surprising, since 85% of the planet is covered in salt water. This book is a tribute to the knowledge and skill of those accomplished early anatomists. Here, in *The Anatomy of the Sea*, we can revisit their work and celebrate it in a modern taxonomic setting.

Taxonomic Terms

Charles Darwin's voyages to South America on the Beagle were instrumental in arousing a wider interest in biology.

Taxonomy is the theory and practice of classifying living things into closely related groups called *taxa* (the singular is *taxon*). Plato (429–347 BC) was the first to provide written definitions of abstract classification terms: "Each individuum is only an imperfect reproduction of a perfect eternal conception of the species and genus." However, it was his pupil, Aristotle, who produced the first classification system based on appearance (anatomy) and function (physiology). His system was crude and incomplete by our current standards, but it was to endure for more than 2,000 years.

Today, taxonomy forms a part of a wider process called systematics. Systematists classify organisms using a wide range of characteristics that help us to understand how a particular group has evolved, based on fossil evidence and DNA analysis. However, systematics' foundations predate Charles Darwin's theories on the origins of species and thus, as with Aristotle's system, it was originally based on anatomy, physiology, and life cycles. Many scientists contributed to the new system of nomenclature, but it was the Swede Carl von Linné (1707–1778), known to many as Carolus Linnaeus, who justly gave his name to the structure that is now in use—the Linnaean system. Examples of the hierarchy used to provide each organism with its own unique classification in the Linnaean system are given in the table on the opposite page. Explanations for the taxonomic terms can be found in the Glossary (*see pages 278–281*).

Carolus Linnaeus's outstanding contribution to science was his system of nomenclature for plants and animals, as outlined in his many publications.

LINNAEAN CLASSIFICATION

Biologists still argue over the definition of a species, but under Linnaeus's system, each is given two names, one identifying the species itself, the other, the genus to which the species belongs. Today, most nonscientists use the common names. Below are two examples of classification. One of these, the Atlantic cod, *Gadus morhua*, has a relatively complex taxonomy; the other, the sea lettuce, *Ulva lactuca*, a relatively simple one (hence the smaller number of taxa).

Taxon	Atlantic Cod	Sea Lettuce
KINGDOM	Animalia	Protista
PHYLUM	Chordata	Chlorophyta
SUPERCLASS	Gnathostomata	
CLASS	Osteichthyes	Chlorophyceae
SUBCLASS	Actinopterygii	
SUPERORDER	Teleosteii	
ORDER	Gadiformes	Ulvales
SUBORDER	Gadoidei	
FAMILY	Gadidae	Ulvaceae
GENUS	*Gadus*	*Ulva*
SPECIES	*morhua*	*lactuca*

About This Book

The Anatomy of the Sea is an introduction to the amazing diversity of life in our vast oceans. The aim in compiling a selection of beautiful line engravings—some more than two hundred years old—is to give the reader a glimpse of the sheer variety of life within the marine environment and to offer some history, anecdotes, and strange facts that surround the subject. This approach means that the book cannot be used as a technical introduction or as a field guide. We hope it is a visual pleasure and a satisfying read; and if it engages you sufficiently to send you in search of more "serious" reference works then it will have served its purpose (for some suggested modern works, *see page 282*).

Because all of the sources used were very old, a policy for naming the different organisms had to be formulated. Common names have always varied from time to time and from place to place, but much of the scientific taxonomy has changed since the source material was written, too—reclassification is perpetual in

this constantly developing field—so we realized that by using old engravings, the taxonomy could not be consistent, or in some cases accurate. Hence, where organisms were not named in the original, we have tried to provide identification. Where the names were no longer in current use but there was insufficient information in the image to provide a positive identification, we have retained the original nomenclature. Also, if identification was obviously incorrect, where possible it has been corrected (sometimes more than one common name has been given, as this is often an ambiguous area). A 🐟 symbol is placed against the name where further or corrected identification is provided so that it is clear the naming is contemporary. A misspelled word has been rectified without adding the 🐟 symbol. Finally, please be aware that reference to the use of any organism as a medicine or food supplement should be interpreted in the context of the anecdotes and not taken as a recommendation for modern use.

Sponges *Porifera*

Sponges are animals. They live by filter feeding, in which water is dragged toward the sponge through tiny pores in the wall and then passes into the central cavity. On passing through the wall, particles in the water are removed and used to nourish the sponge. The clean water is expelled from the cavity through a large pore called an osculum (which means "door" in Latin).

Sponges attach themselves to rocks or other substrata. Each sponge is a hollow colony of relatively independent cells, each cell contributing to the process of filtration. The cells, called choanocytes, have tiny beating hairs that face the central cavity of the sponge.

In order to maintain their shape and prevent them from collapsing, sponges have a primitive skeleton made of tiny repeating units called "spicules." These spicules make the sponge feel gritty when touched. Some sponges can be ground down into their individual cells and the resulting mash passed through muslin. As heartless as this experiment

might sound, the amazing outcome after reducing the sponges in this manner is that, left to themselves, they can re-form themselves back into a complete sponge. This ability to reassemble themselves suggests that sponges are not highly developed organisms. Their cell makeup ranges from single-celled to multicelled organisms. Although the sponges shown on the following pages are marine, sponges are also common in clean freshwaters.

There are three typical growth forms of sponges—*asconoid*, in the form of a simple perforated and hollow pot; *syconoid*, in which the body wall of this pot is folded inward; and *leuconoid*, in which the choanocytes are hidden away in a complicated system of channels in the much-thickened body wall. The classification demonstrates how sponges have adapted over millions of years. Over this long period of time, sponges have had to develop solutions to the problems of obtaining food while being immobile and stuck to a substratum.

Phylum	PORIFERA
Class	CALCAREA Calcareous sponges
Class	HEXACTINELLIDA Glass sponges
Class	DEMOSPONGIAE Silica sponges

001 Pumice stone sponge—*Dactylochalix pumicea*
002 Neptune's cup—*Poterion Neptuni*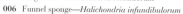
003 Breadcrumb sponge—*Halichondria panicea*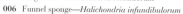
004 Group of *Leuconia, Grantia,* and *Halichondria* species
005 Ling hood—*Halichondria ventilabrum*
006 Funnel sponge—*Halichondria infundibulorum*

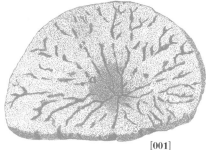

[001]

Sponges

[002]

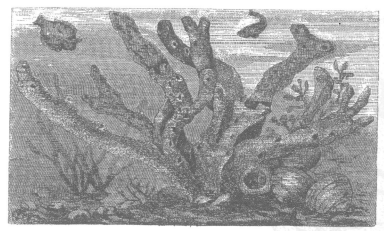

[003]

[004]

THE WELL-DEVELOPED SKELETON of the pumice stone sponge is said to resemble the soft, porous volcanic rock.

The breadcrumb sponge is named for the bread crumb–like appearance of its outer surface. This encrusting sponge is commonly found on the seashore. The ostia look like miniature volcanoes, and the sponge can range in color from green to orange. It is most common on the lower shore, in patches that can cover 30–40 sq. inches. Figure 004 shows a group of sponges nestling under an overhanging rock. This picture also shows a chiton and

[005] [006]

whelk egg capsules. Breadcrumb sponges (*Halichondria*) have spicules that are long, thin, and curved, sometimes resembling a needle without an eye. The ling hood differs from the funnel sponge in having a thick coating of hairlike spines.

Sea Anemones, Corals & Jellyfish *Cnidaria*

The Cnidaria (previously called the Coelenterata) are a successful group of primitive animals found in fresh and salt water. The defining feature of a cnidarian is the possession of stinging cells, which contain tiny "harpoons" and have a filamentous trigger. When a prey item touches the trigger, seawater rushes into the cell, which then immediately turns inside out, plunging the poisoned harpoon into the prey. Using a simple muscular system in the tentacles, the cnidarian passes the prey to the mouth and gut. In the gut, enzymes digest the prey into a soup that is then absorbed into the body of the animal.

The three main classes of cnidarian are the sea anemones, sea pens and fans, and corals (Anthozoa); the jellyfish (Scyphozoa); and the hydroids (Hydrozoa). However, another group of animals, called the sea gooseberries or comb jellies, was wrongly classed as jellyfish by the naturalists

and is included in this chapter. Sea gooseberries are free-living animals that resemble gooseberries in size and structure. They differ from jellyfish in that they feed using tiny beating combs on the surface of the body.

Some forms are attached to a base, and others, such as jellyfish, can float in the open sea. Some are individuals, such as the sea anemone, but others, such as the corals, form complex colonies. Some are totally flexible (for example *Hydra*), and others have skeletons. The most skeletonized cnidarians are those that make coral. A typical cnidarian body is called a "polyp." This is made up of a two-layered body-wall that encloses a gut (enteron) with a mouth but no anus. This is called a "blind-ending gut." Indigestible materials have to be expelled through the mouth. Although they have a poorly developed nervous system comprising a nerve net, cnidarians can show complex behavior, including fighting.

Phylum	CNIDARIA
Class	ANTHOZOA
Subclass	HEXACORALLIA
Order	ACTINIARIA

Sea Anemones 1

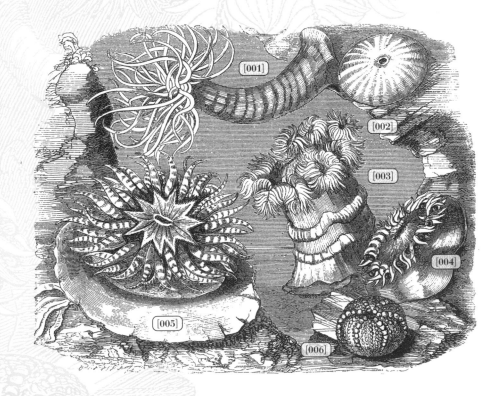

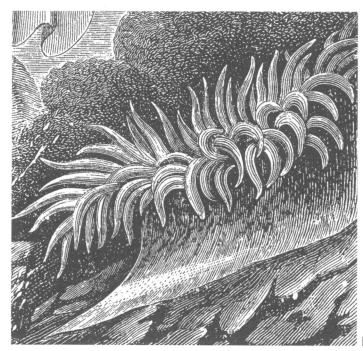

[007]

THE SEA ANEMONES are single polyps that can be found at any depth in the oceans, from rocks on the coastal shelf to wrecks at the bottom of the deep ocean. They have a partly divided gut but no anus. Anemones can grow on the shells of crabs, where they feed on particles of food left by the messy eating of the crab. The poisoned barbs of the sea anemone help to protect the crab against predators. Some crabs will even snip a sea anemone off the rocks and attach it to their shell by its base. Other crabs will hold a sea anemone in a claw and wave it at predators to deter them.

001 *Sagartiogeton undatus*
002 *Sagartiogeton undatus* (closed)
003 *Actinoloba dianthus*
004 Beadlet anemone—*Actinia mesembryanthemum*
005 Gem pimplet anemone (closed)—*Bunodes gemmacea*
006 Gem pimplet anemone (open)—*Bunodes gemmacea*
007 Beadlet anemone—*Actinia equina*

Phylum	CNIDARIA
Class	ANTHOZOA
Class	SCYPHOZOA
Class	HYDROIDS

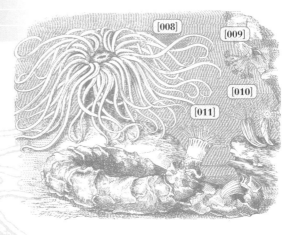

[008]

[009]

[010]

[011]

Sea Anemones 2

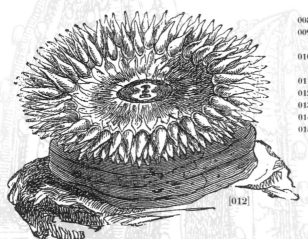

[012]

008 Opelet anemone—*Anthea cereus*
009 Trumpet stalked jellyfish—
Haliclystus auricula
010 Scottish pearlet anemone—*Ilyanthus
scoticus*
011 Pufflet anemone—*Cerianthus lloydii*
012 Beadlet anemone—*Actinia equina*
013 Orange disk anemone—*Sagartia elegans*
014 Opelet anemone—*Anthea cereus*
015 Gemmed anemone (open and closed)—
Bunodactis verrucosa

[013]

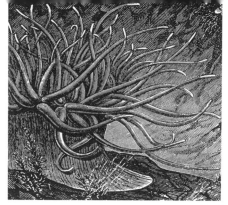

[014]

MOST ANEMONES have twelve or more tentacles. The tentacles of the opelet "wave, and twist and twine, and curl like so many snakes" (Rev. J. G. Wood, *The Illustrated Natural History*). *Half Hour Library* says, "No language can do justice to the beauty of these singular creatures, when seen to advantage in their native element."

The beadlet anemone is found on tidal shores. To prevent drying out when the tide is low, the tentacles retract completely. The anemone then looks like a blob of red jelly on the rock, usually in a sheltered, humid location. Of the gemmed anemone, *Half Hour Library* says, "The body is of a beautiful rose colour. The rows of tubercles are alternately white and grey, the disk when expanded is variegated with different hues, green, white, scarlet, black while the tentacles are of a fine blue colour."

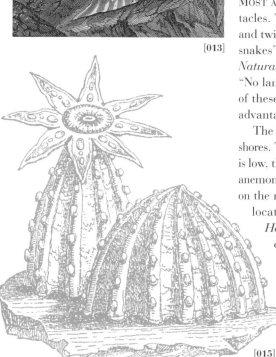

[015]

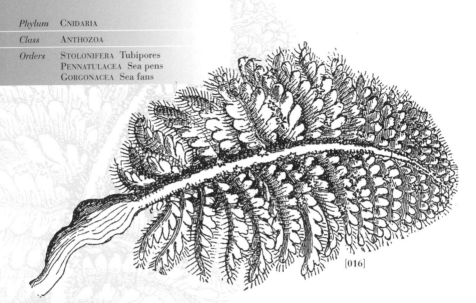

[016]

Tubipores, Sea Pens & Sea Fans

016 Sea pen
017 Sea fan
018 Organ-pipe coral—*Tubipora musica*
019 Sea pen and sea rush—*Pennatula grisea* and *Virgularia mirabilis*
020 Group of *Sertularia* species

[017]

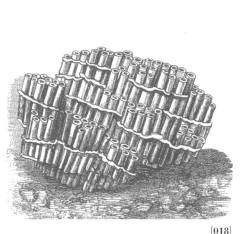

[018]

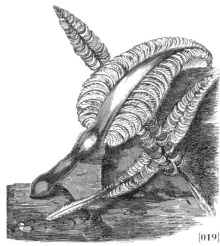

[019]

THE SEA PENS AND SEA FANS represent colonies of cnidarians, sometimes made of 90,000 individuals, united by secretions from the polyps. In *The Illustrated Natural History*, Rev. J. G. Wood says of the sea fan, "The whole structure easily dries and may be found in the dwelling houses of mariners, who have brought home these remarkable objects as presents to their wives." He also notes that the organ-pipe coral is "magnificent...vivified by a light green polyp whose colour contrasts beautifully with the soft and feeble body." The small branching hydroids called sertularians have a "beauty which defies description." Fragments can break off, become attached, and then regenerate another colony. Note that the sertularians were misclassified by Rev. Wood and are actually in the class Hydrozoa.

[020]

Phylum	CNIDARIA
Class	ANTHOZOA
Subclasses	TABULATA, RUGOSA, ZOANTHARIA
Order	SCLERACTINIA

Coral 1

*"My mistress' eyes are
 nothing like the sun;
Coral is far more red than
 her lips' red."*

WILLIAM SHAKESPEARE, Sonnet 130

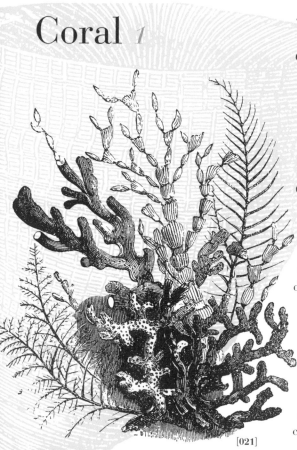

[021]

CORALS ARE COLONIAL CNIDARIANS that secrete a skeleton made of lime. Corals have specific requirements for clean, oxygenated, illuminated, warm water. This means that they grow within specific depth limits, neither too deep nor too shallow. Atolls are rings of coral. Charles Darwin proposed an explanation for atoll formation. He suggested that corals grow within their limits in the sublittoral zone, thus forming a ring around an island. There would be a lagoon between the coral reef and the land. This lagoon

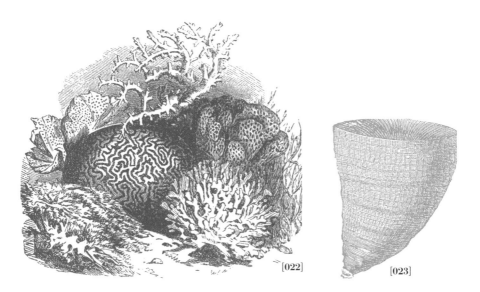

[022]

[023]

lacks living coral because the reef reduces the turbulence and oxygenation of the lagoon water. However, dead coral falls from the reef into the lagoon, gradually filling it up. If the island gradually sinks due to movements of the earth's crust (or if the sea rises), the coral grows upward so that the living coral is always in the correct zone. After some time, the reef becomes an atoll, made of a ring of coral, without an island in the center. Because of their requirements for successful living, and the way in which they increase the structural complexity of a reef, corals are important indicators of good health in a tropical ocean environment.

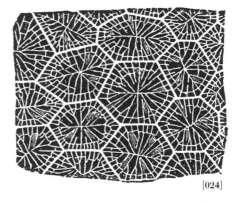

[024]

021 Branches of corals and corallines
022 Group of corals
023 Extinct horn coral—*Zaphrentis* sp.
024 Fossil corals in a rock section—*Stauria astraeiformis*

Phylum	CNIDARIA
Class	ANTHOZOA
Subclasses	TABULATA, RUGOSA, ZOANTHARIA
Order	SCLERACTINIA

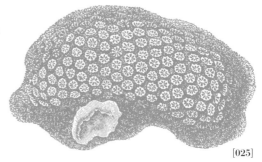

[025]

Coral 2

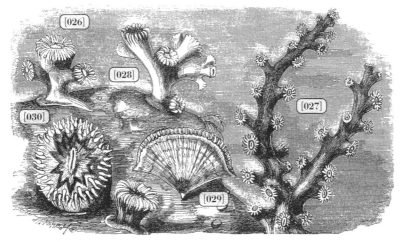

CUP CORALS ARE DEEPWATER ANIMALS that can sometimes be found on the seashore, individually or in groups, under overhangs or in deep cracks. They have a white disk with about fifty tentacles. The star coral is a member of the brain or madreporarian corals that are predomi- nately found in warmer waters. These brain corals have short bodies and twelve simple tentacles, and they crowd together over the surface of the coral mass. This group is a major contributor to the process of reef building. Stone corals are solitary, and they can be found at depths of up to

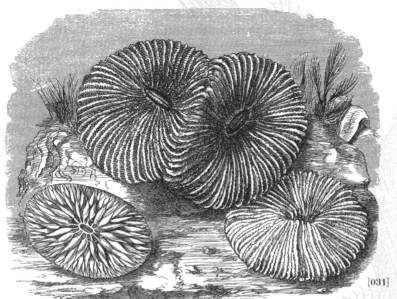

[031]

025 Star coral—*Astraea* sp.
026 Devonshire cup coral—*Caryophyllia smithii*
027 Tree coral—*Dendrophyllia nigrescens*
028 Tuft coral—*Lophophelia prolifera*
029 Endive coral—*Euphyllia pavonia*
030 Devonshire cup coral with skeleton
031 Stone coral, mushroom coral—*Fungia* sp.
032 Fossil chain coral—*Halysites catenulatus*

25,000 feet. They are sometimes called mushroom corals. Corals have been on earth for 600 million years. The whole of Wenlock Edge in England is an ancient Silurian reef, including fossils such as the 400-million-year-old chain coral shown here [032].

[032]

Phylum	CNIDARIA	
Classes	ANTHOZOA	Sea anemones and corals
	SCYPHOZOA	Jellyfish
	HYDROZOA	Hydroids

Jellyfish *1*

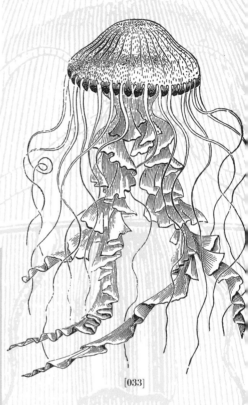

[033]

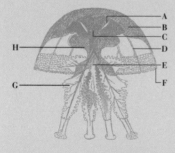

Section through the moon jellyfish

A Gonad
B Mesogloea
C Main gastric chamber
D Gastric filament
E Mouth
F Sensory tentacles
G Frilly feeding tentacles
H Manubrium

JELLYFISH ARE PRIMITIVE. The life cycle of the jellyfish begins with a larva floating in the open sea, feeding on tiny organisms. It sinks to the bottom and begins to grow into a segmented column of individuals [035]. Each segment is cast off, in turn, into the water. Floating on the currents, each segment develops into a male or female jellyfish. At maturity, a male sheds

033 Moon jellyfish—*Chrysaora* sp.
034 Moon jellyfish—*Aurelia aurita*
035 The early stages of the moon
 jellyfish—*Aurelia aurita*

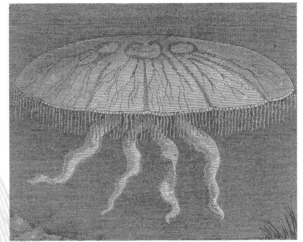

[034]

sperm into the water, to be drawn into a female for fertilization of the eggs. The larval form is then released, and the cycle begins again. When the conditions are right, usually when food is abundant, swarms of jellyfish can occur. Jellyfish can only vaguely orient to light and can swim only slowly, with the current.

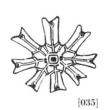

[035]

Jellyfish 2

036 Portuguese man-of-war, bluebottle—*Physalis pelagica*
037 *Aequorea cyanea* Aequorea vitrina*
038 *Eudora undulosa*
039 Venus's girdle—*Cestum veneris*
040 By-the-wind sailor, sallee man(-of-war)—*Velella velella*
041 Sea nettle—*Chrysaora fuscescens*

ALTHOUGH EARLY SCIENTISTS classified the Portuguese man-of-war as a jellyfish [*036*], it is in fact a large, colonial hydroid with specially adapted cells (zooids) that form float, sail, and tentacles. It is famously venomous, and its sting can cause very painful side effects.

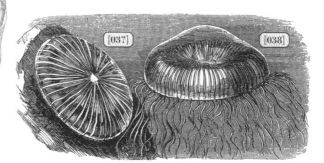

[037] [038]

[036]

Rev. J. G. Wood says, in *The Illustrated Natural History*, "[Bits of cartilage] are sometimes found strewn in great numbers on the surface of the water…Naturalists have now ascertained that the true cause of their destruction is to be found in the sea-lizard (glaucus) that feeds upon these curious inhabitants of the ocean, and devours the body with the exception of the firm cartilaginous plates." Although this is generally correct, we now know much more, including the fact that jellyfish do not contain cartilage and that the glaucus is a mollusk, not a lizard.

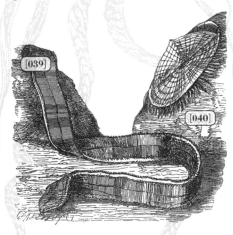

[039]

[040]

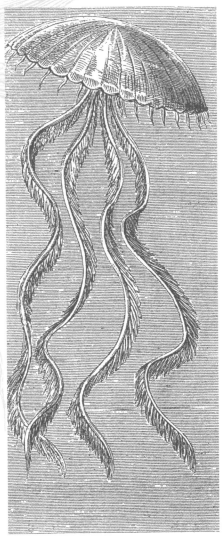

[041]

Phylum CNIDARIA

Classes ANTHOZOA Sea anemones and corals
 SCYPHOZOA Jellyfish
 HYDROZOA Hydroids

Jellyfish *3*

AURELIA AURITA IS A HARMLESS, blue-ringed jellyfish, about 2–4 inches in diameter, common in temperate waters. By contrast, *Cyanea* species can be 7 feet in diameter. Rev. J. G. Wood in *The Illustrated Natural History* writes of being stung by a venomous *Cyanea*: "At its first infliction, the pain is not unlike that caused by the common stinging nettle, but rather sharper and with more of a tingling sensation. Presently, however, it increases in violence

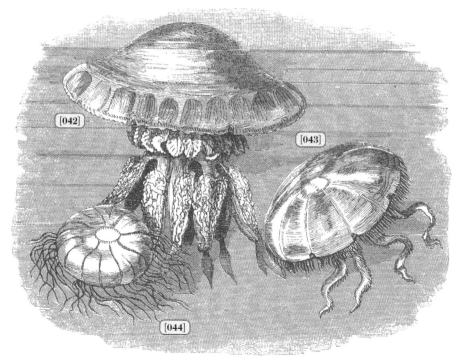

[042]

[043]

[044]

and then seems to attack the whole nervous system, occasionally causing a severe pain to dart through the body as if a rifle-bullet had passed in one side and out at the other."

Sea gooseberries look like gooseberries trailing two long tentacles. "Lines of longitude" running down the body shimmer with refracted colors. The beating of tiny combs attached along the lines creates the colors. The sea gooseberry uses these combs to filter food from seawater.

[045]

042 *Rhizostoma cuvieri*
043 Moon jellyfish—*Aurelia aurita*
044 Lion's mane jellyfish—*Cyanea capillata*
045 Sea gooseberries—*Ctenophores*
046 Sea gooseberry (left)—*Pleurobrachia bachei*
 and Jellyfish in postlarval form (scyphistoma)
 (right)

[046]

Sea Mats *Bryozoa*

Furneaux (1911) describes sea mats as "pretty, lace-like patches on the fronds of seaweeds, while others are built into flat, frond-like, branching objects that are often mistaken for seaweeds by young collectors… The sea mat Flustra consists of many minute cells, with horny or calcareous walls, the mouth of each cell being closed by an operculum. On placing the colony in seawater however, we find that each little cell is the home of a small animal that protrudes from the cell, exposing a mouth that is surrounded by a crown of tentacles."

Sea mats, of the phylum Bryozoa (Greek *bryon* "moss," *bezoion* "living creature"), are minute animals, less than one-thirtieth of an inch in diameter, that are successful suspension feeders, commonly found on the seashore. Like hydroids (see *page 16*), bryozoans are sedentary and colonial, with a horny exoskeleton and tentacles. Most seashore species are encrusting, though a few species form branched filaments. Unlike hydroids, however, each individual is not connected

up to others but inhabits its own cup, or zooecium. Also, they do not have stinging cells. Through a lens, the tentacles can be seen to be arranged in a horseshoe pattern around a central mouth. The tentacular crown is called a lophophore.

The tentacles are covered in cilia (hairlike filaments) that draw in water containing food and oxygen. A bryozoan thus lives and feeds in the same way as a sea squirt (*see page 138*). Bryozoans extend their colonies by cloning but also use sexual reproduction to produce larvae, which disperse through the oceans via the plankton.

The evolutionary background of the Bryozoa is yet to be fully clarified. Genetic relationships between species are often indicated by their larval development, and some elements of egg fertilization in Bryozoa suggest kinship with the Chordata and with echinoderms— but other factors that arise during embryonic development tend to negate this.

Sea Mat Anatomy

THE CLASS STENOLAEMATA comprise a group of bryozoans that have up to 30 tentacles and do not have muscular body walls. They live in a calcareous tube into which they can retract. They change shape by varying internal pressure. After the tentacles have been pulled in, the tube is sealed with a membrane. Reproduction involves both fertilization of an egg by sperm and cloning thereafter. A fertilized egg buds off secondary embryos that in turn can bud off tertiary embryos.

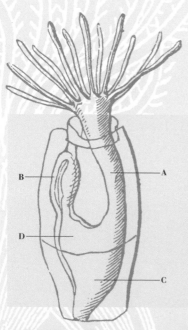

Member of the class Gymnolaemata

Eschara cervicornis individual

A Esophagus
B Rectum
C Stomach
D Hindgut

Thus a single fertilization can lead to the development of 100 individuals.

The Gymnolaemata are the most abundant and successful bryozoans. Unlike the Stenolaemata, they change shape by using internal muscles. When an individual retracts into its partially calcified tube, the top is sealed with a "door" called an operculum. A single colony may be made up of different types of individuals (zooids)—zooids that eat, zooids that clean, and zooids that grasp, for example.

[001]

Member of the class Stenolaemata

Eschara cervicornis individual

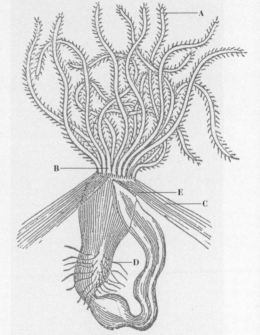

A Tentacles (lophophore)
B Esophagus
C Retractor muscles
D Stomach
E Anus

001 Branch of *Eschara cervicornis*, showing arrangement of individuals in tubes

Phylum	BRYOZOA
Class	STENOLAEMATA Marine Bryozoa
Class	GYMNOLAEMATA Marine Bryozoa
Order	CHEILOSTOMATIDA, CTENOSTOMATIDA

002 Bishop's mitre—*Euthyroides episcopalis*
003 Bishop's mitre (magnified)—*Euthyroides episcopalis*
004 *Flustra foliacea*
005 *Flustra foliacea* (magnified)
006 *Electra pilosa*
007 *Electra pilosa* (magnified)
008 *Bugula avicularia* (magnified)
009 Lady's slipper (magnified)—*Scruparia chelata*
010 *Notornium avicularia* (magnified)

Sea Mats *1*

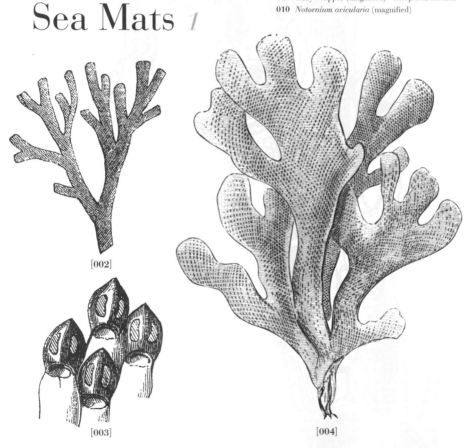

[002]

[003]

[004]

BRYOZOANS such as *Euthyroides episco-palis* can grow in erect clumps, increasing the diversity of habitats in coastal waters. In some temperate waters, bryozoans perform a similar function to coral. This can be seen in New Zealand, southern Australia, and parts of the Mediterranean. Research suggests that *Euthyroides epis-copalis* may produce compounds that could in time be used as antibiotic and anticancer drugs. *Bugula* species can form dense tufts in crevices on the lower shore. They seem to have characteristic depths at which they grow.

Dead *Flustra foliacea* is commonly found washed up on the shores of the North Atlantic Ocean. It resembles a piece of rough, light-brown leather that has been damaged by the waves. However, close examination, even with the naked eye, will reveal the tiny compartments that make up the colony.

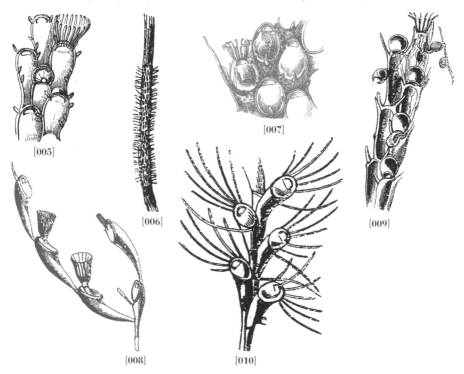

[005]

[006]

[007]

[008]

[009]

[010]

Phylum	BRYOZOA
Class	STENOLAEMATA Marine Bryozoa
Class	GYMNOLAEMATA Marine Bryozoa
Order	CHEILOSTOMATIDA, CTENOSTOMATIDA

[011]

[012]

[013]

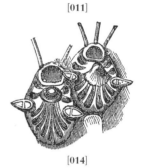

[014]

Sea Mats 2

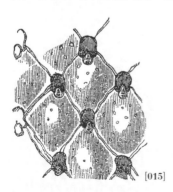

[015]

AVICULARIA ARE THE PREHENSILE processes that have the shape of a bird's bill in some Bryozoa. Hartwig, in 1873, writes about "very remarkable appendages, or processes, presenting the most striking resemblance to the head of a bird. Each of these processes, or aviculariae, as they have been called, has two 'mandibles' of which one is fixed like the upper jaw of a bird, the other movable like its lower jaw; the latter is opened and closed by two sets of muscles, which are seen in the interior of the head, and between them is

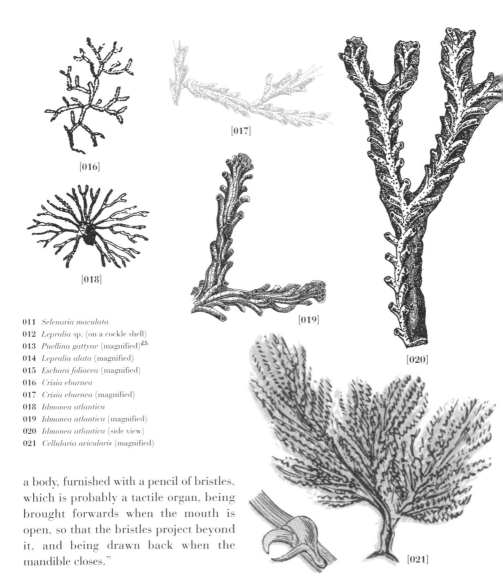

[016]

[017]

[018]

[019]

[020]

[021]

011 *Selenaria maculata*
012 *Lepralia* sp. (on a cockle shell)
013 *Puellina gattyae* (magnified)
014 *Lepralia alata* (magnified)
015 *Eschara foliacea* (magnified)
016 *Crisia eburnea*
017 *Crisia eburnea* (magnified)
018 *Idmonea atlantica*
019 *Idmonea atlantica* (magnified)
020 *Idmonea atlantica* (side view)
021 *Cellularia aricularis* (magnified)

a body, furnished with a pencil of bristles, which is probably a tactile organ, being brought forwards when the mouth is open, so that the bristles project beyond it, and being drawn back when the mandible closes."

Phylum	BRYOZOA
Class	STENOLAEMATA Marine Bryozoa
Class	GYMNOLAEMATA Marine Bryozoa
Order	CHEILOSTOMATIDA, CTENOSTOMATIDA

Sea Mats 3

[022]

[023]

[024]

[025]

[026]

[027]

ALCYONIDIUM GELATINOSUM forms smooth, pale-brown, encrusting, gelatinous patches on algae. Each animal has 19–20 tentacles, but it is not easy to distinguish them. The fawn-yellow embryos are visible in autumn and winter on algae on the lower shore.

Bowerbankia imbricata is unusual in having a contractile gizzard lined with teeth, which may be used to help in digestion.

Tubulipora pulchra is found in southeastern Australia. However, the classification is in flux, and it is not easy to identify. In likening this animal to a tube-dwelling polychaete worm, Rev. J. G. Wood (1863) writes: "The singular resemblance between the lengthened cells of this species and the hard, shelly tubes of the genus known as *Serpula,* so familiar on account of its scarlet and white plumes and marvelously engraved stopper, must be evident to everyone who has seen the little creature, or even noticed its empty habitation."

022 *Alcyonidium gelatinosum*
023 *Alcyonidium gelatinosum* (single zooid magnified)
024 *Pedicellina echinata*
025 *Pedicellina echinata* (magnified)
026 *Bowerbankia imbricata* (magnified)
027 *Serialaria landigera (*magnified)
028 *Serialaria landigera*
029 *Alecto dichotoma* on shell
030 *Alecto dichotoma* (magnified)
031 *Discopora patina*
032 *Discopora patina* contorted form (magnified)
033 *Tubulipora pulchra*

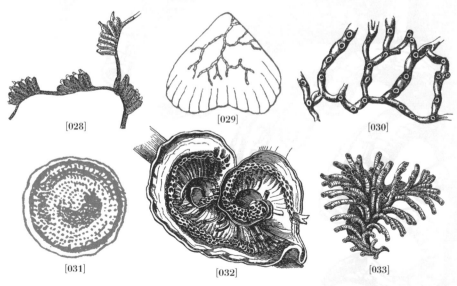

[028] [029] [030]

[031] [032] [033]

Marine Worms *Annelida*

The Annelida have soft, fluid-filled bodies made up of repeating segments, and a gut that runs from one end of the body to the other. They can change shape by pushing bodily fluids from one segment to another. Many worms have appendages, sometimes comprising merely one or two hairs or spines (called setae or chaetae, respectively), whereas others may be complicated projections of the body wall, resembling legs. These projections are called parapodia (*para* "comparable with," *podia* "feet"). Annelids can range in length from one-twentieth of an inch up to five feet.

There are three main groups of segmented annelid worms. The Oligochaeta are typified by the common garden worm, which has few (*oligo-*) spines (*chaetae*). The Hirudinea are the leeches, and lack setae but possess a large oral and a smaller ventral sucker. They are more common in fresh water than in seawater. The Polychaeta have many (*poly-*) spines (*chaetae*) protruding from each segment. These are the

worms that can most characteristically be described as marine. Marine worms have parapodia that can be well developed and differentiated into several parts. Many polychaetes have a large crown of tentacles that fringes the mouth. In some burrowing species, the segment in front of the mouth can be pumped full of liquid to 100 times its normal size. Many species of marine worms have a tail.

One marine worm, the lugworm *Arenicola* spp., lives in a U-shaped burrow in organically-rich sediments. It excavates a head chamber and pumps water and sand (as a worm cast) out of the outlet hole. Meanwhile, at the inlet hole, detritus and sand collapse into a cone-shaped depression and are drawn down into the feeding chamber. Black worm casts at the surface of the sand usually indicate decomposing organic material below, often as a result of sewage discharge. As a result, it is advisable for health reasons not to bathe where black worm casts are visible on the sand surface.

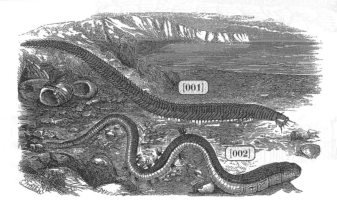

Worms *1*

001 Great eunice—*Eunice gigantea*
002 Lugworm—*Arenicola marina*⌂
003 Pearly nereis—*Phyllodoce maculata*
004 King ragworm, clam worm—*Nereis virens*
005 Sand mason worm—*Lanice conchilega*⌂

[003]

[004]

THE WORMS ON THIS PAGE are typical of most marine annelids. The great eunice is an active, hunting worm in the class Errantia and can reach nearly 10 feet in length. The common lugworm is a member of the Sedentaria, burying itself in a deep U-shaped burrow, and revealing its presence by the characteristic coiled worm cast. Ragworms are common predators on northern seashores, and like lugworms are popularly used as bait by rod fishermen. The pearly nereis is one of the paddleworms, so called because they have paddle-shaped lobes on the back. The sand mason worm is widely distributed on sandy shores and lives in a tube of sand and shell fragments that protrudes above the surface of the sand. When the tide is in, the sand mason worm filter feeds with its crown of tentacles.

[005]

Phylum	ANNELIDA
Class	POLYCHAETA Marine worms
Orders	ERRANTIA, SEDENTARIA

Worms 2

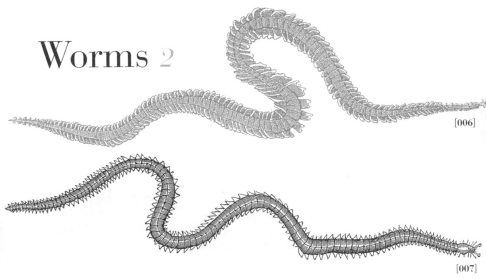

[006]

[007]

[010]

[011]

PHYLLODOCE PARETTI is a Mediterranean paddleworm. Rev. Wood (1863) says that under the microscope, the bristles of what he calls *Nereis margariticea* are "the very arsenal of destructive weapons, the barbed spear, the scimitar, the sabre, the sword-bayonet and the cutlass all being represented; while there is no lack of more peaceful instruments such as the grapnel, the sickle and the fish-hook." In fact, these are organs of locomotion, not predation.

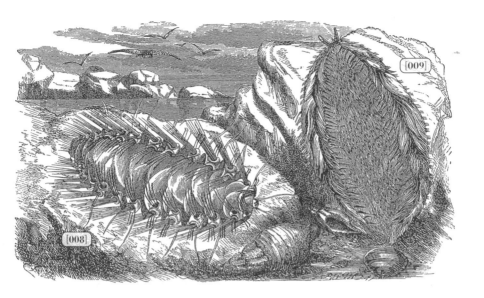

006 *Phyllodoce paretti*
007 *Nereis margaritacea*
008 Porcupine sea mouse—*Aphrodite hystricella*
009 Sea mouse—*Aphrodite aculeata*

010 *Syllis maculosa*
011 *Cirratulus lamarckii*
012 Honeycomb worms—*Sabella* spp.

Aphrodite species are called sea mice, because of their appearance. *Syllis* reproduce by budding. *Cirratulus* live in slimy channels in muddy gravel, while the *Sabella* are described as fan worms because of the shape of their tentacle crown. They construct a tube of sand grains embedded in mucus. The worm stores suitable sandgrains in two sacs below the mouth, and a string of mucus and sand grains is used to build a tube in which the worm lives.

[012]

Phylum	ANNELIDA
Class	POLYCHAETA Marine worms
Orders	ERRANTIA, SEDENTARIA

Worms *3*

[013]

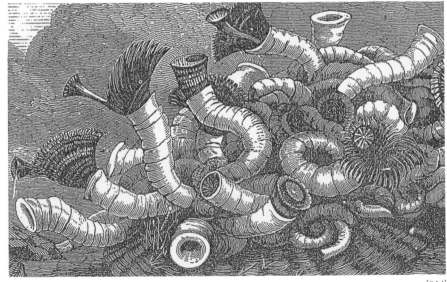

[014]

SERPULIDS ARE SUSPENSION FEEDERS that inhabit calcareous tubes on hard surfaces. *Serpula vermicularis* inhabits trumpet-shaped tubes along the Pacific Coast. The body of the worm is yellow-red, and in sufficient densities, the worms form reefs.

Flatworms and ribbon worms are not segmented and are therefore grouped separately from the annelids. Flatworms in the phylum Platyhelminthes have no gut, and although there are many free-living species, others are parasitic. Ribbon worms in the phylum Nemertea are carnivores and can be enormously long.

Edward Step, in *By the Deep Sea*, says: "How any creature can carry on the ordinary functions of life so tightly coiled and twisted and knotted is a marvel. And yet hopeless as the task appears, *Lineus* accomplishes it without any of those strainings that the juggler puts on when he has been tied up by the sailor, until the confusing rope is all knots."

013 *Sabella contortuplicata*
014 Red tubeworm—*Serpula vermicularis*
015 Banded flatworm—*Pseudoceros* sp.
016 Bootlace worm, giant ribbon worm—*Lineus longissimus*

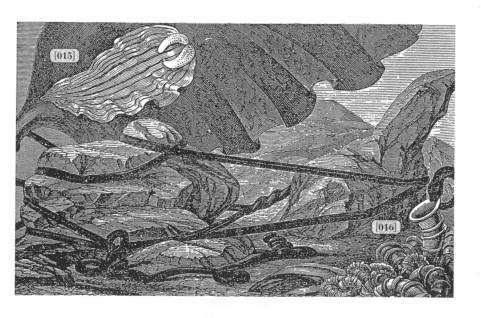

Crustaceans *Arthropoda*

The world's oceans teem with countless billions of crustaceans. From the tiny planktonic water fleas, barely one-hundredth of an inch long to the 12-foot giant spider crabs in the Sea of Japan, these creatures have been a major driving force in the oceanic food chain and the cycling of nutrients for nearly 600 million years. They include among their number the crabs, lobsters, shrimps, prawns, and crayfish as well as the sea monkeys, barnacles, copepods, seed shrimps, krill, clam shrimps, and fairy shrimps. They occupy every marine habitat, often in such abundance that the sea can be completely colored by them. The largest of all creatures ever to have lived, the blue whale, feeds almost exclusively upon them, as do many other commercially important fish species.

More than 32,000 species of crustaceans have so far been described, making them second only to insects and mollusks, in terms of taxonomic diversity. However, they are unrivalled among any animal group in terms of their structural diversity.

Many are important human food sources, harvested in seemingly never-ending abundance. Others, such as some crayfish species, have been victims of pollution or hunted almost to extinction.

Crustaceans are invertebrates (with no backbone) and arthropods (a group that also includes the insects). Like the insects, crustaceans have a hard external skeleton formed from chitin, but few species have ever successfully broken with their marine origins and adapted to a life on land. Conversely, very few of the insects have adapted to a marine origin, and thus the two most diverse groups on earth surpass each other in their respective environments but rarely compete with each other for resources.

One feature of the crustaceans is their many pairs of legs. These have become specialized for different purposes in different species. Examples include claws or pincers for catching or eating prey, "paddles" for swimming, and "nets" for catching prey.

Phylum ARTHROPODA

Class CRUSTACEA

THE HARD EXOSKELETON of the crustaceans organizes the body in segments, each segment having one pair of appendages that can be used for different functions such as sensing, eating, walking, swimming, or reproduction. The segments are further

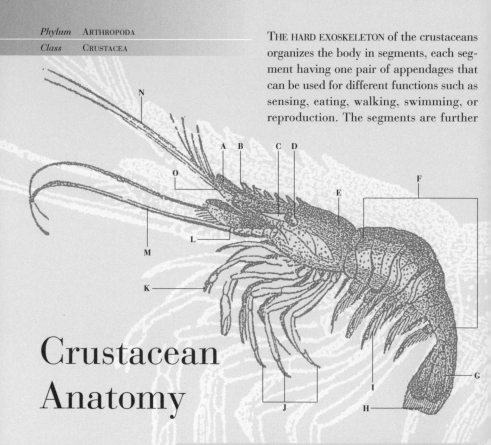

Crustacean Anatomy

Anatomy of a penaeid prawn

A Rostrum	**F** Abdominal segments	**K** Forelegs
B Dorsal rostrum spine	**G** Telson	**L** Antenna
C Antennal spine	**H** Uropods	**M** Antennal flagellum
D Eye	**I** Pleopods	**N** Flagellum
E Carapace	**J** Pereiopods	**O** Antennule

arranged in distinct regions that are specialized for different purposes. The head or cephalon (typically 6 segments at the embryo stage) carries most of the sensory appendages (antennae and antennules), although in some groups these have become specialized for swimming. The thorax (8 segments) is often difficult to distinguish from the head and tends to carry the appendages needed for feeding and walking. The abdomen (6 segments) usually bears appendages specialized for swimming or carrying eggs. The segmented regions are often difficult to distinguish separately. Where head and thorax are fused into what is called the cephalothorax, they are generally protected by a hard shield known as the carapace.

Anatomy of a crayfish or lobster

A	Antenna	K	Cephalic groove
B	Rostrum	L	Abdominal segments
C	Antennule	M	Uropods
D	Eye	N	Telson
E	Chela	O	Ischium
F	Propodus	P	Merus
G	Carpus	Q	Carpus
H	Merus	R	Propodus
I	Ischium	S	Dactylus
J	Cheliped	T	Carapace

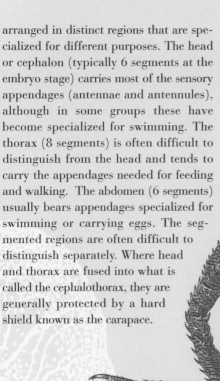

Barnacles

[010]

001 Goose barnacle, gooseneck barnacle—*Lepas anatifera*
002 Pacific goose barnacle—*Pollicipes mitella*
003 *Coronula diadema*
004 *Conchoderma aurita*
005 Acorn barnacle, rock barnacle—*Balanus crenatus*
006 Buoy-making barnacle—*Lepas fascicularis*
007 *Pyrgoma grande*
008 *Balanus tintinnabulum*
009 Acron barnacle, rock barnacle—*Tubicinella trachealis*
010 Goose barnacles, gooseneck barnacles—
 Lepas anatifera
011 *Pyrgoma anglicum* on cup coral
012 Acorn barnacle, common barnacle—*Balanus balanoides*
013 *Scalpellum vulgare*
014 Porcate barnacle—*Balanus sp.*
015 Goose barnacle, gooseneck barnacle—*Lepas anatifera*

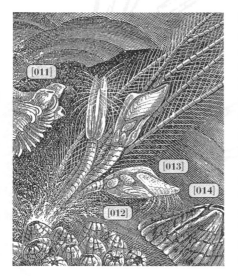

MOST BARNACLES spend their adult lives attached to solid objects. Acorn barnacles are abundant on the seashore, and live cemented to rock by their antennae, which have evolved to become hard calcareous plates within which the body is enclosed, and from which the cirri (frondlike legs) protrude upward. The goose barnacle is similar but attaches to rock by a stalk. The Victorian zoologist Louis Agassiz described a barnacle as "nothing more than a little shrimp-like animal, standing on its head in a limestone house and kicking food into its mouth." Barnacles are mainly hermaphrodite and fertilize their neighbors by means of a disproportionately long penis. The resulting nauplius larvae swim freely as zooplankton, molting several times before becoming cypris larvae. Individuals settle and cement themselves headfirst to a surface before maturation.

Phylum	ARTHROPODA
Class	CRUSTACEA
Subclass	MALACOSTRACA/BRANCHIOPODA
Order	STOMATOPODA/ANOSTRACA

Mantis &
Brine Shrimps

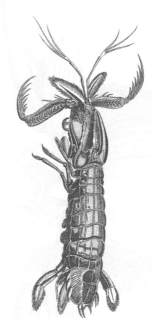

[017]

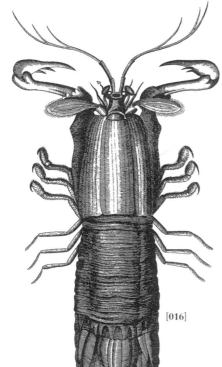

[016]

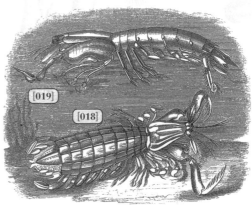

[019]

[018]

MANTIS SHRIMPS APPEAR long and flattened. Their one pair of greatly enlarged limbs resemble those of the praying mantis. They can attain a length of 14 inches, and hide in dark crevices, grabbing shrimps and passing fish with their powerful barbed limbs. In Bermuda and the West Indies, their strength and ferocity when captured have earned them the name split-thumb. Kept in aquariums, they have been known to crack the glass with their powerful limbs.

Brine shrimps [020–022] are tiny creatures that measure up to two-thirds of an inch in length, and feed mainly on green algae. J. G. Wood writes: "The movements of this little creature are most graceful. It mostly swims on its back, its feet being in constant motion, and its course directed by means of its long tail."

016 Species of mantis shrimp
017 Mantis shrimp—*Squilla mantis*
018 Mantis shrimp—*Squilla mantis*
019 Gouty shrimp—*Squilla chiragra*
020 Brine shrimp nauplius (magnified)—*Artemia salina*
021 Brine shrimp adult—*Artemia salina*
022 Brine shrimp adult (magnified)—*Artemia salina*
023 *Squilla desmaresti*

[020]

[021]

[022]

[023]

Phylum	ARTHROPODA
Class	CRUSTACEA
Subclass	MALACOSTRACA
Order	MYSIDACEA/ISOPODA

Opossum Shrimps, Fish Lice & Sea Slaters

[028]

[024]

[027]

[025]

[026]

024 Glassy ericthus—*Ericthus vitreus*
025 Armed ericthus—*Ericthus armatus*
026 Chameleon shrimp—*Mysis chameleon*
027 Club-horned phyllosome—
　　　Phyllosoma clavicorne
028 Baffin bay arcturus—*Arcturus baffinii*
029 Ione—*Ione thoracious*
030 Gribble—*Limnoria terebrans*
031 Water hoglouse—*Asellus aquaticus*
032 Great sea slater—*Ligia oceanica*
033 Great sea slater—*Ligia oceanica*

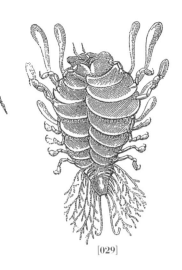

[029]

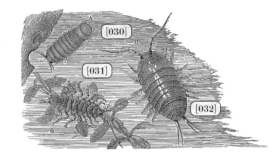

[030] [031] [032]

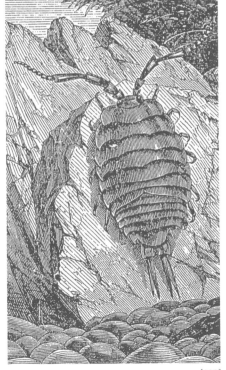

[033]

THERE ARE ABOUT 450 species of opossum shrimp—the name is derived from the brood pouch where the female carries her developing young. Most live in deep cold water *[026]*.

The Isopod Crustacea is a large group encompassing some 4,000 species, including the sea slaters *[032 and 033]*, various parasites (including fish lice), and some unusual *Antarcturus* and *Arcturus* species *[028]*. Most (but not all) bear a resemblance to the common wood louse; the body is flat and elongated, and the back is covered by a series of armorlike plates. This group also includes about 20 species of gribble *[030]*—tiny marine woodboring crustaceans that once were a serious pest on wooden ships.

Phylum	ARTHROPODA
Class	CRUSTACEA
Subclass	MALACOSTRACA
Order	AMPHIPODA

Sand Hoppers, Sand Screws & Ghost Shrimps

[034]

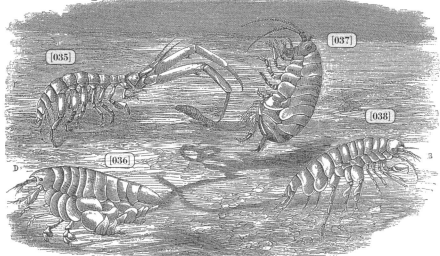

[035]

[037]

[036]

[038]

THE EUROPEAN SAND HOPPER *[037]* is so named because of its ability to leap, which is accomplished by rapidly flicking the abdomen. Sand hoppers dig short burrows along the strandline of beaches and remain submerged during the day, emerging at night to feed on organic debris, such as decaying seaweed. They have well-developed eyes and can use the angle of the sun and its polarized light to navigate.

Related to the sand hopper is the common sand screw *[036]*.

Ghost shrimps are also known as skeleton shrimps *[034]*. They have a thin, elongated body and are found in abundance on vegetation and hydroids on the lower shore.

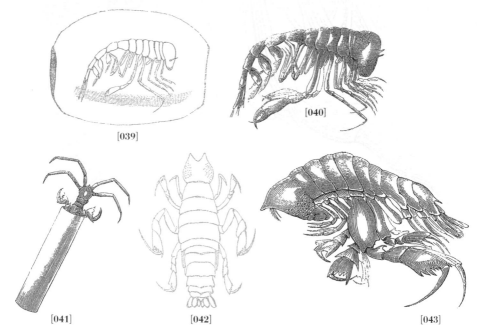

[039]

[040]

[041] [042] [043]

034 Skeleton shrimp, ghost shrimp—*Caprella linearis*
035 Pernys—*Corophium longicorne*
036 Sand screw—*Sulcator arenarius*
037 Sand hopper—*Talitrus sultator*
038 Kroyer's sand screw—*Kroyera arenaria*

039 Fleming's hermit sand screw—*Phronima sedentaria*
040 Fleming's hermit sand screw—*Phronima sedentaria*
041 Caddis shrimp—*Cerapus tubularis*
042 *Dactylocera nicaeensis*
043 *Dactylocera nicaeensis*

Phylum	ARTHROPODA
Class	CRUSTACEA
Subclass	MALACOSTRACA
Order	DECAPODA

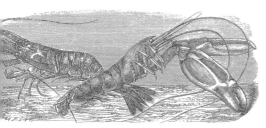

[046]

[047]

Prawns & Shrimps

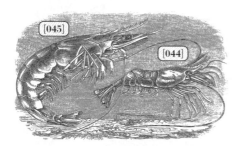

[045]

[044]

044 Pink shrimp—*Pandalus annulicornis*
045 Endeavor prawn, redtai—*Penaeus ensis*
046 Short-beaked red shrimp—*Alpheus brevirostris*
047 Common shrimp—*Crangon vulgaris*
048 Common prawn—*Leander serratus*
049 Burrowing prawn, mud shrimp—*Axius stirhynchus*
050 Mud burrower—*Callianassa subterranea*
051 Common shrimp—*Crangon vulgaris*
052 Common prawn—*Leander serratus*

THE PRAWNS AND SHRIMPS belong to the order Decapoda—a name that literally means "ten legs," although so many legs are not evident in some species. Most prawns and shrimps belong to the suborder Natantia, of which there are about 2,000 species worldwide. The common shrimp [*047 or 051*] is a commercially important species, found in coastal waters on both sides of the North Atlantic. It grows to about 3 inches and is gray or brown with reddish spots.

The common prawn [*048 and 052*] is transparent when alive, with fine yellow and red markings on the body and legs.

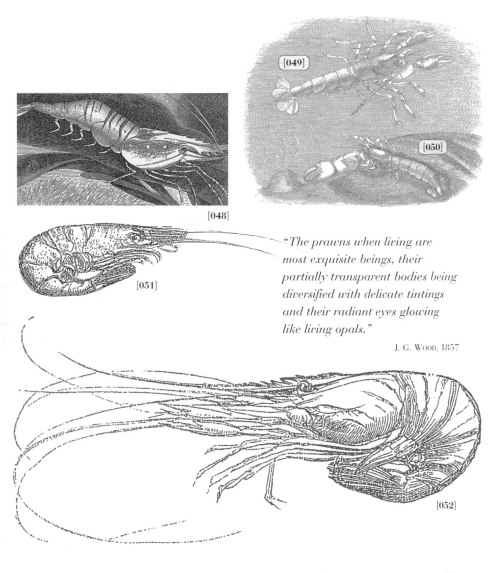

[048]

[049]

[050]

[051]

"The prawns when living are
most exquisite beings, their
partially transparent bodies being
diversified with delicate tintings
and their radiant eyes glowing
like living opals."

J. G. Wood. 1857

[052]

Phylum	ARTHROPODA
Class	CRUSTACEA
Subclass	MALACOSTRACA
Order	DECAPODA

True Lobsters & Crayfish *1*

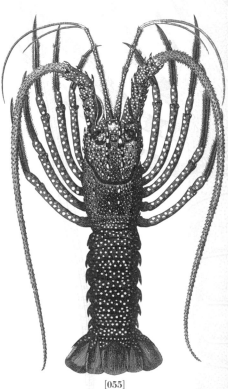

[055]

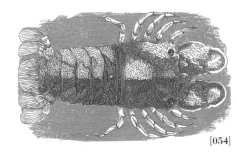

[054]

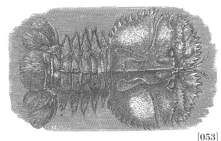

[053]

ALL OF THE REMAINING CRUSTACEAN species shown in this book are from the former suborder Reptantia, which comes from the Latin, meaning "crawling" (the name is now discontinued). Their most spectacular feature is the first pair of walking legs that have evolved into powerful pincers. In contrast, the spiny lobsters [*055–057 and on page 69, see 063*] can be distinguished from other lobsters by a lack of pincers, and abdominal segments that are sharply spined. The larva is a transparent planktonic phyllosoma [see *027, on page 60*], which the Victorian naturalists mistook for a crustacean species completely unrelated to lobsters.

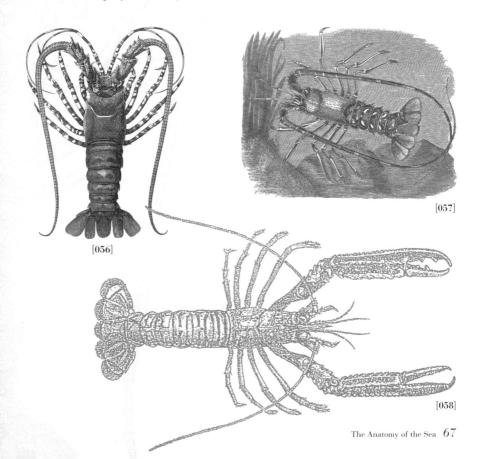

[056]

[057]

[058]

Phylum	ARTHROPODA
Class	CRUSTACEA
Subclass	MALACOSTRACA
Order	DECAPODA

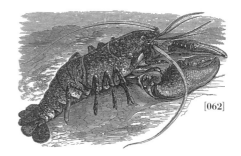

[062]

True Lobsters
& Crayfish 2

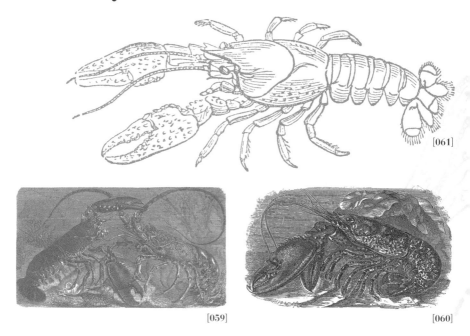

[061]

[059]

[060]

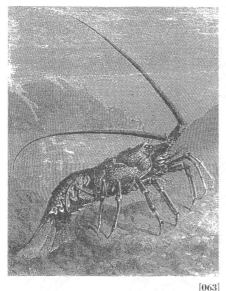

[063]

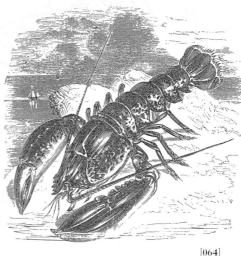

[064]

THE COMMON LOBSTER, *Homarus gammarus*, is found from Norway to the Mediterranean Sea and has long been a favored delicacy. Indeed, Mrs. Beeton, in her 1906 edition of *Beeton's Household Management*, lists 29 recipes for serving it, and describes large quantities of its American cousin, *H. americanus*, as being imported to satisfy British demand. Today, lobsters still form the most valuable fishery product of the state of Maine.

Lobsters are aggressive, territorial animals that frequently lose their claws when fighting rivals. New claws eventually replace them, but in the meantime, the creatures are of little value to fishermen. J. G. Wood informs us that "Lobsters... will sometimes shake them [the claws] off on hearing a sudden noise."

059 Common lobster and spiny lobster
060 Common lobster, European lobster, blue lobster—
 Homarus vulgaris 🖾
061 Common lobster, European lobster, blue lobster—
 Homarus gammarus 🖾
062 Common lobster, European lobster, blue lobster—
 Homarus gammarus 🖾
063 Spiny lobster
064 Common lobster, European lobster, blue lobster—
 Homarus gammarus 🖾

Phylum	ARTHROPODA
Class	CRUSTACEA
Subclass	MALACOSTRACA
Order	DECAPODA

Squat Lobsters, Hermit Crabs & Porcelain Crabs

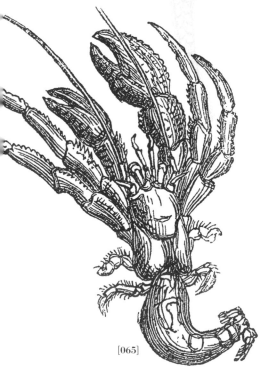

[065]

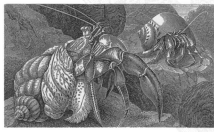

[066]

SQUAT LOBSTERS [*068 and 069*] and hermit crabs [*65*] are from a section of the Reptantia called the Anomura. J. G. Wood described them as "a sort of intermediate link between the crab and the lobster." Indeed, they differ from the crabs in having a fan tail similar to that of a lobster, but differ from the latter in having an abdomen that is either similar to a crab's

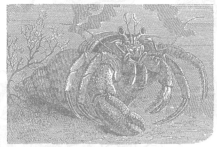

[067]

[068]

065 The body of a hermit crab
066 Hermit crabs
067 Hermit crab—*Pagurus bernhardus*
068 Spiny squat lobster with hairy porcelain crab,
 broadclawed porcelain crab—*Galathea strigosa* and
 Porcellana platycheles
069 Common plated lobster with hairy porcelain crab,
 broadclawed porcelain crab—*Galathea strigosa* and
 Porcellana platycheles
070 Hermit crab—*Pagurus bernhardus*

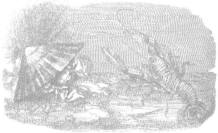

[069]

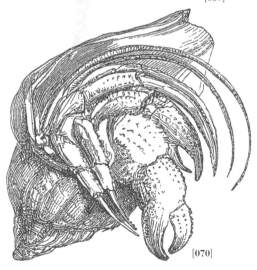

[070]

and folded beneath the thorax (as with the squat lobsters) or is soft with reduced swimmerets (as with the hermit crabs). Porcelain crabs [*also 068 and 069*] are the most crablike of the group but have a small, fan-shaped tail.

Squat lobsters rely on speed as their major skill in self defense; porcelain crabs, on remarkable camouflage.

Phylum	ARTHROPODA
Class	CRUSTACEA
Subclass	MALACOSTRACA
Order	DECAPODA

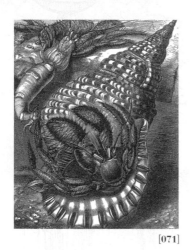

[071]

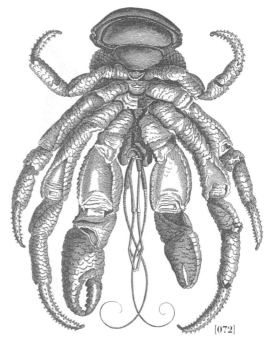

[072]

Hermit Crabs

HERMIT CRABS are well known for their habit of protecting their large, soft abdomens by coiling them inside the empty shells of mollusks such as whelks and winkles. Some have distinct preferences for a particular type of shell; others are less fussy, changing their shells as soon as they encounter a more desirable residence.

Rev. J. G. Wood tells us that the "Crafty Hermit-Crab is found in the Mediterranean and among other shells that it inhabits, the variegated triton is known to be the favourite. In the illustration [*071*] the crabs have fought for the shell and the vanquished is on the ledge above it, whither it has been flung by the conqueror."

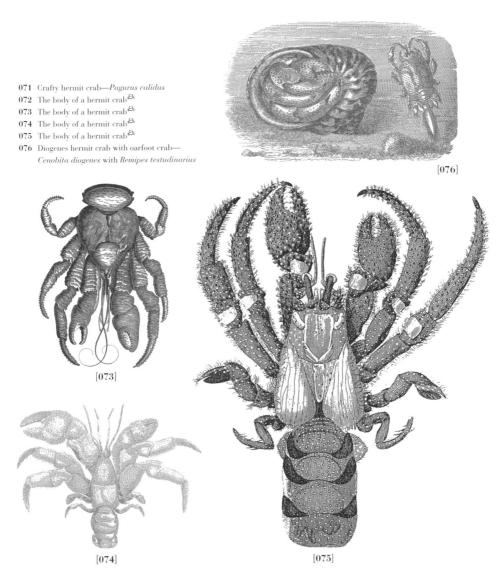

071 Crafty hermit crab—*Pagurus calidus*
072 The body of a hermit crab↫
073 The body of a hermit crab↫
074 The body of a hermit crab↫
075 The body of a hermit crab↫
076 Diogenes hermit crab with oarfoot crab—
 Cenobita diogenes with *Remipes testudinarius*

[076]

[073]

[074]

[075]

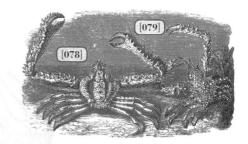

True Crabs *1*

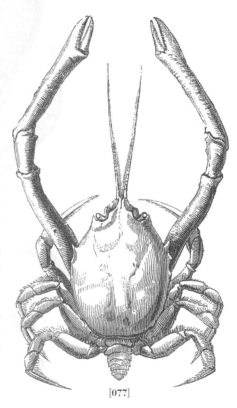

THE TRUE CRABS, like other related decapods, have 5 pairs of walking legs, with the first pair modified to form powerful and often enlarged pincers; the remaining four pairs are used for locomotion, which is typically sideways in direction. The strong, and usually heavy-duty, carapace or shell is flattened, with the remaining abdominal sections tucked underneath it, giving the crab its squat, oval appearance. Crabs range in length from a few tenths of an inch up to 13 feet for the giant spider crab.

Many crabs rely on their armored shells and the pugnacious use of their large pincers to deter predators, but others actively seek to camouflage themselves. For example, spider crabs have long spindly legs and move sluggishly; not built for confrontation, they have adapted to hide in seaweed and use a mucus secretion to fix camouflage material to their bodies.

[077]

077 Masked crab—*Corystes cassivelaunus* 🦀

078 Spine-armed lambrus—*Lambrus spinimanus*

079 Strawberry crab, shortlegged spider crab—
Eurynome aspera 🦀

080 Thornback crab, spiny spider crab—*Maja squinado* 🦀

081 Thornback crab, spiny spider crab—*Maja squinado* 🦀

082 Three-spined spider crab—*Pericera trispinosa*

083 *Chorinus*

084 Thornback chorinus—*Chorinus acanthonotus*

085 Gouty crab—*Lissa chiragra*

086 *Doclea calcitrapa*

087 Thornback crab, spiny spider crab—*Maja squinado* 🦀

088 Ramshorn crab—*Criocarcinus superciliosus*

089 Thornclaw crab—*Acanthonyx zebrida*

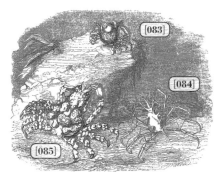

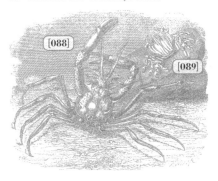

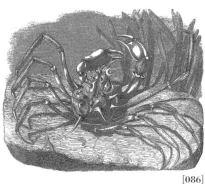

[086]

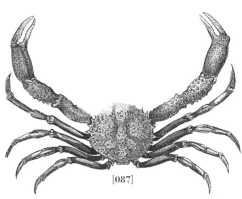

[087]

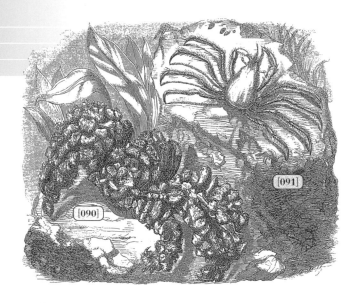

True Crabs 2

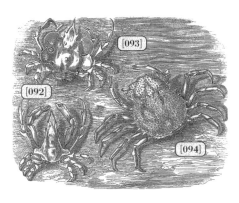

THE DECORATOR CRAB [*090 and 091*], a resident of coral reefs, is covered with tiny hooks to which it attaches specially selected algae and sponges, thus "the hairy limbs, as well as the whole body, are encrusted so thickly that their true shape is quite indistinguishable...." (J. G. Wood). The herald crab [*093*] was so called by the Victorians "because the shape of the carapace presents a fanciful resemblance to the shield and mantle employed by heraldic painters." These tropical crabs decorate their carapace with large fronds of living seaweeds, rendering them almost invisible amongst the chosen weed species.

In contrast to the decorators, the fighting crab (now called the fiddler crab) [*099*] deters predators by waving its huge claw in a threatening manner. The genus has now been renamed *Uca*, but the Victorian *Gelasimus* included here was derived from a Greek word signifying laughter and was so given because of the crab's comical claw-waving antics.

090 *Camposcia retusa* covered in sponges
091 *Camposcia retusa* without sponges
092 Longsnouted crab—*Huenia elongata*
093 Herald crab, arrowhead crab—*Huenia heraldica*
094 Micippa—*Micippa philyra*
095 *Leptopodia sagittata*
096 *Stenorhyncus phalangium*
097 Porcupine crab—*Lithodes hystrix*
098 Angular crab—*Gonoplax angulata*
099 Fighting crab—*Gelasimus bellator*

[097]

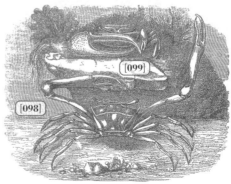

Phylum	ARTHROPODA
Class	CRUSTACEA
Subclass	MALACOSTRACA
Order	DECAPODA

True Crabs 3

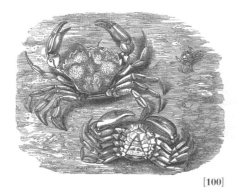

[100]

[102]

[101]

100 Green crab—*Carcinus maenas*
101 Shore crabs—*Carcinus maenas*
102 Spinose parthenope—*Parthenope horrida*
103 Spotted crab—*Carpilius maculatus*
104 Tuberculed galene—*Galene dorsalis*
105 Smooth galene—*Galene ochtodes*
106 Flattened mudcrab—*Thelphusa depressa*

THE GREEN CRAB of North America or common shore crab of Britain [*100 and 101*] belongs to a large family of almost 300 species. These are the swimming crabs or Portunidae. Unlike many in the family, green crabs have a very limited ability to swim, but this disadvantage has not prevented them from becoming the most common of all the crabs in the regions where they are found. They have been introduced, accidentally or otherwise, to numerous locations around the world, including southern Australia, where it is feared that they may outcompete the native decapods. The reasons for its success seem to be an ability to hunt on, above, or below the waterline, and an amazing tolerance to pollution and extremes of temperature.

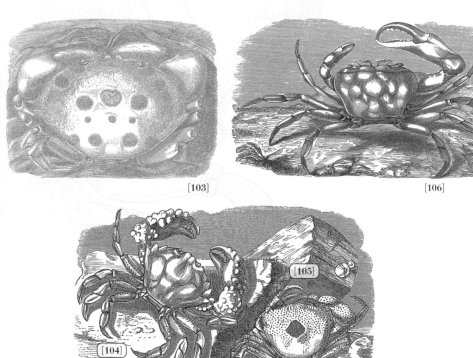

[103]

[106]

[105]

[104]

Phylum	ARTHROPODA
Class	CRUSTACEA
Subclass	MALACOSTRACA
Order	DECAPODA

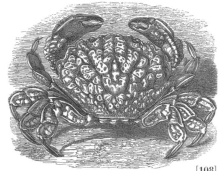

[108]

True Crabs *4*

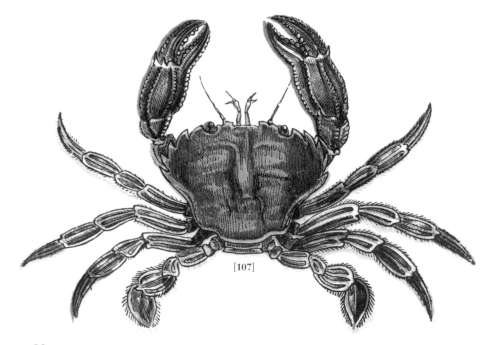

[107]

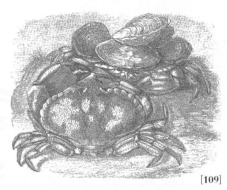

[109]

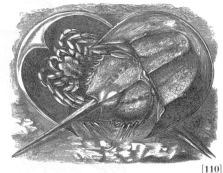

[110]

THE VELVET FIDDLER CRAB [*107*] belongs to the swimming crabs. J. G. Wood tells us that "Their motions are very like those of an oar when used in 'sculling' a boat, and are…thought to resemble the movements of a fiddler's arm while playing a lively tune…A full-grown specimen is a really handsome creature, with its coat of velvet pile, its striped feet and legs, its scarlet and blue claws, and its vermilion eyes set in their jetty sockets." But he warns us, "This species is not one whit less voracious or cruel than the edible crab." The economically important edible crab [*109*] is found off British and European coasts.

The horseshoe or king crabs [*111 and 112*] are not true crabs, but are related to scorpions and spiders, all which have chelicerae rather than mandibles and have ancestry dating back almost 500 million years to the Ordovician period.

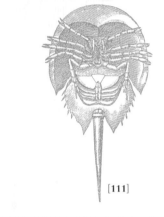

[111]

[112]

Mollusks *Mollusca*

Snails, slugs, clams, and squid are all classified together in the phylum
Mollusca, from the Latin *molluscus*, meaning "soft-shelled." They have
been on the planet for 400 million years, and they are the second largest
phylum after the nematode worms, with 100,000 different species. They
evolved in the sea and then colonized the land to form the slugs and snails
we see in our gardens and on the seashore. All have a soft, compact, unseg-
mented body made up of a head, mantle, foot, and visceral mass. Most
secrete an external shell that can be a single valve (for example, in snails)
or a double valve (as in clams).

The mollusks are immensely important to humans. They are economi-
cally important as a source of food (clams, mussels, squid), but also dev-
astate agriculture through the action of slugs and snails all over the world.
Mollusks spread diseases, too, particularly in the tropics. For example,
aquatic snails are intermediate hosts of liverflukes, which can then go on
to infect both domestic animals and people.

Over millions of years, the body form of mollusks has been honed by the environment so that they now show a range of innovative and sometimes extreme adaptations of form. Thus squid use jet propulsion and have an eye that is as good as the human eye, clams use hinges, and some snails hunt with poisoned harpoons.

There are eight classes. Of these, the major classes are the chitons (Polyplacophora), the slugs and snails (Gastropoda), the clams and mussels (Bivalvia), the tusk shells (Scaphopoda), and finally the squids and their relatives (Cephalopoda). Victorian malacologists did not classify mollusks in the way we do today. The following arrangement uses the Victorian pattern—for example, chitons are wrongly placed next to limpets, as this is how they would have been presented in the original source books. The modern taxonomy of mollusks is in constant flux, and we have made a selection from more than one recent classification for the information presented here.

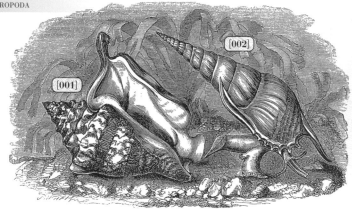

Strombids & Muricids

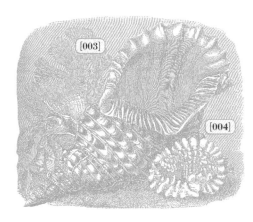

THE STROMBIDS AND MURICIDS are whelks, or rock shells. These carnivorous snails feed through a large trunklike proboscis with teeth and mouth at the end. To feed, these creatures push out their proboscis (pushing it out from their body) and use it to rasp away at the shells of other mollusks or crustaceans. The shell is thick and sculptured with a pointed spire. When the animal retracts into the shell, the aperture is closed by an oval, horny door called an operculum.

001 Three-horned stromb—*Strombus tricornis*
002 Beaked spindle—*Rostellaria curvirostra*
003 Sea trumpet—*Triton variegatus*
004 Wrinkled triton—*Triton anus*

005 Common spidershell—*Pteroceras lambis*
006 Orange-mouthed spider shell—*Pteroceras aurantia*
007 Sting winkle or oyster drill—*Murex erinaceus*
008 Caltrop murex, venus's comb—
 Murex tribulus tenuirostrum

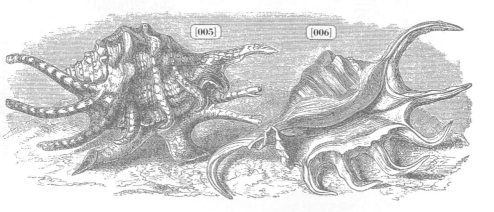

The sting winkle is a pest on oyster beds. By contrast, the ornate shells of some members of this group make them a target for shell collectors all over the world.

The spidershells and tritons are found in warmer waters. A triton shell may be used as a musical horn. A hole is bored into it, then air is blown across it, like playing a flute.

Phylum	MOLLUSCA
Class	GASTROPODA
Subclass	PROSOBRANCHIA
Order	CAENOGASTROPODA

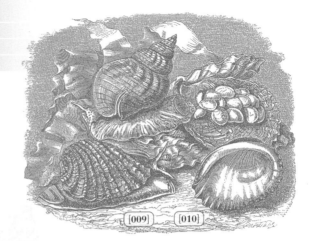

[009] [010]

Whelks

THE COMMON WHELK lives just offshore in the North Atlantic, and its large dead shells are often found washed up onto the strandline of the shore. It is a scavenger and can be caught in baited traps. Rev. J. G. Wood writes, "Vast quantities of whelks are taken annually for the markets and are consumed almost totally by the poorer classes who consider them in the light of a delicacy. They are, however, decidedly tough and stringy in texture." *Concholepas* is a South American whelk that is evolving into a limpetlike form, with a short spire and a widened aperture. The netted dog whelk lives much farther up the shore

[011]

than the common whelk and crawls over rocks, feeding on barnacles and snails. It consumes its prey through a tiny circular hole made in the shell of its prey.

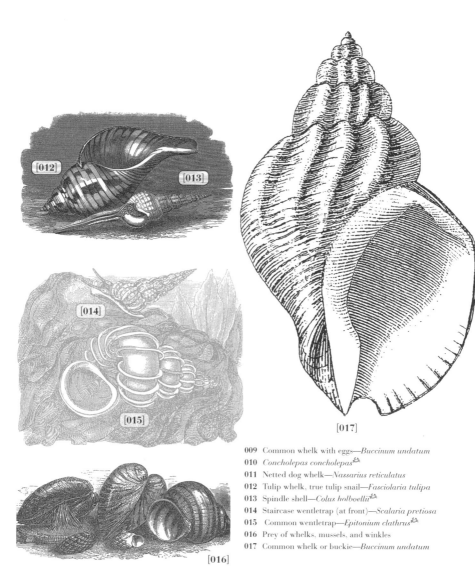

009 Common whelk with eggs—*Buccinum undatum*
010 *Concholepas concholepas*
011 Netted dog whelk—*Nassarius reticulatus*
012 Tulip whelk, true tulip snail—*Fasciolaria tulipa*
013 Spindle shell—*Colus holboellii*
014 Staircase wentletrap (at front)—*Scalaria pretiosa*
015 Common wentletrap—*Epitonium clathrus*
016 Prey of whelks, mussels, and winkles
017 Common whelk or buckie—*Buccinum undatum*

Cones & Volutes

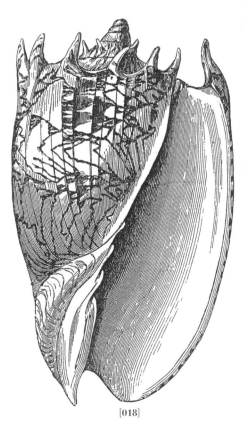

[018]

CONE SHELLS vary from 1 to 8 inches in length. They are carnivorous, and some eat fish. The latter cones use a harpoon loaded with a cocktail of venoms, which paralyze the prey immediately the harpoon penetrates its skin. They can be lethal to species other than fish. The first recorded case of a cone killing a human was in the 1930s on a Barrier Reef island. The victim who was stung was with his mother. They were in too remote a place to get help, so she tended him for the four hours he took to die. To her credit, she took notes. Gradually, paralysis set in; when it reached his diaphragm, he was unable to breathe and died. An American marine on Guam is reputed to have died in 4 seconds when two cones fired on both sides of his neck simultaneously while he was posing for a photograph in water.

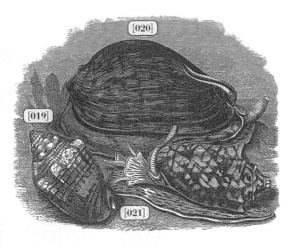

018 *Mela diadema*
019 Common music volute—*Voluta musica*
020 Neptune's boat—*Cymba neptuni*
021 Bat volute—*Cymbiola respertilio*
022 Admiral cone—*Conus ammiralis*
023 Textile cone—*Conus textile*
024 Bishop's mitre—*Mitra mitra*

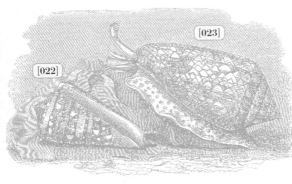

[024]

[025]

Prosobranch Snails

025 *Tonna dolium* ⚏

026 Apple tun shell—*Tonna dolium* ⚏

027 Spotted ivory shell—*Babylonia areolata* ⚏

028 Spotted needle shell—*Terebra maculata*

029 Black olive—*Oliva vidua* ⚏

030 Bishop's mitre, episcopal mitre—*Mitra mitra* ⚏

031 Lightning dove shell—*Pyrene ocellata* ⚏

THE TUN SHELLS comprise relatively few species in the family Tonnidae. The spire is small and ends in a wide aperture. The outer surface is usually sculptured in thick spiral ribs. Most tun shells occur in sand beyond the edges of coral reefs. The needle shells derive their name from the long, thin spire. Indeed, *Terebra maculata* sometimes goes under the common name "the marlinspike." Of the olives, Rev. J. G. Wood says, "In spite of their elegant and harmless appearance, they are predaceous and hungry creatures and can readily be captured by the simple process of tying a piece of meat to a line, lowering it towards the spot where the Olives are creeping and hauling it up at intervals."

About 350 species of mitre shells are known, most of the larger species living in the tropics. The prettily marked dove shells occur in warmer waters, often on sandy shores.

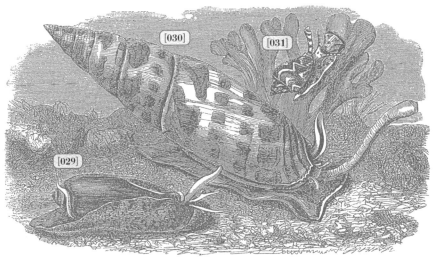

Phylum	MOLLUSCA
Class	GASTROPODA
Subclass	PROSOBRANCHIA
Order	CAENOGASTROPODA

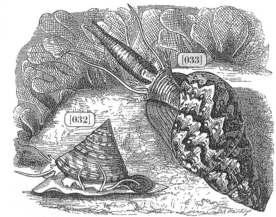

Trochids & Turritellids

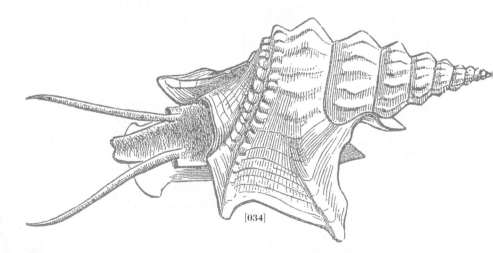

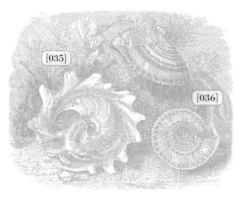

032 Common top shell, Jujuban top shell—
 Calliostoma zizyphinus

033 Australian pheasant shell, painted lady—
 Phasianella australis

034 Pelican's-foot shell, spout shell—*Aporrhais pes-pelecani*

035 Indian carrier shell—*Onustus indicus*

036 Staircase trochus—*Architectonica maxima*

037 Pelican's-foot shell, spout-shell—*Aporrhais pes-pelecani*

038 Mud creeper, large club shell—*Terebralia palustris*

039 Tower shell, turritella—*Turritella communis*

040 Worm shell, wormsnail—*Vermicularia radicula*

041 Snake shell, squamous worm shell—*Siliquaria anguina*

THE COMMON TOP SHELL frequently occurs on rocky temperate seashores. It is an important food resource for crabs. The crab holds the shell like an ice-cream cone in one claw. With its other claw, it follows the whorls, peeling and breaking off shell from the edge of the aperture until it reaches the soft body parts.

The turritellids are so named because the shell resembles a tower or a spire.

Some turritellids can eject a dark purple fluid when molested. The large club shell and the other cerithids differ from the turritellids by having an expanded lip on the shell aperture. The spout shell resembles a cerithid but has an enormously expanded shell lip, drawn out into lobes that look like the foot of a bird, hence the name *pes-pelecani*. The snake shells are carnivores that live inside sponges.

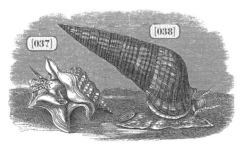

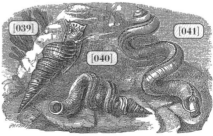

[042]

Cowries
& Ear Shells

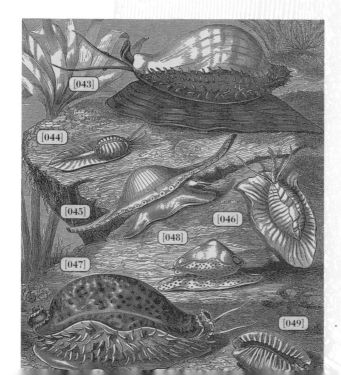

[043]

[044]

[045]

[046]

[048]

[047]

[049]

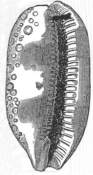

[050b]

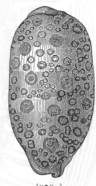

[050a]

THERE HAS ALWAYS BEEN a lucrative industry involving trade in seashells. This industry began when shells were used as jewelry and currency in certain parts of the world. Cowrie shells, found on seashores all over the world, have been a particular focus for these human activities. Cowries are carnivorous animals that begin life looking like volutes but mature into the characteristic adult shape typified by the European cowrie in the illustration. Rev. Wood has described how Sandwich Islanders fashioned cowrie shells into bait for catching cuttlefish.

Haliotids (ears shells, or abalone) are primitive limpets, differing from other gastropods in that the shell is perforated by one or more holes. They graze on rock surfaces. Water is drawn in under the shell, used for respiration, then passed out through the holes. The inside of the shell, called the nacreous layer, is iridescent and is a major source of mother-of-pearl.

042 European cowrie—*Trivia monacha*
043 Poached-egg cowrie—*Ovulum ovum*
044 European cowrie—*Trivia monacha*
045 Shuttle—*Phenacovolva brevirostris*
046 Marginella, brown-line marginella—
 Marginella diadochus
047 Panther cowrie—*Cypraea pantherina*
048 Warty egg cowrie—*Calpurnus verrucosus*
049 Deep-toothed cowrie—*Cypraea caurica*
050a *Cypraea* sp. (050b is the view from above)
051 Ass's ear shell—*Haliotis asininus*
052 Furrowed ear shell—*Haliotis scalaris*
053 Green ormer, abalone—*Haliotis tuberculata*
054 Green ormer, abalone—*Haliotis tuberculata*

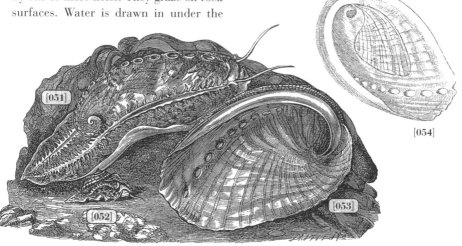

[051]

[052]

[053]

[054]

Phylum	MOLLUSCA
Class	GASTROPODA
Subclass	PROSOBRANCHIA
Order	ARCHAEOGASTROPODA Limpets
Class	POLYPLACOPHORA Chitons

Limpets
& Chitons

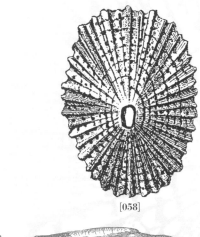

[058]

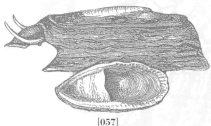

[057]

LIMPETS ARE ACTUALLY a form of snail. The "Chinaman's hat" form of the shell is effective for life on the seashore, and it has evolved independently in a range of limpets. The cone-shaped shell is equivalent to the largest whorl of a snail shell. The smaller whorls, which form the spire of the shell, disappear completely during development. The animal attaches to the rock by a horseshoe-shaped muscle, allowing the head to push forward at the front. Keyhole limpets take in water around the rim of the shell and expel it through a hole in the apex.

Chitons are a major group within the phylum of molluscs, and are frequently found on the seashore.

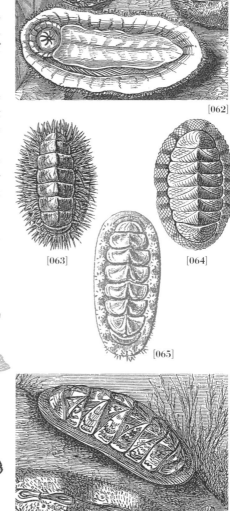

[062]

[063]

[064]

[065]

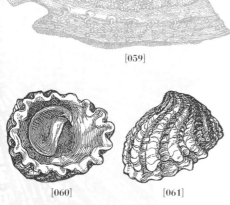

[059]

[060]

[061]

[066]

Phylum	MOLLUSCA
Class	GASTROPODA
Subclass	PROSOBRANCHIA
Order	HYPSOGRASTROPODA Phorus and Raft snails
Subclass	OPISTHOBRANCHIA
Order	TECTIBRANCHIA Bubble shells

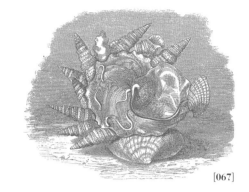

[067]

Bubble, Phorus & Raft Snails

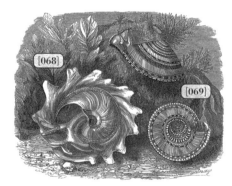

[068]

[069]

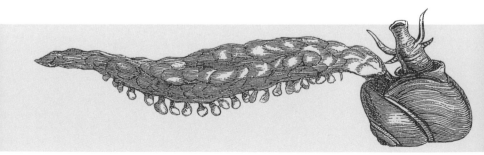

[070]

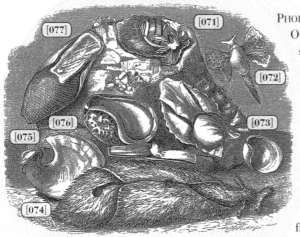

PHORUS SNAILS live in the Indian Ocean and cement empty shells of other snails onto their own shells. Identifying characteristics of the family are an asymmetrical operculum and a shell interior that is not nacreous. There are only a few species in the family. Rev. Wood (1863) says of these mollusks: "The name Phorus is of Greek origin and signifies a carrier. The movements of the Phorus are said to be very clumsy, the animal staggering and tumbling about." Raft snails such as the violet snail are pelagic, oceanic snails, which produce a raft containing air vesicles. The eggs are attached to the underside.

The opisthobranch snails have gills at the rear of the body. Bubble shells have a rudimentary, delicate shell. The gills are usually on one side of the back.

067 *Phorus conchylophorus*
068 Indian Carrier shell—*Onustus indicus*
069 Perspective trochus, staircase trochus—
 Architectonica maxima
070 Violet raft snail—*Janthina communis*
071 Bubble shell—*Aplustrum aplustre*
072 *Lobiger philippi*
073 *Philine aperta* (empty shell to right)
074 Hatchet shell—*Dolabella rumphii*
075 Bubble shell—*Bulla ampulla*
076 *Cylichna cylindracea*
077 Bubble shell—*Scaphander lignaria*

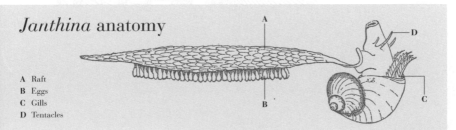

Janthina anatomy

A Raft
B Eggs
C Gills
D Tentacles

Phylum	MOLLUSCA
Class	GASTROPODA
Subclass	OPISTHOBRANCHIA
Order	NUDIBRANCHIA
Order	PTEROPODA

Sea Slugs *1*

[078]

[079]

[080]

THE SUBCLASS OPISTHOBRANCHIA includes two important orders, namely the Nudibranchia and the Pteropoda. Nudibranchs live on the bottom of the sea in coastal waters and are so called because of their naked, external gills, which can be retracted and which sometimes have eyespots. Some nudibranchs have a symbiotic relationship with one-celled green algae called Zooxanthellae. The algal cells are protected while living in the gill-like projection of the body wall of the nudibranch, and the nudibranch may gain benefit from the sugars created by the algae during photosynthesis.

Pteropods (*ptera* "wing," *pod* "foot") are tiny mollusks with finlike lobes that project from the body, using which the animal swims in the pelagic zones of the ocean. The shells are thin and translucent.

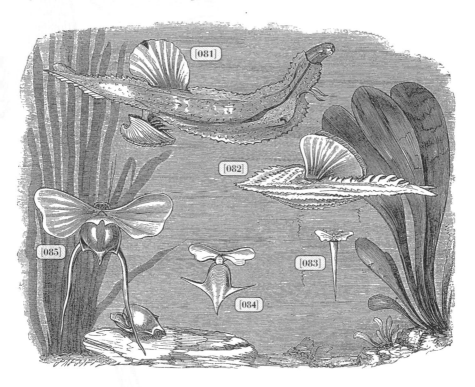

Phylum	MOLLUSCA
Class	GASTROPODA
Subclass	OPISTHOBRANCHIA
Order	NUDIBRANCHIA

Sea Slugs 2

[087]

[086]

086 *Tritonia plebeia*
087 *Goniodoris nodosa*
088 *Jorunna tomentosa*
089 *Aegires punctilucens*
090 *Tethys fimbriata*
091 *Goniodoris nodosa*
092 *Aeolis coronata*
093 *Glaucus atlanticus*

[088]

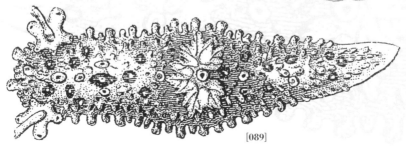

[089]

THE SHELLS OF SEA SLUGS, sea hares, and sea lemons are either rudimentary or absent. Some feed on sea anemones. Rev. Wood (1863) writes: "The sea anemones are favourite prey of these voracious creatures and many an enthusiast naturalist has gained a knowledge of their habits at the expense of his special favourite; for whenever a nudibranch is placed in the same aquarium with specimens of actiniae [sea anemones], it is sure to attack them, eating great holes in their substance."

[091]

[092]

[090]

[093]

Phylum	MOLLUSCA
Class	BIVALVIA
Subclass	PALEOTAXODONTA
Subclass	HETERODONTA
Subclass	ANOMALODESMATA

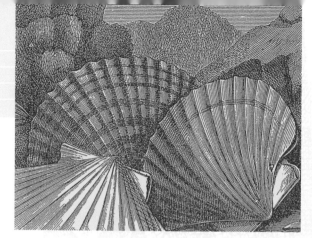

[094]

Bivalves

IN THE CLASS BIVALVIA, the soft body is compressed from side to side between two shells, called valves. Bivalves are usually relatively immobile, resting in or on sediments in fresh, salt, or brackish water. The head is almost nonexistent and lacks a radula or any significant eyes. The shell valves articulate together above the dorsal midline, the hinge being held together by a ligament. Large adductor muscles close the valves together, sealing in the soft body. Clams are mostly filter feeders; when the

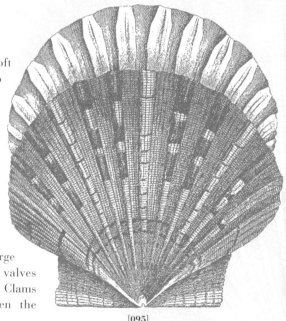

[095]

094 Scallop bed
095 Clam, great scallop—
 Pecten maximus
096 Pearl oyster— *Pinctada
 margaritifera*
097 Trawling for scallops

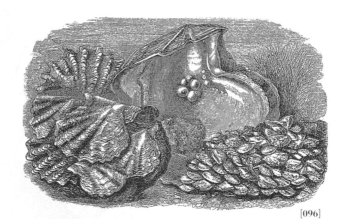

[096]

Bivalve anatomy

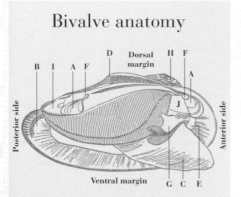

A Adductor muscle
B Inhalant opening
C Foot
D Ligament
E Mouth
F Pedal muscles
G Palps around mouth
H Umbo—apex of a valve
I Exhalant opening
J Accessory pedal muscle

[097]

muscles relax, a gape between the valves permits a water current to flow in (inhalant), through the gills, and out again (exhalant). As in the sea squirts (*see pages 138–141*), the current is driven by tiny hairlike filaments (cilia) on the gills. The current is used for gas exchange, but in some species is also used for feeding.

Boring Bivalves & Venus Shells

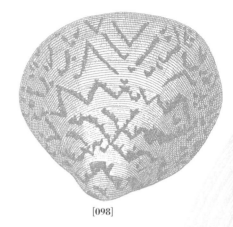

[098]

VENUS SHELLS HAVE SOLID, rounded shells with umbones twisted toward the anterior end. Bivalve hinges have teeth that can lock the valves together when the gape is closed. Venus shells have 3 or 4 teeth in each valve. The siphons are fused except at the tip.

Like many bivalves, the borers begin as planktonic larvae that, as they mature, sink and attach to a surface. On wood, shipworms excavate deep burrows. Before protective chemicals were invented to prevent this, wooden ships were destroyed by them. Watering pot shells have much reduced valves and a huge extension of the soft body, encrusted with sand and calcium salts. Like piddocks, they burrow into rock.

[099]

[100]

[101]

[102]

[103]

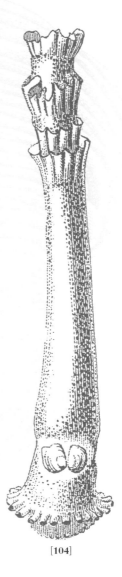

098 *Lioconcha hieroglyphica*
099 *Cytherea dione*
100 Common piddock—*Pholas dactylus*
101 Common piddock—*Pholas dactylus*
102 Paper pholas—*Pholas papyracea*
103 Watering pot shell—*Aspergillum pulchellum*
104 Watering pot shell—*Aspergillum vaginiferum*

[104]

Phylum	MOLLUSCA
Class	BIVALVIA
Subclass	PALEOHETERODONTA
Order	PTEROIDA Oysters and Scallops
Order	MYTILOIDEA Sea mussels and Pen shells

Oysters, Scallops & Mussels

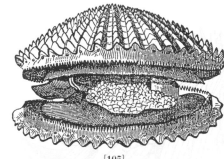

[105]

[106]

105 *Pecten varius* (ventral view into gape)
106 Atlantic thorny oyster—
 Spondylus americanus
107 Thorny oyster—*Spondylus princeps*
108 Edible mussel—*Mytilis edulis*
109 Blue mussel—*Mytilis smaragdinus*

[107]

OYSTERS ARE IMPORTANT as food but also as a source of natural pearls. In thorny oysters, the shell is extended into protective spines. The bizarre yet attractive shapes mean that they are highly valued by shell collectors who maintain a significant trade in thorny oyster shells. Scallops are also an important food resource, and are dredged wholesale from shallow coastal waters. In France, they are the seafood delicacy known as Coquille Saint Jacques. When disturbed, scallops can swim by clapping their shell-valves together. They have simple eyes around the mantle edge. Oysters and scallops generally live in clean waters. However, mussels are naturally found closer to estuaries, where conditions are more turbid and rich in detritus. For this reason, mussels are important as sentinels of pollution.

[108]

[109]

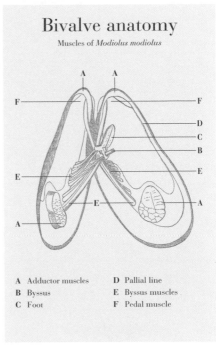

Bivalve anatomy

Muscles of *Modiolus modiolus*

A Adductor muscles
B Byssus
C Foot
D Pallial line
E Byssus muscles
F Pedal muscle

Cockles & Clams

TRIDACNIDS ARE RECOGNIZED by the deeply indented edges of the valves. Of the giant clam, Wood (1863) writes: "The natives of the coasts on which it is found—namely the Indian Seas—are extremely fond of this creature and eat it without any cooking, as we do oysters." A valve of a giant clam was used as a bénitier for holding holy water in the Church of St. Sulpice in Paris. Wood also reports Charles Darwin as having said that "if a man were to put his hand into one of the shells, he would not be able to withdraw it as long as the animal lived."

Cockles live buried in sand on the lower shore. Wood (1863) notes that cockles form "a valuable and wholesome addition to the limited variety that the Irish peasant boasts at his humble board; and afford children, too young for other tasks, safe and useful employment." Nowadays, we know that cockle pickers can be in serious danger from the incoming tide.

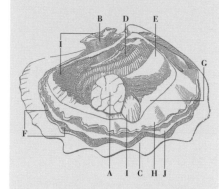

Internal anatomy of *Tridacna crocea*

A Single adductor muscle
B Byssus
C Exhalant opening
D Small, grooved foot
E Gills
F Inhalant opening
G Broad pallial muscle
H Double mantle margin
I Pedal muscle
J Siphonal border

[110]

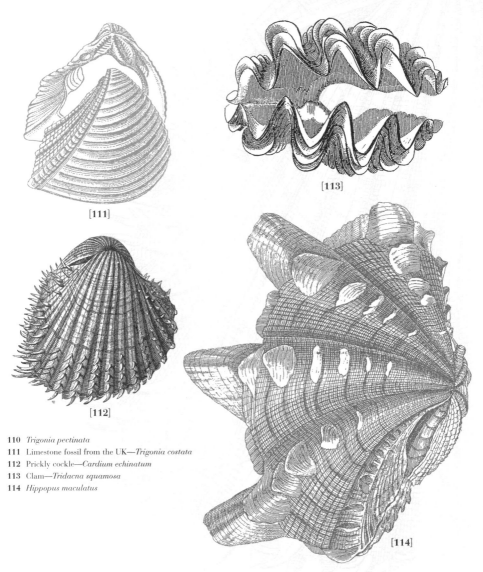

[111]

[113]

[112]

110 *Trigonia pectinata*
111 Limestone fossil from the UK—*Trigonia costata*
112 Prickly cockle—*Cardium echinatum*
113 Clam—*Tridacna squamosa*
114 *Hippopus maculatus*

[114]

Phylum	MOLLUSCA
Class	CEPHALOPODA
Subclass	NAUTILOIDEA Nautilus
Subclass	COLEOIDEA Squids, Octopuses, and Cuttlefish

THE CEPHALOPODA (deriving from the Greek *kephale-* "head," *pod-* "foot") are highly intelligent invertebrates. There is a large head with a well-developed brain and eyes. A ring of tentacles, covered with suckers, encircles the mouth. A fold of the mantle surrounds the body and is shaped into a tube called a siphon, through which water can be impelled, allowing jet propulsion. The mouth opens into a two-jawed beak that injects poison into prey.

Cephalopods

Cuttlefish anatomy

A Tentacles
B Horny jaws
C Eye
D Salivary gland
E Brain
F Gullet
G Internal shell
H Stomach
I Intestine
J Siphon
K Ink-sac
L Liver
M Gill, enclosed in gill-chamber
N Gill-heart, driving venous blood to gill
O Systemic heart circulating blood through body
P Mantle

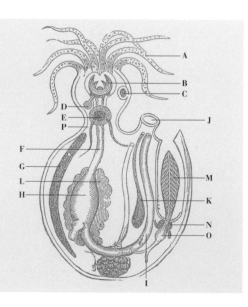

There are five fossil groups, including Nautiloids, which are cephalopods that have survived for 600 million years; an example is the pearly nautilus, which lives to depths of 2,000 feet in the Indian Ocean. Squid and cuttlefish have an internal shell and ten arms, two of which comprise longer tentacles. Octopods have eight arms and no internal shell.

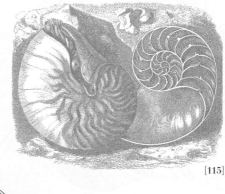

[115]

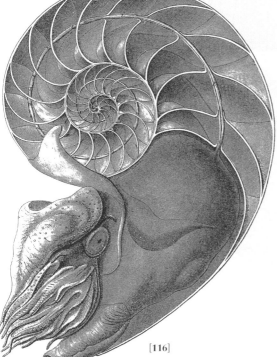

[116]

115 Pearly nautilus—*Nautilus pompilius*
116 Section through pearly nautilus

Phylum	MOLLUSCA
Class	CEPHALOPODA
Subclass	NAUTILOIDEA Nautilus
Subclass	COLEOIDEA Squid, Octopuses, and Cuttlefish

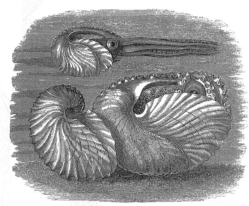

[117]

Paper Nautilus & Cuttlefish

117 Paper nautilus—*Argonauta argo*
118 Paper nautilus—*Argonauta argo*
119 Common European cuttlefish—*Sepia officinalis*

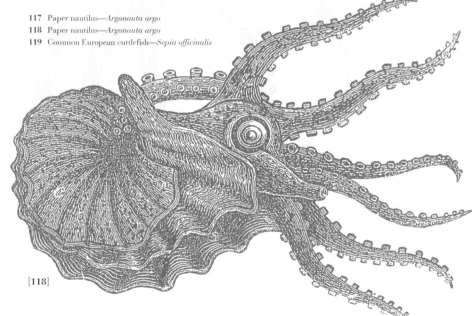

[118]

THE PAPER NAUTILUS is not a true nautilus but a type of octopus with a shell. It illustrates the scientific principle of convergence. Many fossil cephalopods had shells, and it seems that the combination of tentacles and a coiled shell gives survival value, so that it has developed over millions of years in several different groups, such as the ammonites and the paper nautilus in the subclass Coleoidea.

When disturbed, Cuttlefish secrete ink from a gland over the anus. The ink cloud distracts the attacker, which gives the cuttlefish time for escape. Cuttlefish have an interior shell that is filled with gas; it helps to maintain buoyancy. They feed on crabs, fish, and other mollusks and can be cannibalistic. The long tentacles shoot out and grasp the prey. Like all cephalopods, the pigment cells in the skin are directly connected to the brain. You can actually see what a cephalopod is thinking!

Cuttlefish sucker

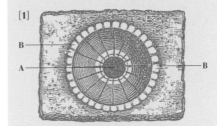

[1]

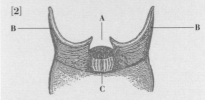

[2]

Diagram 1 *sucker seen from above*
A Circular aperture in the center of sucker
B Cartilaginous rim or border of sucker

Diagram 2 *longtitudinal section of sucker*
A Central aperture in profile
B Cartilaginous rim in section
C Retractile muscular piston

[119]

Phylum	MOLLUSCA
Class	CEPHALOPODA
Subclass	NAUTILOIDEA Nautilus
Subclass	COLEOIDEA Squid, Octopuses, and Cuttlefish

Squid & Octopus

[120]

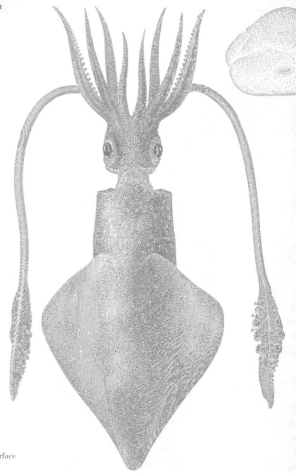

120 Common squid—*Loligo vulgaris*
121 Common squid—*Loligo vulgaris*
122 Common octopus—*Octopus vulgaris*
123 Unreal picture of giant squid at the surface
124 Assault of a cuttle

[121]

[123]

[122]

[124]

GIANT SQUID (*Architeuthis dux*) are some of the biggest animals (that is, longest) to have ever lived. However, they live in the deepest ocean, and cannot survive for long at the surface. Exaggerated stories about cuttlefish and squid abound. A cuttlefish, "after losing its hold on the rocks, suddenly sprang upon Mr. Beale's arm and clung to it by means of its suckers with great power, endeavoring to get its beak, which could now be seen between the roots of its arms, in a position to bite. A sensation of horror pervaded his whole frame, when he found this monstrous animal had fixed itself so firmly on his arm" [*124*] (Gosse, 1886). We now know that cuttlefish, squid, and octopus are curious, playful, and harmless creatures.

Echinoderms *Echinodermata*

The echinoderms—a group that includes feather stars, sea lilies, starfish, brittle stars, sea cucumbers, and sea urchins—are quite unusual because they have a radial structure with no obvious head. Their bodies are covered with tiny projections that can act either as tube feet or as cleaning devices. Those projections that undertake the cleaning have a pair of tiny jaws called pedicellariae, which pick off detritus from the surface of the animal. For the purposes of reproduction, sperm and eggs are shed into the sea where they unite to form a planktonic, ciliated larva. When in due course it has grown sufficiently large, it settles on a substratum and eventually becomes an adult.

A characteristic feature of echinoderms is the hydraulic system of locomotion that drives the tube feet and allows some species to be ferocious predators, despite their slow movement.

Rev. J. G. Wood (1885) writes: "If you put into a basin of sea-water one of the pretty kind, which we find so abundantly under stones at low

water, whose green spines are tipped with rosy purple...you will presently observe it marching majestically along by means of the hundreds of sucker feet, which it possesses in common with the star fish. Now, if you have the empty box of an urchin of the same kind, and, taking it into your hand hold it up to the light, and look into the cavity from the under or mouth side...light streams in through a multitude of minute holes, as smooth and regular as if drilled with a fairy's wimble; and these holes are arranged in a pattern of elegant symmetry.

"Put the living and the dead together. These tiny orifices, as minute as the point of the finest cambric needle...afford exit to the suckers, which are, of course, equally numerous. Through these pass the slender pellucid tubes, filled with elastic fluid, which carry at their tips a flat ring of calcareous shell, affording to each the form and firmness to make it an adhesive sucking disc, in the centre of which a tiny vacuum is created at will by muscular retraction."

[001]

Digestive tube

001 Sea urchin dissected
002 Sea urchin
003 Apex of sea urchin shell
004 Section through a sea urchin
005 Sea urchin shell
006 Sea urchin masticatory apparatus

Echinoderm Anatomy

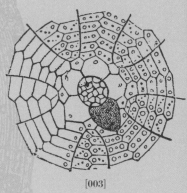

[003]

Spines removed [002]

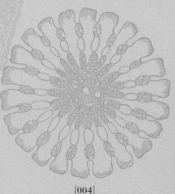

[004]

ECHINODERMS (Greek *ekhinos* "hedge-hog," *derma* "skin") have an exoskeleton of calcareous plates, which may form a "test" (sea urchins) or be embedded in the skin (starfish). The body has five parts arranged around a central axis.

The images here show the anatomy of the common sea urchin (*Echinus esculentus*). In figure 001, the animal has been cut in half to show the gut extending from the ventral mouth (left) to the dorsal apex (right). Figure 002 shows a dorsal view, with some spines removed, and figure 003 shows detail of the apex where the gut exits as the asymmetrically placed anus. The sex organs open to the outside through pores in the other four plates. Figures 005 and 006 show side views of the jaws, which protrude through the ventral mouth, operated by a sophisticated musculature.

— Protruding teeth

[005]

[006]

Interior of sea urchin shell

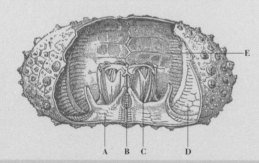

A B C D

A Ventral plates around mouth
B Mouth
C Jaw apparatus (known as "Aristotle's Lantern")
D Internal projection of test
E Hollow interior containing hydraulic tubes, gut, and gonads

Phylum	ECHINODERMATA
Class	CRINOIDEA
Order	COMATULIDA

Feather Stars & Sea Lilies

FROM THE CALYX, the cup-shaped central body of a crinoid, extend 5–200 arms, depending on the species. Grooves in each arm meet at the central mouth. The arms also have branches called pinnules, which carry tube feet arranged in groups of three. The tube feet are coated with mucus that ensnares the prey. The body is covered in calcareous plates, and the gonads are located in the arms: fertilization takes place in open seawater during

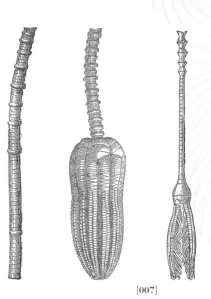

[007]

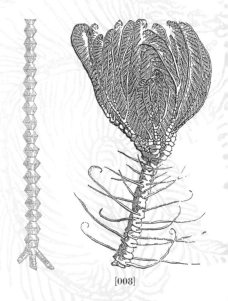

[008]

mass spawnings. There are two kinds of crinoid: the stalked sea lilies at depths of 330 feet or more, and feather stars, which have only a stalk in the larval stage.

Crinoids were abundant in Paleozoic times 300 million years ago. Thick banks of their dead calcareous skeletons gradually compressed to form many of the thick limestone beds of the world. Much of the island of Malta is made of crinoidal limestone.

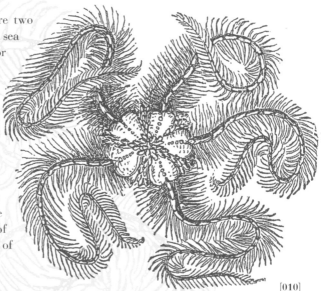

[010]

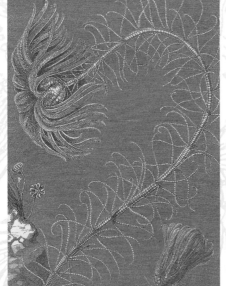

[009]

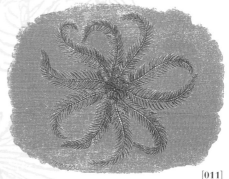

[011]

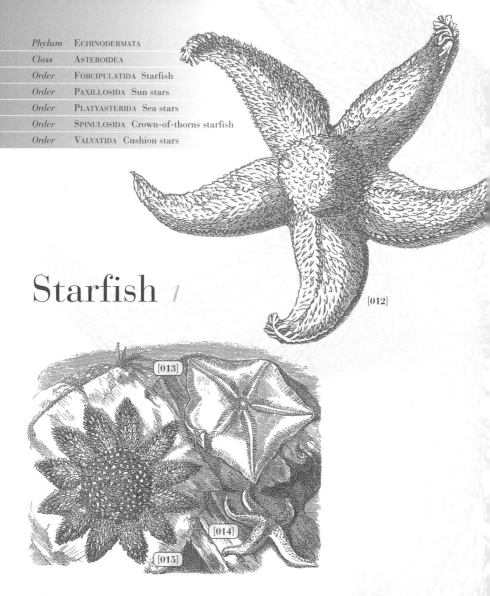

Starfish *1*

[012]

[013]

[014]

[015]

STARFISH HAVE NO HEAD, so the gut goes directly from the ventral mouth to the dorsal anus. This raises a problem of where the brain should go. Over millions of years, starfish have solved this problem by doing without a brain altogether. Instead, they have a nerve net under the skin, with nerves running down the arms, connected to a ring of nervous tissue surrounding the gut. The gut itself has extensions into the arms. Partly because of this peripheral distribution of functions, starfish and crinoids have tremendous powers of regeneration and can rebuild lost or damaged limbs. Even a single arm can regenerate a complete body [*018*]. Furneaux (1911) writes: "We sometimes meet with such monstrosities as a five-rayed star with six or more rays, some smaller than the others, the smaller ones representing two or more that have grown in the place of one that has been lost."

012 Common starfish—*Asterias ruben*
013 Goosefoot cushion star—*Palmipes membranaceus*
014 Bloody Henry starfish—*Henricia oculata*
015 Sun star—*Solaster papposus*
016 Cushion star—*Porania pulvillus*
017 Cushion star—*Asterina gibbosa*
018 Common starfish regenerating itself from an arm

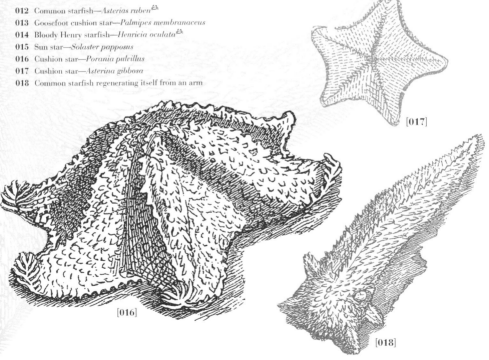

[017]

[016]

[018]

Phylum	ECHINODERMATA
Class	ASTEROIDEA
Order	FORCIPULATIDA Starfish
Order	PAXILLOSIDA Sun stars
Order	PLATYASTERIDA Sea stars
Order	SPINULOSIDA Crown-of-thorns starfish
Order	VALVATIDA Cushion stars

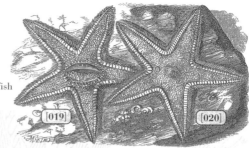

[019] [020]

Starfish 2

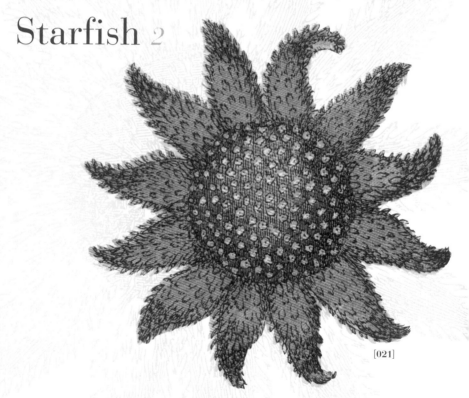

[021]

[022]

THOUGH THEY LACK a head, teeth, or jaws, starfish are predators. Wood (1886) says: "The starfish is one of the most mischievous of creatures in an oyster bed, many thousands of the inmates falling victims to it every year." He describes the process: "First the star-fish lays itself upon the oyster and encloses it, so to speak, by wrapping its rays around it. Then it protrudes its stomach from its own mouth...and introduces it between the two shells of the oyster, gradually enclosing the body of the oyster within it." Although this description is basically correct, we now know that the starfish first uses the immense power of its hydraulic tube-foot system to force apart the valves of the oyster (or any other mollusk), then allowing the starfish to complete the feeding process as described above by Wood.

[023]

Phylum	ECHINODERMATA
Class	ASTEROIDEA
Order	FORCIPULATIDA Starfish
Order	PAXILLOSIDA Sun stars
Order	PLATYASTERIDA Sea stars
Order	SPINULOSIDA Crown-of-thorns starfish
Order	VALVATIDA Cushion stars

[025]

Starfish 3

[024]

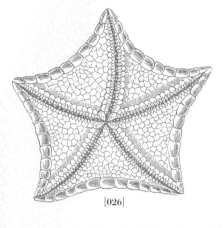

[026]

024 *Astropecten aurantiacus*
025 Bloody Henry starfish—*Henricia oculata*
026 Cushion star—*Palmipes membranaceus*
027 Cushion star—*Palmipes membranaceus*
028 Blood star—*Henricia sanguinolenta*
029 Sea cucumber—*Cucumaria normani*
030 Spiny starfish regenerating their arms—
 Marthasterias glacialis

THE LARGEST STARFISH can reach 3 feet in diameter, but most are much smaller than this. However, a fossil crinoid has been found with a stem 130 feet long.

The fluid pressure system of echinoderms is unique in the animal kingdom. As an extension of the body cavity (the coelom), it connects to the outside world by a porous stonelike organ (the madreporite) on the dorsal side of the body, adjacent to the anus. It links with a ring canal that encircles the gut. The ring canal branches into each arm, and subsidiary branches feed each of the thousands of tiny tube feet. Each tube foot contains muscles and a valve controlled by the nervous system. The valve enables each tube foot to exert suction. Because of this suction, starfish may feel sticky when they are picked up. Starfish do not bite or sting, and are generally harmless to humans.

Phylum	ECHINODERMATA
Subclass	OPHIUROIDEA Basket stars, Brittle stars, and Snake stars
Order	OEGOPHIURIDA
Order	OPHIURIDA
Order	PHRYNOPHIURIDA

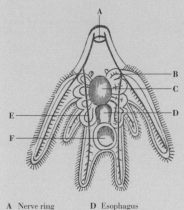

Pluteus larva

A Nerve ring D Esophagus
B Nerve tract E Body cavity
C Stomach F Mouth

Brittle Stars

[031]

[032]

[033]

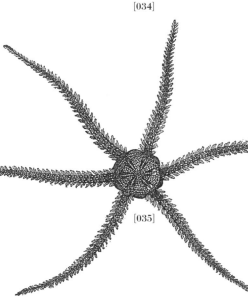

[034]

[035]

MOST ECHINODERMS LIVE on the sea bottom and move slowly. The larva is a useful way of dispersing through the oceans, and each class has a characteristic larva. In the brittle stars it is called a pluteus (see diagram). The structure and development of the larva resembles that of the sea squirt (*see pages 138–141*), suggesting a common ancestry of vertebrates and echinoderms.

Brittle stars are active animals, using their arms to crawl relatively quickly. They are well named since they easily cast off and regenerate their arms. Rev. J. G. Wood (1885) quotes Prof. Edward Forbes: "I spread it on a rowing bench the better to admire its form and colors. On attempting to remove it for preservation, I found only an assemblage of rejected members…It is now badly represented in my cabinet by an armless disk and a diskless arm."

031 Brittle star—*Ophiothrix fragilis*
032 Brittle star—*Ophiothrix fragilis*
033 *Ophiurus albida*
034 Shetland argus—*Astrophyton scutatum*
035 *Ophiura* sp.

Phylum	ECHINODERMATA
Class	HOLOTHUROIDEA Sea cucumbers
Order	APODACEA
Order	ASPIDOCHIROTACEA
Order	DENDROCHIROTACEA

Sea Cucumbers

[037]

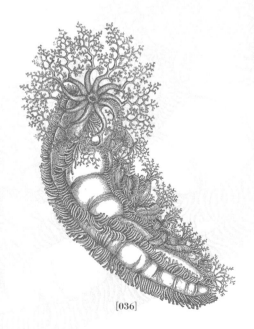

[036]

UNLIKE THE OTHER ECHINODERMS, sea cucumbers have a front end and a back end. On the ventral side, there are usually three tracts of tube feet. Their hard calcareous skeleton, reduced to microscopic spicules, is buried under the skin. Some sea cucumbers can expel sticky white threads to entangle or distract would-be predators, and some even expel their internal organs when disturbed.

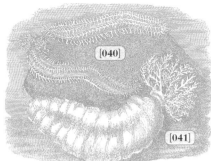

036 Sea cucumber
037 Sea cucumber and brittle star
038 *Leptosynapta inhaerens*
039 *Synapta digitata*
040 *Pentacta pentactes*
041 *Neopentadactyla mixta*
042 *Psolinus brevis* (on stipe of seaweed)
043 *Psolus phantapus*
044 Sea cucumber (possibly *Cucumaria frondosa*)

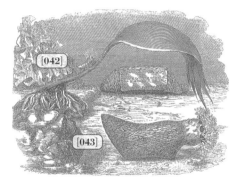

Although they occur in all oceans, they are most common in the warm waters of the Indian Ocean and the Southwest Pacific, sometimes at great depths. In a smoked, dried form the sea cucumber is a prized food in Southeast Asian markets. In 1803, while charting the Australian coast, Matthew Flinders sighted a fleet of 60 Indonesian vessels collecting it in the Gulf of Carpentaria.

[044]

Phylum	ECHINODERMATA
Class	ECHINOIDEA Sea urchins & Sand dollars
Order	ATELOSTOMATA Heart urchins
Order	DIADEMATACEA

Sea Urchins *1*

[047]

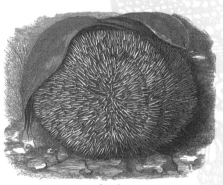

[045]

[048]

[049]

[046]

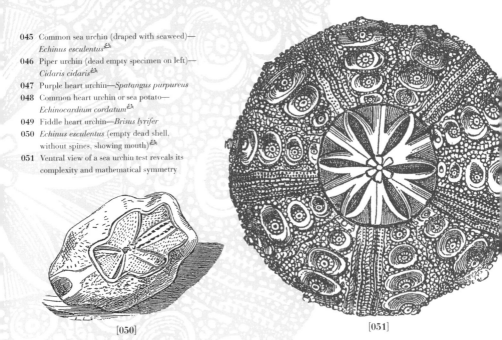

[050] [051]

"WHAT A WONDERFUL PIECE of mechanism is a Sea Urchin! Accustomed as I am to the multitudinous contrivances and compensations that present themselves at every turn to the philosophic naturalist, often as surprising and unexpected as they are beautifully effective, I am yet struck with admiration at the structure of an Echinus whenever I examine it anew" (Gosse, quoted by Wood, 1885).

Species that live on solid substrata such as sand, rock, or coral use both spines and tube feet for crawling. As they crawl about, the mouth is underneath, and the five hard jaws are used for grazing algae and other small organisms from the substratum.

Some species, such as *Echinocardium cordatum*, burrow into sediments. The environmental constraints of this have caused them to evolve to become asymmetrical, and thus have posterior and anterior ends. These burrowing animals usually feed on detritus present in the sediments, and the jaw apparatus is consequently reduced.

Phylum	ECHINODERMATA
Class	ECHINOIDEA Sea urchins & Sand dollars
Order	ECHINACEA Sea urchins
Order	GNATHOSTOMATA Sand dollars
Order	CLYPEASTROIDA Cake urchins

Sea Urchins 2

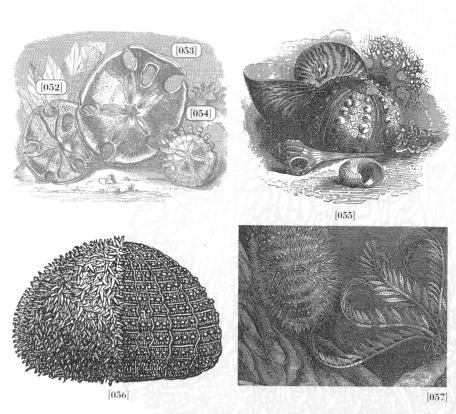

[052]

[053]

[054]

[055]

[056]

[057]

SEA URCHINS ARE HEMISPHERICAL, heart urchins are ovoid, and sand dollars are disklike. All have an exoskeleton or test of solid plates called ossicles, which are organized into ten rows, like lines of longitude. Five of the rows are pierced by holes for the tube feet. These rows are called ambulacra. The other rows are the interambulacra. The test is covered with joints, called tubercles, from which spines and pedicellariae articulate.

Rev. J. G. Wood (1863) quotes F. D. Bennett's encounter with a sea urchin: "I felt a severe pain in my hand, and upon withdrawing it, found my fingers covered with slender spines, evidently those of an Echinus, and of a grey colour, elegantly banded with black. They projected from my finger like well-planted arrows from a target, and their points, being barbed, could not be removed, but remained for some weeks as black specks in the skin."

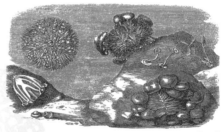

[058]

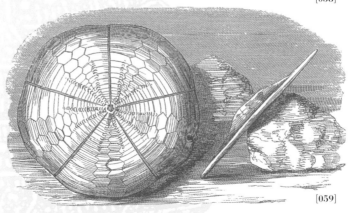

[059]

Sea Squirts *Chordata*

Furneaux (1911) writes of the sea squirts and salps, "While searching the rocks and weeds at low-tide, one's fingers will constantly be coming in contact with fixed, soft-bodied animals that suddenly eject a fine stream of water as they are touched. These are the Sea Squirts, sometimes spoken of as the Tunicate worms. They are semi-transparent creatures of oval or elongated form...and derive their popular name from the fact that they are covered by a continuous tunic or wall of tough structure."

The sea squirts and salps (sometimes called tunicates) are relatives of the vertebrates, the animals with backbones. Although superficially quite different from vertebrates, tunicates have features that mark them out as our special relatives—in particular, a dorsal stiffening rod (called a notochord), segmentation of the body muscles, and a dorsal hollow nerve cord. During their development from embryo to adult, all vertebrates (including fish, amphibians, reptiles, birds, and mammals) have these characteristics at some stage in their lives.

Adult tunicates have soft, gelatinous bodies and can easily be mistaken for sponges or sea anemones. The typical adult sea squirt is attached by its base to a rock and filters food and oxygen from the water, using a technique similar to that used by a sponge. Tiny beating hairlike filaments draw water into the mouth (pharynx) of the animal by an inhalant siphon, and the filtered water is passed out via an exhalant siphon. The adult looks nothing like a vertebrate, and comprises mainly the jellylike outer casing (the tunica) and the large filtering branchial basket that occupies 80% of the space inside the tunica. However, the larva resembles a tadpole and has all the chordate characteristics described earlier. In the distant past, some of these larvae became sexually mature and did not develop into adults. This process, called neoteny, is common in the animal kingdom. Such "tadpoles" almost certainly gave rise to the ancestors of fish and thence all vertebrates.

Phylum	CHORDATA	
Subphylum	UROCHORDATA	
Class	ASCIDIACEA	Tunicates and Sea squirts
Class	THALIACEA	Salps

[001]

Sea Squirts

[002]

[003]

SEA SQUIRTS ARE (a) solitary such as *Ciona* sp.; (b) single but attached to others at their bases, such as *Dendrodoa grossularia*; (c) colonial, sometimes stalked, such as *Clavelina lepidiformis*; or (d) encrusting colonies, such as *Botryllus* sp. Because most species spend their adult lives attached, it is the tadpolelike larval stage that swims, filter feeds, and disperses in the open ocean.

Salps are pelagic sea squirts that can float singly or in colonies. They can show a vague, directional movement when they live as a colony. However, the colony breaks up easily and individuals are often washed up on the shore.

[004]

001 Group of sea squirts
002 Colonial sea squirts—
 Botryllus sp.
003 *Dendrodoa grossularia* on
 shell of bivalve mollusk
004 *Cynathia aggregata*

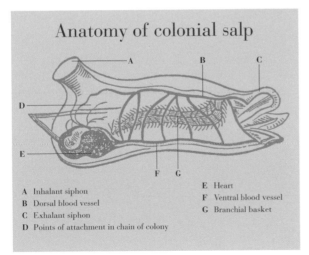

Anatomy of colonial salp

A Inhalant siphon
B Dorsal blood vessel
C Exhalant siphon
D Points of attachment in chain of colony
E Heart
F Ventral blood vessel
G Branchial basket

Cartilaginous Fish *Chordata*

The animals in this and all of the following chapters belong to the same group as humans: the vertebrates—animals with backbones. The current evidence suggests that they have evolved from the same ancestors as the echinoderms (*pages 118–137*), from which the sea squirts (*pages 138–141*) have also evolved. It is thought that the backbone first appeared in relatives of the sea squirts and salps, the first fossil fragments appearing during the Upper Cambrian, more than 530 million years ago. By the end of the Ordovician, 90 million years later, the scant fossil record suggests that the ancestors of the sharks and other jawed fishes had already evolved.

The first vertebrates were well protected externally with bony armor, but the skeletons inside them were made of cartilage, a tough, flexible, gristly substance formed from proteins laid in a jellylike substrate. Later, during the Devonian period (ca. 395 million years ago), fish with bony skeletons appear in the fossil record. Bone is a stronger, more rigid

material made of proteins and minerals, particularly calcium and phosphorus. Several groups of fishes, including the sharks, rays, chimaeras, lampreys, and hagfish, still have skeletons of cartilage, as do the embryos of all other vertebrates, including humans.

The early vertebrates had no jaws, which must have made eating and defending themselves particularly difficult, although evidently not impossible. The next great evolutionary leap was thus represented by the appearance of the hinged jaw, and teeth, which were much more successful at ensuring species survival. By the end of the Devonian period, the diversity and number of jawed fish by far outstripped the number and diversity of the jawless fish.

Today, just a few jawless species survive in our oceans while there are more than 650 species of cartilaginous fish with jaws. These include the largest of all fish, the whale shark, and one of the most feared animals on the planet, the great white shark!

Phylum	CHORDATA
Subphylum	VERTEBRATA
Superclasses	AGNATHA/GNATHOSTOMATA
Classes	CEPHALASPIDOMORPHI/PTERASPIDOMORPHA/CHONDRICHTHYES

Cartilaginous Fish Anatomy

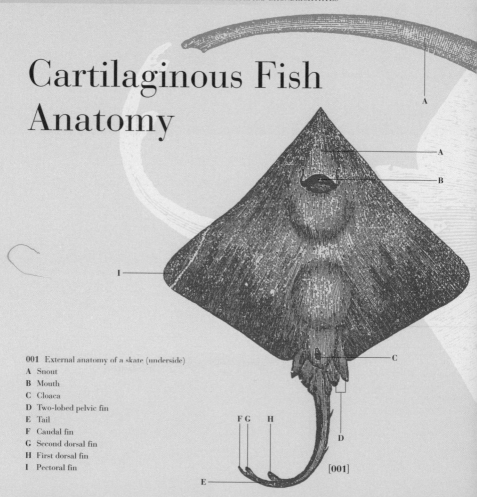

001 External anatomy of a skate (underside)

A Snout

B Mouth

C Cloaca

D Two-lobed pelvic fin

E Tail

F Caudal fin

G Second dorsal fin

H First dorsal fin

I Pectoral fin

[001]

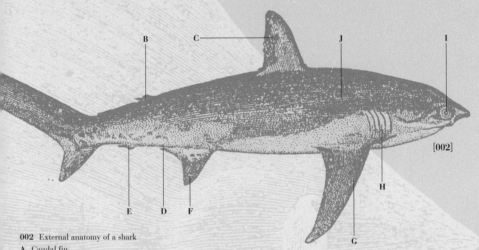

[002]

002 External anatomy of a shark
A Caudal fin
B Second dorsal fin
C First dorsal fin
D Claspers (male only)
E Anal fin
F Pelvic fin
G Pectoral fin
H Gill slits
I Eye with nictitating membrane
J Spiracle

THE EVOLUTION OF A BACKBONE gave several important advantages to the vertebrates. First, an internal skeleton made up of many units of cartilage and, more particularly, bone can be modeled into a huge variety of shapes, combining rigidity with flexibility. The linkage to muscles ensures flexibility without compromising strength. Furthermore, the evolution of internal pectoral and pelvic girdles enabled independent limbs to form that could eventually become fins or legs. Possibly in response to this increase in the scope of the activities of such animals, a more complex nervous system began to evolve, and thus a skull to house and protect the brain became necessary.

In male sharks and rays, the pectoral fins are modified to long structures called claspers, which they use to grasp the female during mating.

Subphylum	VERTEBRATA
Superclass	AGNATHA
Class	CEPHALASPIDOMORPHI PTERASPIDOMORPHA
Order	PETROMYZONIFORMES MYXINIFORMES

[005]

Lampreys
& Hagfish

[003]

[004]

[006]

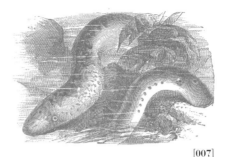

[007]

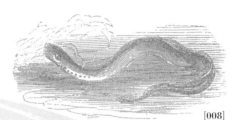

[008]

FOSSILS OF THESE STRANGE, eellike fish first appeared more than 300 million years ago. They differ from all other fish by lacking jaws and pelvic fins. The lampreys [007] have only a single nostril and a suckerlike mouth with horny teeth, used by the adults of some species to suck the blood of bony fish. Both groups are found only in the cooler oceans of the world, and all 50 or so lamprey species either live in freshwater or swim up rivers to breed. In past centuries, lampreys were considered a great delicacy on the dining table. In this respect their popularity has declined markedly, perhaps because they are thought to have killed King Henry I of England when he ate a surfeit of them.

The hagfishes [005 and 009] are similar to lampreys but live only in the sea and are the bane of fishermen because they often burrow into the flesh of dead and dying fish caught on their lines.

[009]

003 Sea lamprey—*Pteromyzon marinus*
004 European river lamprey, lampern—*Lampetra fluviatilis*
005 Hagfish, Myxine—*Myxine glutinosa*
006 Pouched lamprey—*Geotria australis*
007 Lamprey
008 European river lamprey, lampern—*Lampetra fluviatilis*
009 Hagfish—*Myxine glutinosa*

Superclass	GNATHOSTOMATA
Class	CONDRICHTHYES
Subclass	ELASMOBRANCHII
Order	HEXANCHIFORMES, SQUALIFORMES

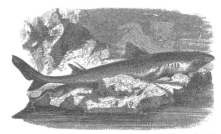

[013]

Frilled & Dogfish Sharks

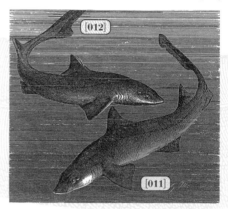

[012]

[011]

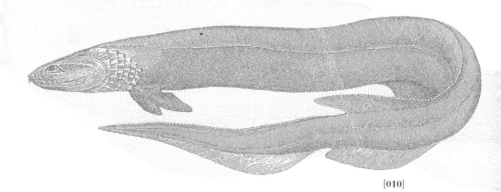

[010]

[014]

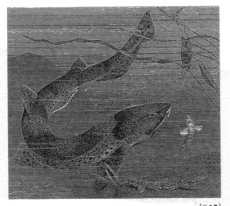

[015]

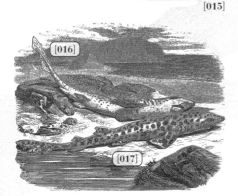

[016]

[017]

010 Frilled shark—*Chlamydoselachus anguineus*
011 Smooth dogfish, smooth-hound—*Mustelus* sp.
012 Spiny dogfish, spurdog—*Squalus acanthias*
013 Piked or picked dogfish—*Acanthias vulgaris*
014 Dogfish egg case (known as a "mermaid's purse")
015 Dogfish
016 Little dogfish—*Scyliorhinus canicula*
017 Rock dogfish, nursehound—*Scyliorhinus stellaris*

"A SHARK IS THE GREAT watery enemy of mankind...." Thus spoke the Rev. J. G. Wood in 1885. However, we now know that this most ancient of all predators kills fewer people each year than bees, pigs, dogs, deer, or horses. The first sharks appeared more than 400 million years ago, and since their origins in the Silurian seas, they have survived four global mass extinctions. Estimates suggest that commercial fishing and pollution caused the populations of larger species to decline by at least 80% during the 20th century.

The dogfish sharks on this page are so called because they follow the shoals of migrating fish.

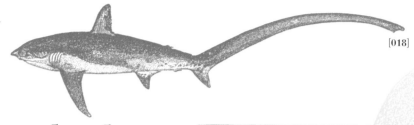

[018]

Sawsharks & Mackerel Sharks

[019]

[020]

[021]

FOUR HUNDRED MILLION YEARS of evolution have produced the ultimate predator! The fastest marine vertebrate is reckoned to be a close relative of the great white shark [022 and 023], the shortfin mako, which can swim at speeds of 60 mph. The great white, star of the movie *Jaws*, is probably the most feared of all the mackerel sharks, growing to 20 feet in length and possessing about 3,000 teeth. This species is responsible for most unprovoked attacks on humans, but it is believed that the majority of these are a case of mistaken identity since their preferred prey are fish, seals, and sea lions. Their only enemies (apart from humans) are larger great whites and the occasional killer whale. Like many other shark species, they produce only a few live young, called pups.

[022]

[023]

Superclass	GNATHOSTOMATA
Class	CONDRICHTHYES
Subclass	ELASMOBRANCHII
Order	LAMNIFORMES
	CARCHARHIFORMES

Mackerel & Ground Sharks

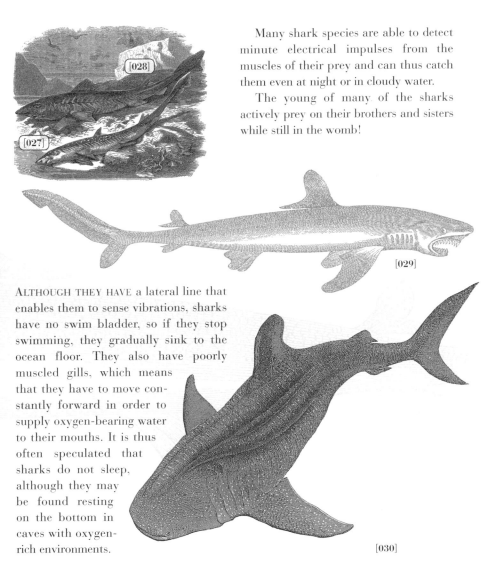

Many shark species are able to detect minute electrical impulses from the muscles of their prey and can thus catch them even at night or in cloudy water.

The young of many of the sharks actively prey on their brothers and sisters while still in the womb!

ALTHOUGH THEY HAVE a lateral line that enables them to sense vibrations, sharks have no swim bladder, so if they stop swimming, they gradually sink to the ocean floor. They also have poorly muscled gills, which means that they have to move constantly forward in order to supply oxygen-bearing water to their mouths. It is thus often speculated that sharks do not sleep, although they may be found resting on the bottom in caves with oxygen-rich environments.

Superclass	GNATHOSTOMATA
Class	CONDRICHTHYES
Subclass	ELASMOBRANCHII
Order	CARCHARHINIFORMES

[032]

Ground Sharks

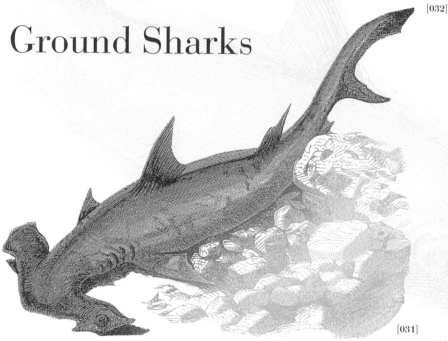

[031]

> *"This was a fish built to feed on all the fishes in the sea, that were so fast and strong and well armed that they had no other enemy."*
>
> ERNEST HEMINGWAY,
> *The Old Man and the Sea* (1952)

THE LONG EVOLUTION of the sharks has equipped them to survive natural phenomena. Cancers and circulatory diseases are almost unknown, and they heal remarkably quickly, even when severely injured. Scientists have discovered a promising antitumor agent in them and are testing its effectiveness in humans.

Some sharks may produce as many as 30,000 teeth during their lifetime; each one is formed from a membrane inside the jaw, which is continually pushed forward as new teeth develop behind it, to replace a tooth when lost or shed. Each new tooth is larger than the one it replaces. This production line ensures that tooth size keeps pace with the shark's own increase in size. In young great white sharks, the tooth replacement rate is from 105 to 120 days, whereas in older animals, it is about 220 to 250 days.

[033]

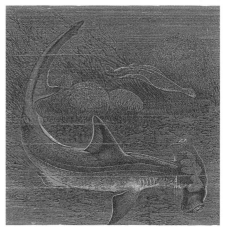

[034]

031 Smooth hammerhead shark—*Sphyrna zygaena*
032 Blue shark—*Prionace glauca*
033 Shark fishing
034 Smooth hammerhead shark—*Sphyrna zygaena*

Superclass	GNATHOSTOMATA
Class	CONDRICHTHYES
Subclass	ELASMOBRANCHII
Order	TORPEDINIFORMES

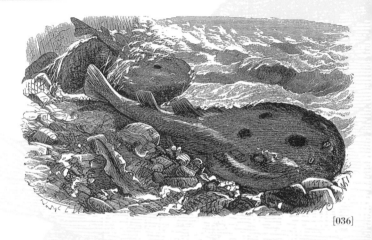

[036]

Electric Rays

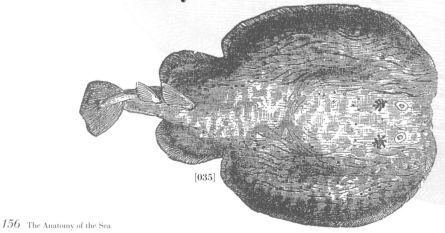

[035]

[037]

[038]

THE ELASMOBRANCHS on this and the following pages have flattened bodies with their eyes on the uppermost surface. This enables many of them to inhabit the ocean floor, where they may feed on animals in the sediments or lie in wait for unwary animals swimming above. The gill slits are on the underside of the body, so in order to prevent them from clogging with mud, the fish have evolved an opening just behind their eyes through which water is inhaled before passing out of the gills.

There are about 40 species of electric ray, some of which grow up to 6 feet in length. They produce numbing electric shocks of up to 220 volts from muscles behind their gills, which they use to stun their prey or deter predators.

Electric rays swim and breed in relatively warm waters: only adult common and marbled electric rays travel into chillier temperatures farther north.

035 Marbled electric ray, torpedo ray—*Torpedo marmorata*
036 Eyed electric ray—*Torpedo torpedo*
037 The torpedo—*Torpedo scutata*
038 Torpedo ray with other rays

Subphylum	VERTEBRATA
Superclass	GNATHOSTOMATA
Class	CONDRICHTHYES
Subclass	ELASMOBRANCHII
Order	TORPEDINIFORMES RHINOBATIFORMES

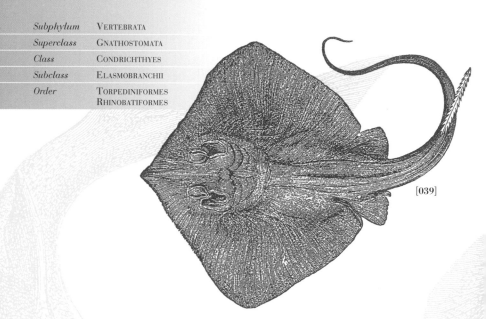

[039]

Stingrays, Eagle Rays & Guitarfish

039 Common stingray—*Dasyatis pastinaca*
040 Spotted eagle ray—*Myliobatis aquila*
041 Common stingray—*Dasyatis pastinaca*
042 Guitarfish, fiddler ray, banjo shark

THE ANCIENT CIVILIZATIONS called electric rays "numbfish," believing that they could bewitch their prey and any fishermen who caught them. Their "numbing" properties were adapted by humans for a number of medical uses: treating gout, fever, and as pain relief for childbirth and

[040]

[041]

[042]

anesthetic for operations. The Greek word for "numbness" is *narke*, from which we derive the English word narcosis.

The stingrays [*039 and 041*] have long, smooth, whiplike tails with a projecting spine, armed with sharp cutting teeth and venom-producing tissues. The unfortunate victim of a ray attack finds itself lassoed by the tail and lacerated by the spine. Such attacks are excruciatingly painful and occasionally fatal to humans.

Guitarfish [*042*] are so named because their shape is superficially similar to that of the musical instrument.

Superclass	GNATHOSTOMATA
Class	CONDRICHTHYES
Subclass	ELASMOBRANCHII
Order	PRISTIFORMES
	RAJIFORMES

Sawfish & Skates

[043]

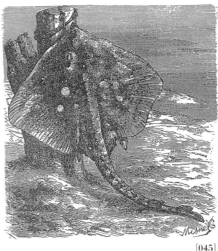

[045]

[044]

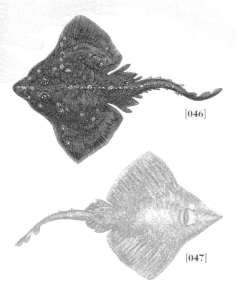

[046]

[047]

SAWFISH [*043 and 044*] first appear in the fossil record 56 million years ago, probably having evolved from a species of guitarfish. They grow up to 33 feet in length (including their saw) and have a fearsome sawlike snout with which they can wreak havoc among fishermen's nets. It was once believed that they used their saw to attack whales, but more recently it has been discovered that they mainly use it to root in the seabed to expose buried invertebrates, on which they largely feed.

Skates feed mainly on bottom-feeding invertebrates and flatfish, using their thorny whiplash tails to defend themselves from predators.

Superclass	GNATHOSTOMATA
Class	CONDRICHTHYES
Subclass	ELASMOBRANCHII
	HOLOCEPHALI
Order	RAJIFORMES
	CHIMAERIFORMES

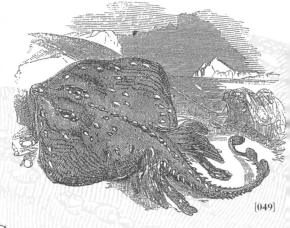

[049]

Skates & Chimaeras

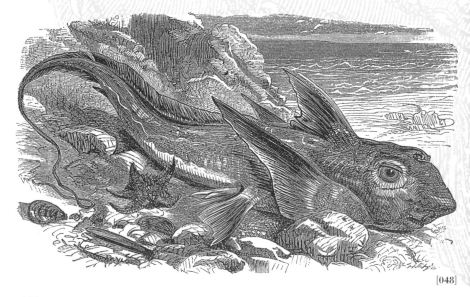

[048]

[050]

[051]

SKATES, LIKE THE DOGFISH, lay their eggs in a protective leathery sheath that the Victorian fishermen affectionately called "skate barrers" due to their resemblance in shape to a four-handled barrow [051]. The Rev. J. G. Wood, writing in 1902, reports that fishermen told him that they boiled and ate skate eggs like hens' eggs.

Chimaeras or ratfish [048] appear in the fossil record more than 360 million years ago. They differ from the other cartilaginous fish in that the upper jaw is fused with the cranium. They are bottom feeders in the temperate oceans, eating invertebrates and small fish.

048 Chimaera, ratfish, rabbit fish—*Chimaera monstrosa*
049 Thornback ray—*Raja clavata*
050 Thornback rays—*Raja clavata*
051 Egg case of skate ("skate barrow")

Bony Fish *Chordata*

The first bony fish fossils appear in the fossil record about 395 million years ago during the Devonian period—often called the "Age of the Fishes." Their exact origins remain uncertain, but it is thought they had a common ancestor with the cartilaginous fish, rather than evolving from them. By the end of the Devonian, two subclasses of bony fish had emerged—the Sarcopterygii, or lobe-finned fishes, and the Actinopterygii, or ray-finned fishes—and representatives of both groups survive today. The Sarcopterygii include the lungfish and the ceolocanth and are recognizable by fleshy, leglike lobes at the bases of their fins. None are shown here because the lungfish is found only in freshwater and the ceolocanth was known only from fossils until 1938, when the scientific world was shaken to discover that Madagascan fishermen often caught them off the Comoros Archipelago.

The Actinopterygii today form the largest group of vertebrate species. About 95% of these belong to the superorder Teleosteii, which evolved

about 65 million years ago. This subclass includes sturgeons, herring, anchovies, eels, salmon, trout, codfish, flying fish, sea horses, bass, perches, tuna, and many other species.

The largest of all bony fish is the ocean sunfish (*Mola mola*), which can grow to a length of 10 feet and a weight of 1½ tons (*see page 210* [*144*]). However, this is tiny compared to the biggest of the sharks, the whale shark (*page 153* [*030*]), measuring 50 feet and weighing 47 tons, or the blue whale, which can grow to 100 feet and weigh 145 tons! No scientist has yet produced a convincing argument to account for this huge size difference.

This group of animals has possibly had more influence on the shaping of human history than any other. Ever since humans first appear in the fossil and archaeological record, fish bones have been found among their dwellings. One school of thought even suggests that we evolved from a species of marine ape.

Phylum	CHORDATA
Subphylum	VERTEBRATA
Superclass	GNATHOSTOMATA
Class	OSTEICHTHYES

Bony Fish Anatomy

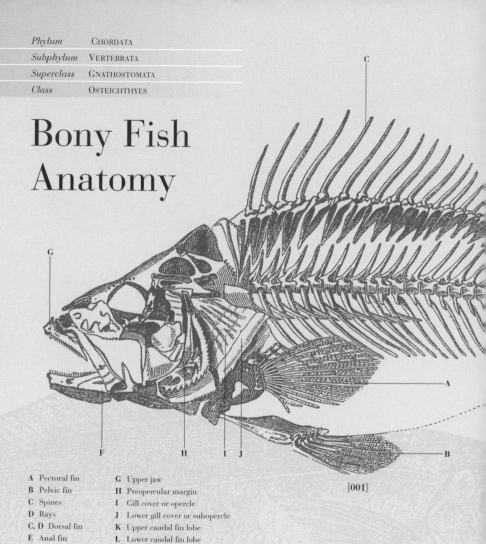

[001]

A Pectoral fin
B Pelvic fin
C Spines
D Rays
C, D Dorsal fin
E Anal fin
F Lower jaw

G Upper jaw
H Preopercular margin
I Gill cover or opercle
J Lower gill cover or subopercle
K Upper caudal fin lobe
L Lower caudal fin lobe
M Lateral line

THE OSTEICHTHYES are characterized by a skeleton formed from spongy bone and three pairs of tooth-bearing bones lining the jaws (dentary, premaxillary, and maxillary). Their upper jaw is movable, allowing them to protrude their mouth as they open it. The Osteichthyes also have a well-muscled bony flap called an operculum, which covers the gills and enables them to actively pump oxygen-bearing water across their gills without having to keep moving. They share a pressure-sensitive lateral line with the cartilaginous fish, but unlike them, most bony fish lay eggs that hatch into a larval stage that feeds on small plankton.

As the name suggests, the ray-finned fish have slender fin rays to support their fins—but as the next pages demonstrate, they have evolved into an amazing array of different forms.

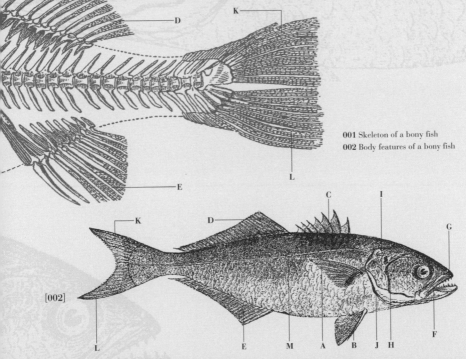

001 Skeleton of a bony fish
002 Body features of a bony fish

[002]

Class	OSTEICHTHYES
Subclass	ACTINOPTERYGII
Superorder	CHONDROSTEII
Order	ACIPENSERIFORMES

[005]

Sturgeons
& Paddlefish

[003]

[004]

AN ANCIENT FISH with a mainly cartilaginous skeleton and a heterocercal tail, the anadromous sturgeon was found in copious quantities by North American settlers. By the early 19th century, 90% of the world's caviar was harvested here, then exported to Europe, and deceptively repackaged as "premium Russian caviar." Within a century, American stocks were fished out and the corresponding scarcity led to a massive price rise. Thereafter, caviar carrying the more exclusive Russian label was likely to be genuine.

The European sturgeon [*003, 005, 008*] is found on both sides of the Atlantic, and in the Mediterranean and Black Seas. The larger 16-foot beluga [*004*] is found mainly in the Black Sea.

Occasionally found in salt water and first reported by Hernando de Soto in the 16th century, the now rare North American paddlefish or spoonbill [*007*] is characterized by a long paddle-shaped snout, measuring one-third of its body length of 5 feet or more.

003 Common sturgeon—*Acipenser sturio* 🐟
004 Beluga, beluga sturgeon—*Huso huso* 🐟
005 Common sturgeon—*Acipenser sturio* 🐟
006 Amu darya sturgeon, shovelnose sturgeon—
 Pseudoscaphirhynchus kaufmanni 🐟
007 Spoonbill catfish, spoonbill paddlefish—
 Polyodon spathula 🐟
008 Common sturgeon—*Acipenser sturio* 🐟

[008]

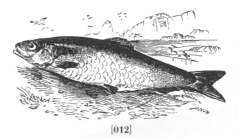

[012]

Herring & Anchovies

009 Atlantic herring—*Clupea harengus* 🐟
010 Sprat—*Sprattus sprattus* 🐟
011 Atlantic herring—*Clupea harengus*
012 European pilchard—*Sardina pilchardus* 🐟
013 Silverstriped round herring—
 Spratelloides gracilis
014 European anchovy—*Engraulis encrasicolus* 🐟
015 Allis shad—*Alosa vulgaris*
016 Atlantic herring—*Clupea harengus*

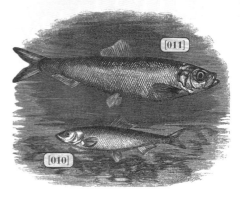

[011]

[010]

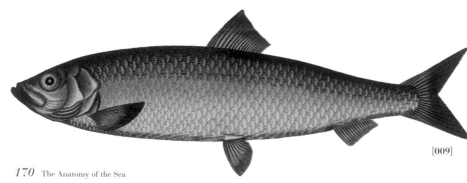

[009]

[013]

HERRING are surface-living, pelagic fish that live in large shoals in coastal waters. The Atlantic herring is found on both the North American and European coastlines. Together with the sprat [*010*] and the pilchard or sardine [*012*], these fish are not only of economic significance but also provide food for fish and other marine animals. Young clupeid fish are harvested for fish meal and whitebait.

[014]

[015]

Anadromous shad [*015*] were once a commercial fish of European countries, but overfishing and habitat destruction have made them scarce.

Mediterranean anchovies [*014*] were esteemed by the Greeks and Romans as a delicacy; the fisheries are still of great economic importance today.

In Holland, around 1350, Willem Breukelszoon van Biervliet perfected a technique for gutting herring, leaving the pancreas in situ. Pancreatic enzymes cured the fish, allowing prolonged storage at sea. Nowadays the herring catch is frozen.

[016]

Class	OSTEICHTHYES
Subclass	ACTINOPTERYGII
Superorder	TELEOSTEI
Order	ANGUILLIFORMES/ NOTACANTHIFORMES

017 European eel—*Anguilla anguilla*
018 Moray eel—*Muraena helena*
019 Sharpnosed eel—*Anguilla acutirostris*
020 Broadnosed eel—*Anguilla latirostris*
021 Moray eel—*Muraena helena*
022 Largescale tapirfish—*Notacanthus nasus*
023 Conger eel—*Conger conger*
024 Moray eel—*Muraena helena*

Eels & Spiny Eels

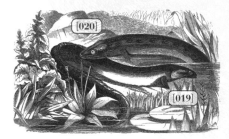

[021]

[018]

[020]

[019]

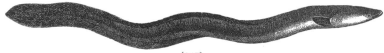

[017]

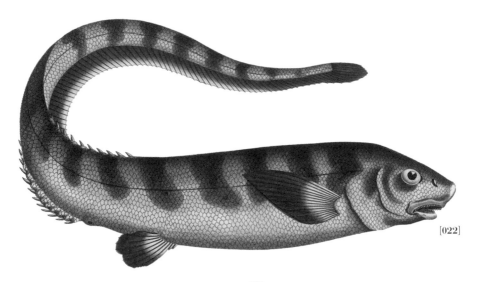

[022]

THERE ARE APPROXIMATELY 600 species of eel. Slender and serpentlike, European and North American eels are catadromous, spawning in the warm, deep waters of the Atlantic but spending most of their lives in freshwater.

The flesh of some species is toxic to humans; however, one edible Mediterranean species (*Muraena helena* [*018, 021, 024*] was considered a great delicacy by the Romans and was cultivated by them in seaside pools.

Conger eels [*023*] are found in all oceans and number about 100 species.

Spiny eels such as the largescale tapirfish [*022*] are not related to true eels and live at depths of more than 6,500 feet!

[023]

[024]

Class	OSTEICHTHYES
Subclass	ACTINOPTERYGII
Superorder	TELEOSTEII
Order	SALMONIFORMES

[027]

[028]

[026]

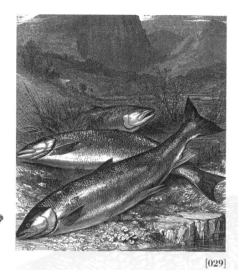
[029]

025 Atlantic salmon (female)—*Salmo salar*
026 A month-old salmon (fingerling)
027 Salmon egg
028 Newly-hatched salmon (alevin)
029 Atlantic salmon—*Salmo salar*
030 Atlantic salmon (male)—*Salmo salar*
031 Atlantic salmon (female)—*Salmo salar*
032 Atlantic salmon (female)—*Salmo salar*
033 Atlantic salmon (male)—*Salmo salar*
034 Sea trout

Salmon & Trout

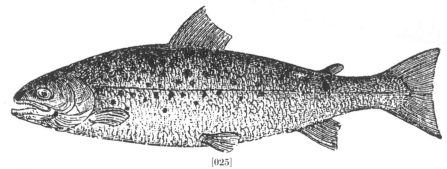
[025]

THE ATLANTIC SALMON [025–033] is found on both sides of the Atlantic. After a period in freshwater, young salmon migrate to ocean waters for growth, after which they return to freshwater to spawn and die. Pacific salmon have a similar life cycle.

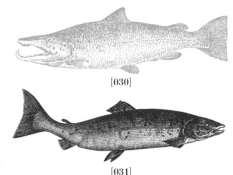
[030]

Both wild species have been reduced by industrial pollution, silting, and the damming of rivers for hydroelectric power. Management measures, such as bypass streams and hatcheries, have helped to conserve the Pacific salmon but have been less beneficial for the Atlantic salmon—possibly because Pacific salmon make the perilous return journey to freshwater only once, whereas Atlantic salmon may return several times.

[031]

Sea trout is the generic name ordinarily given to some trout species [034] that enter the sea in order to feed. After the winter spawn, eggs are laid in hollowed-out gravel nests on a riverbed and take up to 12 weeks to hatch.

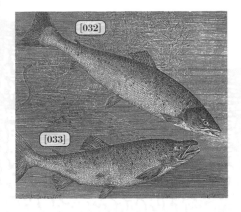
[032]
[033]

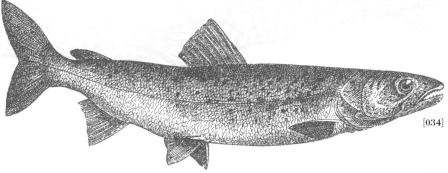
[034]

Class	OSTEICHTHYES
Subclass	ACTINOPTERYGII
Superorder	TELEOSTEII
Order	GADIFORMES

"Wild are the waves when the wind blows;
But fishes in the deep
Live in a world of waters,
Still as sleep."

WALTER DE LA MARE (c. 1910)

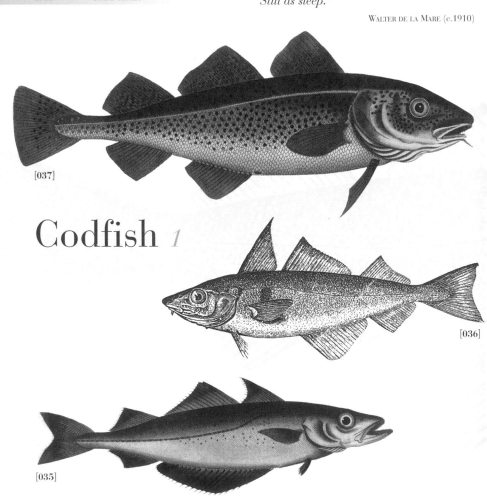

[037]

Codfish *1*

[036]

[035]

ATLANTIC COD (*Gadus morhua* [*037, 040–042*]) can reach 200 pounds in weight. The Victorian naturalist Rev. J. G. Wood once remarked: "No fish is of greater utility. The flesh is firm, white, and of excellent quality, and every part of the fish is capable of being turned to some useful purpose."

Mrs. Beeton said of cod-liver oil: "Fish oil is…more easy of digestion than any other kind of fat, and therefore cod-liver oil is commonly given to invalids." Throughout the 19th century it was a folk remedy for wasting diseases, but in 1922 its vitamin A and D content was discovered. Physicians then began prescribing it as a vitamin supplement to treat conditions such as rickets and infantile tetany. Today it is taken as an omega-3 supplement and is thought to aid mental and cardiovascular health, along with promoting healthy and supple joints.

035 Pollack—*Pollachius pollachius*
036 Haddock—*Melanogrammus aeglefinus*
037 Atlantic cod—*Gadus morhua*
038 Haddock—*Melanogrammus aeglefinus*
039 Whiting—*Merlangius merlangus*
040 Atlantic cod—*Gadus morhua*
041 Atlantic cod—*Gadus morhua*
042 Atlantic cod—*Gadus morhua*

[042]

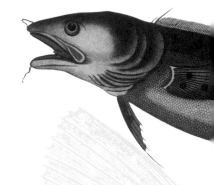

Class	OSTEICHTHYES
Subclass	ACTINOPTERYGII
Superorder	TELEOSTEI
Order	GADIFORMES

Codfish 2

[044]

VICTORIAN NATURALISTS were struck by the fecundity of cod, and saw it as a limitless resource. However, within a century overfishing had made it scarce. Dwindling stocks caused a dispute between Iceland and Britain known as the "Cod War" (1972–1976), when, as an economic and conservation measure, Iceland extended its fishing limits, first to 50 and then to

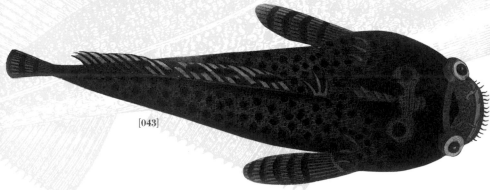

[043]

[045]

200 miles. In 1976 a compromise was reached, allowing 24 British trawlers to fish within the 200-mile limit.

North Atlantic haddock [*036, 038*], a bottom dweller, grows to about 3 feet. Pollack (also known as saithe) [*035*], whiting [*039*], and ling [*045*] are other valuable members of the cod family.

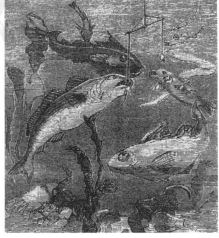

[046]

043 Three-bearded rockling—*Gaidropsarus vulgaris*
044 Atlantic cod—*Gadus morhua*
045 Ling—*Molva molva*
046 Taking the bait
047 Atlantic cod—*Gadus morhua*

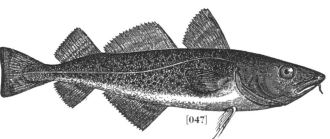

[047]

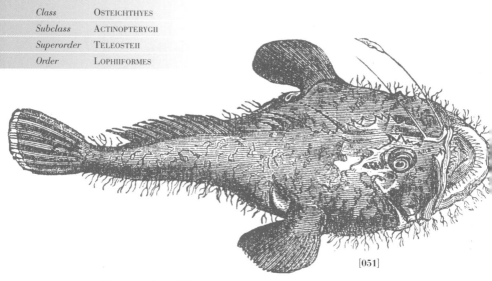

[051]

Anglerfish

[049]

[048]

[050]

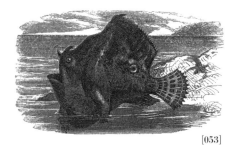

[053]

[052]

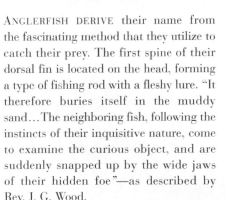

048 Grunting toadfish—*Allenbatrachus grunniens*
049 Monkfish, angler, anglerfish—*Lophius piscatorius*
050 Monkfish, angler, anglerfish—*Lophius piscatorius*
051 Monkfish, angler, anglerfish—*Lophius piscatorius*
052 Monkfish with garfish
053 Shaggy frogfish, shaggy angler monkfish, angler,
 anglerfish—*Antennarius hispidus*
054 Monkfish, angler, anglerfish—*Lophius piscatorius*

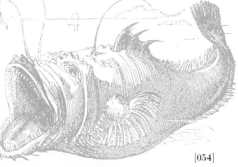

[054]

ANGLERFISH DERIVE their name from the fascinating method that they utilize to catch their prey. The first spine of their dorsal fin is located on the head, forming a type of fishing rod with a fleshy lure. "It therefore buries itself in the muddy sand…The neighboring fish, following the instincts of their inquisitive nature, come to examine the curious object, and are suddenly snapped up by the wide jaws of their hidden foe"—as described by Rev. J. G. Wood.

There are approximately 210 marine species of anglerfish. They are divided into four groups: batfish, goosefish, frogfish, and deep-sea anglers.

In some notable species of deep-sea angler, the much smaller male bites the female and becomes fused to her skin. The bloodstreams of the two fishes become connected; afterward the male becomes parasitic on the female. Some deep-sea angler species have bioluminescent lures, which both attract and illuminate prey.

Class	OSTEICHTHYES
Subclass	ACTINOPTERYGII
Superorder	TELEOSTEII
Order	ATHERINIFORMES

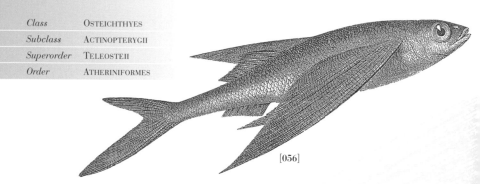

[056]

Flying Fish, Halfbeaks & Garfish *1*

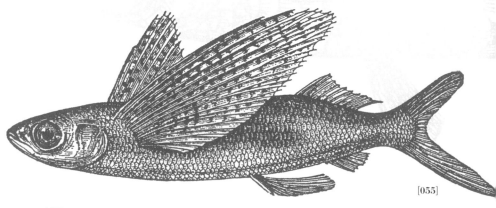

[055]

[057]

[058]

THERE ARE ABOUT 40 species of oceanic flying fish, found worldwide in warm waters. Reaching a maximum length of 18 inches, they are identified by their large flying fins and lopsided tails. They are surface-living fishes, feeding on plankton and small crustaceans.

While on board ship in the Caribbean, the Victorian naturalist Canon Kingsley made the following observations and conclusions about them:

"The flying fish have been for the last two days a source of continual amusement…It has been assumed that these beautiful creatures left the water and sought the air as a refuge from their ever harassing foes. But there is no reason to believe that their foes are either more numerous or more voracious than the ordinary foes of fish. There seems every reason to believe that they rather take flight to exercise, like other creatures…the powers with which they are endowed."

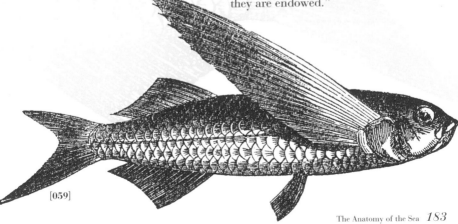

[059]

Class	OSTEICHTHYES
Subclass	ACTINOPTERYGII
Superorder	TELEOSTEII
Order	ATHERINIFORMES

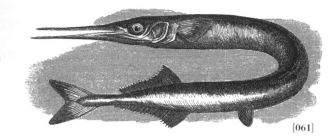

[061]

Flying Fish, Halfbeaks & Garfish 2

060 Gar, garfish, garpike—*Belone belone*
061 Gar, garfish, garpike—*Belone belone*
062 Four-eyed fish, foureyes—*Anableps anableps*
063 Flying fish being pursued by *Coryphaena hippurus*
064 Flying fish

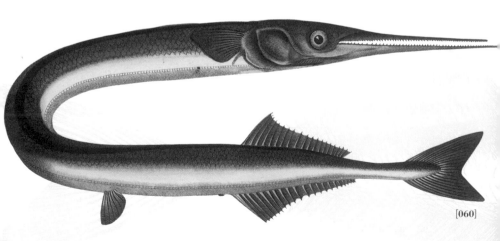

[060]

[062]

[063]

toothed snout. The Victorians called the garfish "greenbone," perhaps because its upper sides are shining green and it is thin enough to seem all bone, perhaps because its bones turn light green when boiled. Rev. J. G. Wood (and many Victorian naturalists) tended toward the latter explanation:

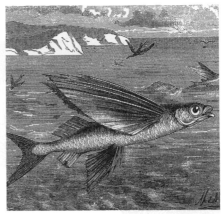

[064]

HALFBEAKS ARE TROPICAL FISHES, so named because of their unusual jaws—the upper being short and triangular, the lower long, slim, and beaklike. These slender, silvery fish can skip or glide across water. Marine halfbeaks breed near the shoreline; their eggs often attach to floating debris with adhesive filaments.

The European gar [060–061] has a long, slender body and a long, sharp-

"The marine fish…is sometimes sent to market, generally causing some little excitement as its long pointed head and brightly covered body lie shining on the dealer's table. It is not however extensively captured, on account of a senseless prejudice…against the fish, the green hue of the spine being the probable cause. Despite the prejudice the fish is an excellent one."

Class	OSTEICHTHYES
Subclass	ACTINOPTERYGII
Superorder	TELEOSTEII
Order	BERYCIFORMES/ZEIFORMES

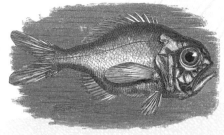

[065]

Squirrelfish, Pinecone Fish & Dories

SQUIRRELFISH HAVE LARGE EYES, spiny fins, and rough, prickly tails. They are often brightly colored, red being predominant, but many have yellow, white, or black markings. Found in warm, rocky, or coral reef areas, they are carnivorous and nocturnal. The fish can generate a variety of grunting and clicking noises by using its swim bladder.

Pinecone fish are found in deep water around the Indo-Pacific. The oval body is covered in platelike scales resembling pinecones, and it has two bioluminescent sacs under the lower jaw. The Japanese pinecone fish [067] is found in schools

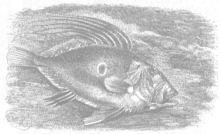

[066]

near the ocean floor, and although small (maximum 5 inches), it is a commercially important food fish.

The name John Dory [066, 068] is derived from the French *jaune dorée* on account of the golden yellow that decorates the fish's body. A food fish of the Atlantic and Mediterranean, it reaches a length of 3 feet and has a distinctive yellow-ringed black spot on each side.

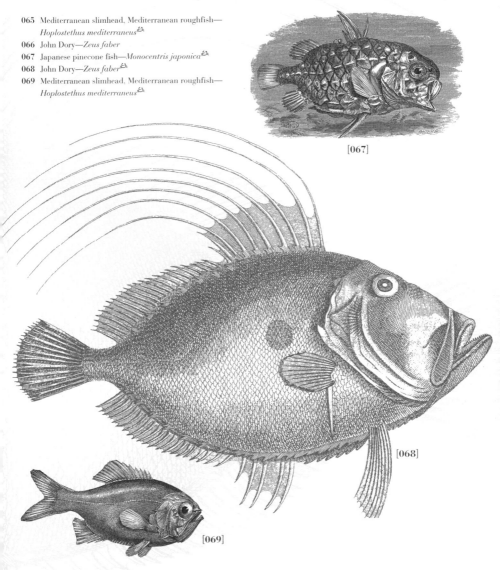

065 Mediterranean slimhead, Mediterranean roughfish—
 Hoplostethus mediterraneus

066 John Dory—*Zeus faber*

067 Japanese pinecone fish—*Monocentris japonica*

068 John Dory—*Zeus faber*

069 Mediterranean slimhead, Mediterranean roughfish—
 Hoplostethus mediterraneus

[067]

[068]

[069]

Class	OSTEICHTHYES
Subclass	ACTINOPTERYGII
Superorder	TELEOSTEII
Order	SYNGNATHIFORMES

[072]

Sea Horses &
Cornetfish *1*

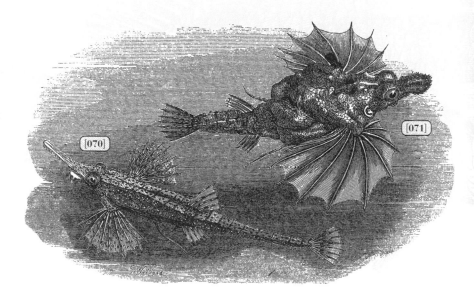

[070]

[071]

PIPEFISH ARE SLENDER and long-bodied with a tubular snout. The body is covered by hard, bony scales, which appear not to overlap but are arranged side by side like tiles. The snake pipefish lives at the sea's surface, but many other species live concealed within algae or seaweed, where they feed on small aquatic organisms. The male carries the fertilized eggs in a brood pouch, or stuck onto the body surface.

Cornetfishes are active predators found in tropical seas. They are devoid of scales and dorsal spines but have a long tail filament. The bluespotted cornetfish [074] grows to about 5 feet in length and is found from New England to Brazil.

Seamoths such as the slender seamoth [070] inhabit the Indo-Pacific regions and are so called because of their mothlike flutter as they move across the seabed in shallow waters.

070 Slender seamoth, shorttailed dragonfish. pegasus— *Pegasus volitans*
071 Sea dragonfish—*Pegasus draconis*
072 Common sniperfish—*Macroramphosus scolopax*
073 Common sniperfish—*Macroramphosus scolopax*
074 Bluespotted cornetfish—*Fistularia tabacaria*
075 Bellows fish—*Macroramphosus* sp.

[073]

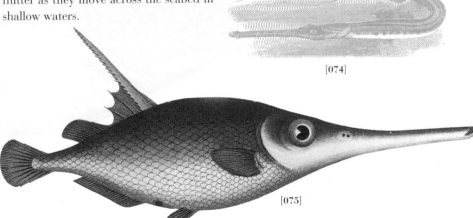

[074]

[075]

Sea Horses & Cornetfish 2

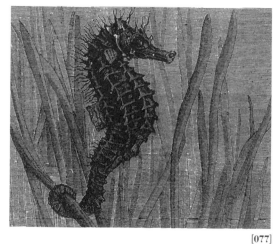

[077]

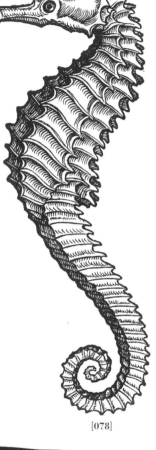

[078]

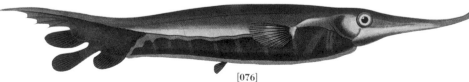

[076]

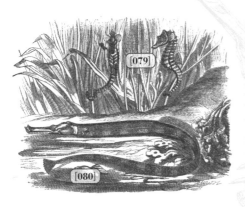

[079]

[080]

[081]

[082]

SEA HORSES ARE THOUGHT to have changed little in body structure since their evolution some 40 million years ago. Rev. J. G. Wood gives this description in his book *Natural History*, "The head of the sea horse is wonderfully like that of the quadruped from which it takes its name, and the resemblance is increased by two apparent ears that project pertly from the sides of the neck. These organs are, however, fins…The sea horse, like the chameleon, possesses the power of moving either eye at will, quite independently."

A true pregnancy is experienced within the male sea horse. Fertilization is internal: the eggs are held within a pouch housing a capillary network, which supplies oxygen and placental fluid to the embryos. The pregnancy lasts from two to three weeks, producing between 5 and 200 young. Meanwhile, the female produces more eggs, which are subsequently passed into the male pouch. Sea horses are monogamous, and the male remains pregnant throughout the breeding season.

076 Serrate razorfish, rigid razorfish—
 Centriscus scutatus
077 Sea horse—*Hippocampus brevirostris*
078 Sea horse—*Hippocampus brevirostris*
079 Sea horse—*Hippocampus brevirostris*
080 Great pipefish, giant pipefish—*Sygnathus acus*
081 Leafy seadragon—*Phycodurus eques*
082 Sea horse—*Hippocampus brevirostris*

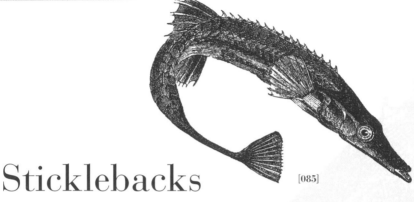

[085]

Sticklebacks
& Tubesnouts

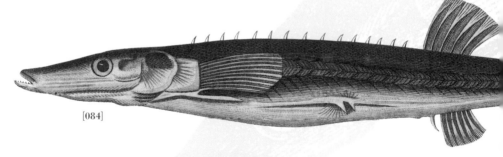

[084]

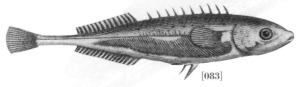

[083]

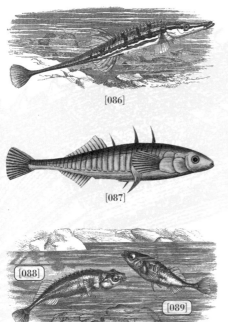

STICKLEBACKS ARE FOUND only in the Northern Hemisphere. There are eight known species, which can be distinguished by the number of spines along the back, varying in number from 3 to 16. The Rev. J. G. Wood described the three-spined stickleback [087, 089] as one of the commonest British fishes, and said of the fifteen-spined stickleback [084–086]: "It is remarkably elongated in proportion to its width, and this formation, together with its armature of sharp toothlike spines, has gained it the name of sea-adder. It is a voracious creature feeding on all sorts of marine animals." Both sticklebacks and their close relatives, the tubesnouts, are nest builders. Nests consist of plant material bound together with mucus. Male sticklebacks defend their young, and are fiercely territorial. First described by Linnaeus in 1758, the stickleback has in modern times consistently become the subject of perhaps surprisingly diverse scientific research. Studies have included the choice of a mate, learning and cognition, potential future evolution, and recently the monitoring of environmental influences, and genetics.

083 Nine-spine stickleback, ten-spined stickleback
—*Pungitius pungitius*

084 Fifteen-spined stickleback—*Spinachia spinachia*

085 Fifteen-spined stickleback—*Spinachia spinachia*

086 Fifteen-spined stickleback—*Spinachia spinachia*

087 Three-spined stickleback—*Gasterosteus aculeatus*

088 Nine-spine stickleback, ten-spined stickleback—
Pungitius pungitius

089 Three-spined stickleback—*Gasterosteus aculeatus*

Class	OSTEICHTHYES
Subclass	ACTINOPTERYGII
Superorder	TELEOSTEI
Order	SCORPAENIFORMES

Scorpionfish & Stonefish

[092]

[091]

[090]

090 Red lionfish, red firefish, turkeyfish—*Pterois volitans*
091 Largescale scorpionfish—*Scorpaena scrofa*
092 Sea raven, sea robin—*Hemitripterus americanus*
093 Red lionfish, red firefish, turkeyfish—*Pterois volitans*
094 Two-stick stingfish, sea goblin, devil scorpionfish—
 Pelor filamentosum
095 Longspined flathead—*Platycephalus longispinis*

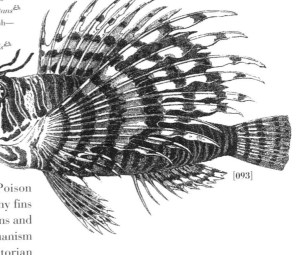

[093]

SCORPIONFISHES are widely distributed in both temperate and tropical seas, many having unusual colorations and striking camouflage patterns. The order Scorpaeniformes contains many poisonous fish. Poison glands are located at the base of spiny fins and can contain powerful neurotoxins and hemotoxins. This self-defense mechanism was explained by the natural historian J. G. Wood when describing the largescale scorpionfish [*091*]: "When captured it certainly plunges and struggles violently in its endeavours to escape, and if handled incautiously it will probably inflict some painful injuries with its bony spears. This result, however, is attributable to the carelessness of the captor and to the natural desire for liberty, and not to any malevolent propensities innate in its being."

Stonefish of the Indo-Pacific are perfectly camouflaged while lying among corals, and produce the most deadly of all fish venoms.

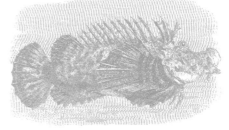

[094]

[095]

Class	OSTEICHTHYES
Subclass	ACTINOPTERYGII
Superorder	TELEOSTEI
Order	SCORPAENIFORMES/ DACTYLOPTERIFORMES

096 Lumpsucker—*Cyclopterus lumpus*
097 Oriental flying gurnard—*Dactyloptena orientalis*⊄
098 European flying gurnard—*Dactylopterus volitans*⊄
099 Oriental flying gurnard—*Dactyloptena orientalis*⊄
100 Sapphirine gurnard—*Trigla hirundo*
101 Hooknose, pogge, armed bullhead—
 Agonus cataphractus⊄

[096]

Gurnards, Sculpins & Flying Gurnards

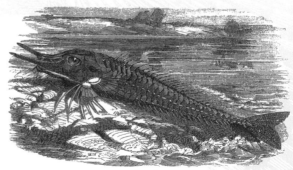

[097]

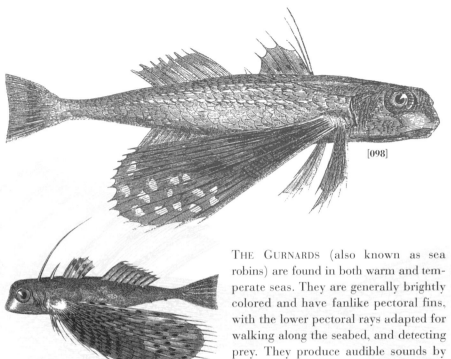

[098]

[099]

[100]

[101]

THE GURNARDS (also known as sea robins) are found in both warm and temperate seas. They are generally brightly colored and have fanlike pectoral fins, with the lower pectoral rays adapted for walking along the seabed, and detecting prey. They produce audible sounds by vibrating their swim bladder. The sapphirine gurnard [*100*] can be found along the British coastline.

The sculpins or bullheads [*101*] are small bottom-dwelling fish with unusually wide and heavy heads. They are sometimes used as bait for lobster pots.

Flying gurnards [*097–099*] are a small group of marine fish similar to the gurnard. They live on the seabed approximately 30–50 feet down, but are capable of gliding through the air in order to escape predators.

[103]

Bass, Perches
& Sea Breams *1*

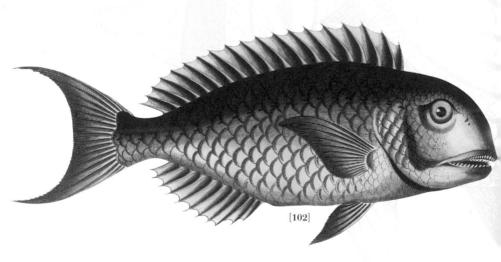

[102]

THE SEA BASSES INCLUDE hamlet, murray cod, grouper [104], graysby, comber, sandfish, hind, cony, and the goliath grouper (formerly the jewfish).

Butterflyfish [107] and dolphinfish or coryphenes [102; see also 063 on page 185] inhabit warm waters, the latter feeding on surface fish, especially flying fish. J. G. Wood wrote the following descriptive passage about dolphinfish: "Words can

hardly express the extreme beauty of the coryphenes as they play easily around the ship, their sides glittering in the sunbeams as if made of burnished gold and silver, and every change of attitude producing some new combination of colour. They have a curious habit of attaching themselves for a time to a passing ship, and are able…to gambol around the vessel as if she were at anchor."

102 Common dolphinfish, mahimahi,
 blue coryphene—*Coryphaena hippurus*
103 Dentex—*Dentex dentex*
104 Dusky grouper, guasa—*Epinephelus guaza*
105 Sea bass—*Dicentrarchus labrax*
106 Common sea bream, red porgy—*Pagrus pagrus*
107 Vagabond butterflyfish—*Chaetodon vagabundus*

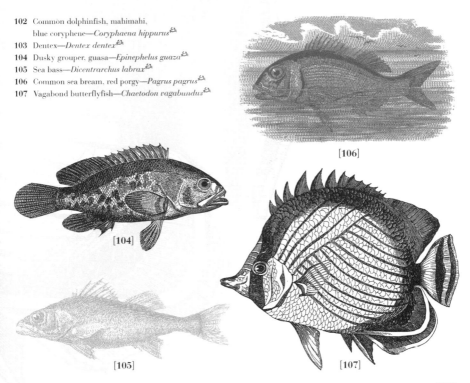

[106]

[104]

[105]

[107]

Subclass	ACTINOPTERYGII
Superorder	TELEOSTEII
Order	PERCIFORMES
Suborder	PERCOIDEI

[111]

[110]

[109]

Bass, Perches
& Sea Breams 2

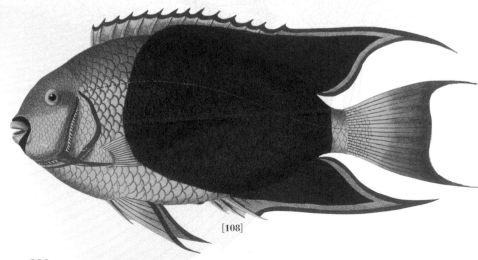

[108]

[112]

[113]

[114]

THE FAMILY SERRANIDAE contains about 400 species of sea bass. Amazingly, many sea bass undergo a sex change during their lifetime; this can be male to female (protandry) or female to male (protogyny). Male black sea bass are territorial seabed dwellers, and larger males can secure bigger territories. Conversely, striped bass are nonterritorial, so older large females can lay more eggs. Striped bass are indigenous to the Atlantic coastline, but they were successfully introduced to the Pacific Coast in the late 1800s. Yearling fish were removed from sites near Red Bank, New Jersey, then transported across the continent by train to San Francisco Bay. Water tanks had to be agitated by hand and replenished en route. The introduction proved so successful that by 1899 the Pacific Coast striped bass catch grossed 1.2 million pounds.

[115]

Subclass	ACTINOPTERYGII
Superorder	TELEOSTEII
Order	PERCIFORMES
Suborder	MUGILOIDEI/SPHYRAENOIDEI/LABROIDEI

[117]

Gray Mullet, Barracuda, Wrasses & Parrotfish

[116]

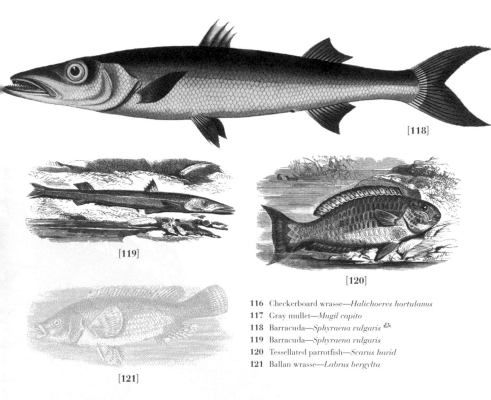

[118]

[119]

[120]

116 Checkerboard wrasse—*Halichoeres hortulanus*
117 Gray mullet—*Mugil capito*
118 Barracuda—*Sphyraena vulgaris* 🐟
119 Barracuda—*Sphyraena vulgaris*
120 Tessellated parrotfish—*Scarus harid*
121 Ballan wrasse—*Labrus bergylta*

[121]

GRAY MULLET [*117*] are a commercially important group of coastal marine fish. Barracuda [*118–119*] are found in all warm and tropical seas. The largest is the great barracuda, which can reach a length of 6 feet. A powerful fish, it has a large mouth with many sharp teeth. Normally fish eaters, great barracuda have occasionally been reported to attack humans.

Wrasses and parrotfish belong to a large group of colorful, mainly tropical, marine fish. Most wrasses and parrotfish undergo a sex change during their lifetime. Parrotfish have molarlike teeth in their throats to grind coral and hard-shelled animals. The residue from this is released as the white sand found around coral reefs. Each parrotfish creates about 1 ton of sand per annum.

Subclass	ACTINOPTERYGII
Superorder	TELEOSTEII
Order	PERCIFORMES
Suborder	BLENNIOIDEI

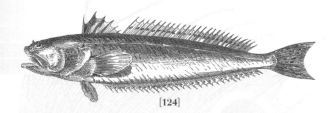

[124]

Blennies, Weavers & Stargazers

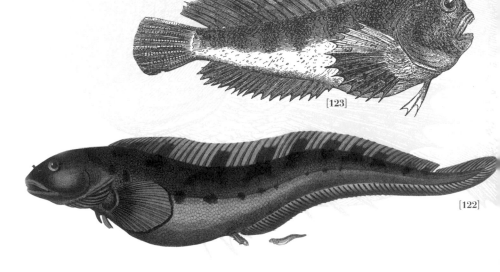

[123]

[122]

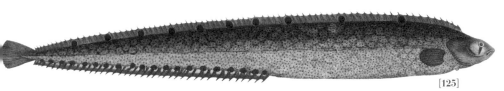

[125]

BLENNIES AND CLINIDS are two closely related but diverse families of mainly littoral (shore-living) fishes, found in both tropical and cold seas. The two families appear similar, but blennies are scaleless whereas clinids are fully scaled.

Venomous weaver fish [*124, 127*] habitually bury themselves in the sand. The Victorian naturalist J. G. Wood gives us the following warning about the great weaverfish: "This species is the dread of fishermen, the wounds occasioned by the sharp spine of the gill-cover, and those of the first dorsal fin, being extremely painful...the evil effects extending from the hand up the arm."

Stargazers [*126*] are not only venomous but also have electric organs behind their eyes that can discharge up to 50 volts of electricity!

122 Viviparous blenny—*Zoarces viviparus*
123 Butterfly blenny—*Blennius ocellaris*
124 Great weaverfish—*Trachinus draco*
125 Butterfish, gunnel rock eel—*Pholis gunnellus*
126 Atlantic stargazer—*Uranoscopus scaber*
127 Weaverfish, sting fish— *Trachinus vipera*

[126]

[127]

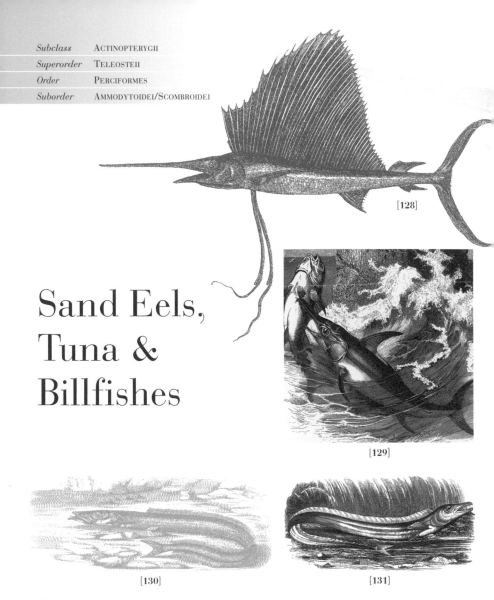

Subclass	ACTINOPTERYGII
Superorder	TELEOSTEI
Order	PERCIFORMES
Suborder	AMMODYTOIDEI/SCOMBROIDEI

[128]

Sand Eels,
Tuna &
Billfishes

[129]

[130]

[131]

SAND EELS [130] are eel-like but are not related to true eels. These fish swim in dense schools, burrowing into sandy seabeds when threatened. They are an important food for many larger marine animals.

The Atlantic mackerel [132] was popular in Victorian times. J. G. Wood states: "The flesh of the mackerel is very excellent…Unfortunately it must be eaten while quite fresh as it becomes unfit for consumption after a very short time…and in consequence…the London costermongers are permitted to hawk it about the streets on Sundays, much to the discomfort of peaceable householders."

Tuna are among the most heavily exploited fish worldwide. The largest, the bluefin [133], can reach a length of 14 feet. Uniquely among fishes, tuna maintain their body temperature up to 25°F above the sea temperature.

128 Indo-Pacific sailfish—*Istiophorus platypterus* 🐟
129 Broadbill swordfish—*Xiphias gladius* 🐟
130 Sand eel—*Hyperoplus lanceolatus* 🐟
131 Silver scabbardfish—*Lepidopus caudatus* 🐟
132 Mackerel—*Scomber scomber*
133 Bluefin tuna, bluefin tunny—*Thunnus thynnus* 🐟
134 Broadbill swordfish—*Xiphias gladius* 🐟

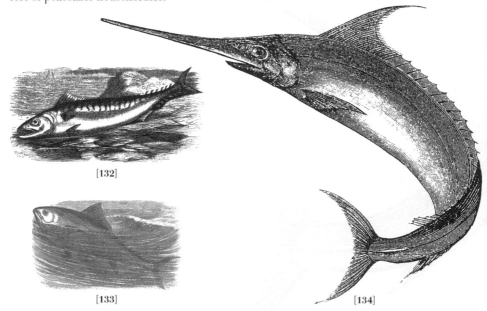

[132]

[133]

[134]

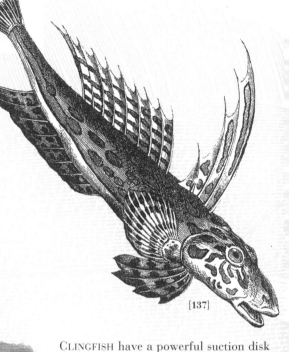

[137]

Clingfish, Dragonets & Flatfish

[135]

[136]

CLINGFISH have a powerful suction disk on their undersurface, formed from pelvic fins. Many live in the shallow water of the intertidal zone, clinging onto rocks.

Dragonets are found in all temperate and tropical seas. All have a spur in front of the gill cover that is often heavily spined. Some are covered in toxic mucus and are brilliantly colored. The most common European dragonet is the gemmeous dragonet [137].

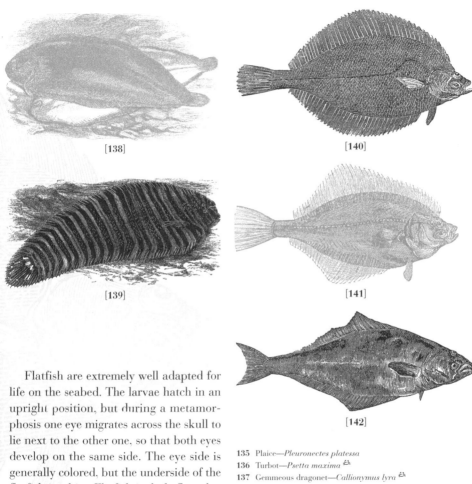

[138]

[139]

[140]

[141]

[142]

Flatfish are extremely well adapted for life on the seabed. The larvae hatch in an upright position, but during a metamorphosis one eye migrates across the skull to lie next to the other one, so that both eyes develop on the same side. The eye side is generally colored, but the underside of the flatfish is white. Flatfish include flounder, brill, dab, halibut, sole, lemon sole, plaice, and turbot.

135 Plaice—*Pleuronectes platessa*
136 Turbot—*Psetta maxima*
137 Gemmeous dragonet—*Callionymus lyra*
138 Sole—*Solea vulgaris*
139 Zebra sole—*Zebrias zebra*
140 Flounder—*Platichthys flesus*
141 Dab—*Limanda limanda*
142 Halibut—*Hippoglossus hippoglossus*

Class	OSTEICHTHYES
Subclass	ACTINOPTERYGII
Superorder	TELEOSTEII
Order	TETRAODONTIFORMES

143 Longhorn cowfish, yellow boxfish—
 Lactoria cornuta

144 Ocean sunfish—*Mola mola*

145 Queen triggerfish—*Balistes vetula*

146 Bristly triggerfish—*Balistes tomentosus*

147 Clown triggerfish—*Balistoides conspicillum*

148 Balloonfish, fine-spotted porcupine fish—
 Diodon holocanthus

149 Black-spotted porcupine fish—*Diodon hystrix*

150 Nile puffer fish, Fahaka puffer—
 Tetraodon lineatum

Triggerfish
& Puffer Fish

[144]

[143]

TRIGGERFISH [*145–147*] have deep, compressed bodies with smooth heavy scales. J. G. Wood tells us that "the name Trigger Fish is derived from the peculiar structure of the dorsal fin. When the fin is erected, the first ray, which is very thick and strong, holds its elevated position so firmly that it cannot be pressed down by any degree of force; but if the second ray be depressed, the first immediately falls down like the hammer of a gun-lock when the trigger is pulled."

Puffer fish [*150*] are so named because of their ability to inflate the stomach with water or air. Many species are poisonous because their internal organs contain a virulent toxin called tetrodotoxin. Such fish are, nonetheless, a delicacy (known as *fugu*) in Japan, when cleaned and cooked by a specially trained chef.

[147]

[148]

[149]

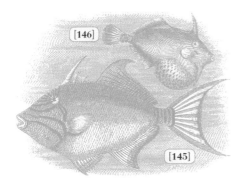

[146]

[145]

[150]

Marine Reptiles *Chordata*

About 400 million years ago, at the beginning of the Devonian, a group of the lobe-finned fishes, the Sarcopterygii, evolved the first of four adaptations that paved the way for the vertebrates to invade the land—the lung. Toward the end of that period, a mere 50 million years later, the second great evolutionary leap had been made: the tetrapods had arrived!

Tetrapoda, a word that derives from the Greek, meaning "four legs," describes all of the backboned animals that have ever walked, from the very first fish to develop limbs with feet to the human race. It also includes those, such as the turtles, sea snakes, whales, and seals, that have returned to a life in the oceans. Stunning fossil discoveries since the 1980s and major advances in our understanding of the way in which genes are inherited lead us to believe that early tetrapods diverged from a common ancestor into two major groups: the amphibians and the amniotes.

Amphibians have largely retained their dependence on watery environments in which they lay eggs that hatch into gill-breathing larvae. A very few have adopted a marine lifestyle, but these need to have fresh water to breed, and seem to have been unknown or of little interest to the Victorian naturalists. For that reason they are (sadly) not included in this section.

Amniotes (derived from the Greek, meaning "foetal membrane") appeared first in the Carboniferous and solved the next two great problems associated with a conquest of the land: an egg that could be laid and develop without a watery environment, and a skin that was waterproof. Very early on in this evolutionary process they diverged into two lines, one that culminated in the living mammals, the other that includes the dinosaurs, reptiles, and birds.

Today's marine reptiles range from some of the most deadly to the most endearing of sea creatures: the crocodiles, sea snakes, lizards, and turtles.

Subphylum	VERTEBRATA
Superclass	AMNIOTA
Class	REPTILIA
Order	CROCODYLIA/SQUAMATA

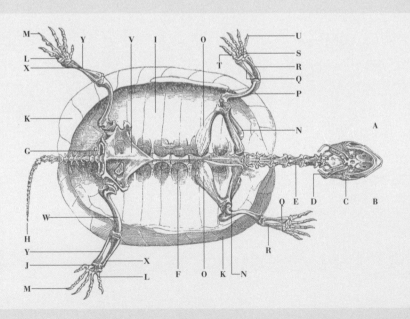

Reptile Anatomy

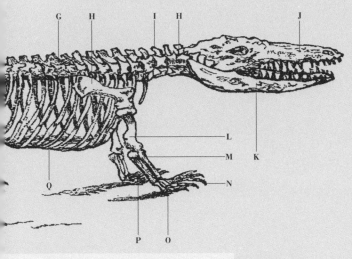

Crocodile anatomy

A Caudal vertebrae
B Pelvic girdle
C Femur
D Tibia
E Fibula
F Tarsus
G Dorsal vertebrae
H Scapula
I Cervical vertebrae
J Superior maxilla
K Inferior maxilla
L Humerus
M Ulna
N Digital phalanges
O Carpus
P Radius
Q Ribcage

Tortoise anatomy

A Superior maxilla
B Inferior maxilla
C Ossiculum auditus
D Os hyoides
E Cervical vertebrae
F Dorsal vertebrae
G Sacrum
H Caudal vertebrae
I Dorsal ribs
J Tarsus
K Marginal scales
L Metatarsus
M Phalanges of the foot
N Scapula
O Coracoid bone
P Ossa humeri
Q Radius
R Ulna
S Bones of the carpus
T Metacarpal bones
U Digital phalanges
V Pelvis
W Femur
X Tibia
Y Fibula

THE WONDERFUL DIVERSITY of the reptiles is well represented by the relatively few marine species found in the oceans of today. All of the main orders have groups that have given up their terrestrial origins for a life in the ocean: from the graceful and remarkable turtles through the terrifying crocodilians and the venomous sea snakes.

Reptile anatomy varies from the ancient form of the crocodile (oldest fossils from about 240 million years ago) to the much more recently evolved snakes and turtles (oldest marine fossils about 150 and 110 million years old respectively).

Subphylum	Vertebrata
Superclass	Amniota
Class	Reptilia
Order	Chelonia

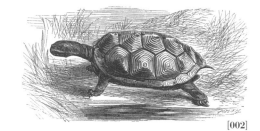

[002]

Turtles *1*

[001]

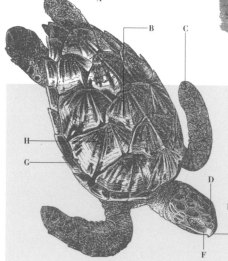

Turtle anatomy

A Rear limbs flattened for swimming
B Vertebral dermal plates or scales
C Forelimbs flattened for swimming
D Head
E Horny upper jaw
F Nostril
G Marginal dermal plates or scales
H Pleural dermal plates or scales

CHELONIA IS DERIVED from the Greek *khelys*, meaning "tortoise." In the United States the term "turtle" refers to all chelonians whereas in Britain it is used exclusively for marine animals. This remarkable group includes some of the largest reptiles and is one of the few back-boned orders to have evolved an external shell that is fused to its skeleton. In the endangered hawksbill turtle [001, 004] the shell is formed from scales that are harvested for the much-prized tortoise-shell. The trade in this material is now banned in most countries, but the Rev. J. G. Wood, writing in 1865, describes the removal of the plates as "a very cruel process, the poor reptiles being exposed to a strong heat." After the plates are removed, "the turtle is permitted to go free as...it is furnished with a second set of plates...of inferior quality."

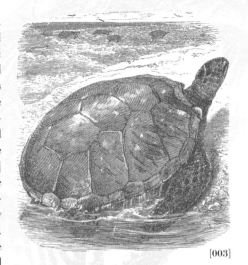

[003]

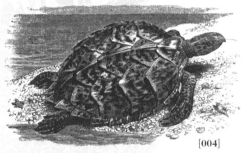

[004]

001 Hawksbill turtles—*Eretmochelys imbricata*
002 Northern diamondback terrapin—
 Malaclemys terrapin
003 Green turtle—*Chelonia mydas*
004 Hawksbill turtle—*Eretmochelys imbricata*
005 Green turtle—*Chelonia mydas*

[005]

Subphylum	VERTEBRATA
Superclass	AMNIOTA
Class	REPTILIA
Order	CHELONIA

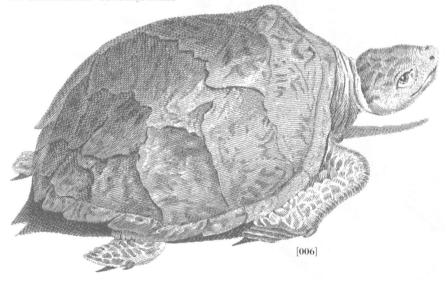

[007]

Turtles 2

006 Hawksbill turtle—*Eretmochelys imbricata*
007 Green turtle—*Chelonia mydas*
008 Loggerhead turtle—*Caretta caretta*
009 Green turtle—*Chelonia mydas*
010 Leatherback turtle—*Dermochelys coriacea*

[006]

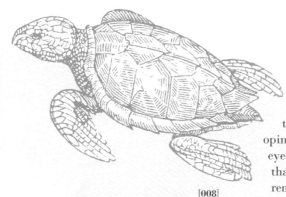

[008]

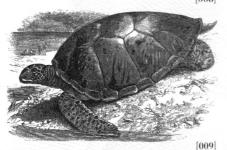

[009]

TURTLES HAVE ADAPTED to their oceanic lifestyle by developing tear ducts that protect their eyes from excess salt, and bones that have flattened to form fins reminiscent of the prehistoric plesiosaur. Although the fins enable them to swim with graceful elegance, they also render them cumbersome and vulnerable when they come ashore in order to lay their huge clutches of eggs.

Green turtles [*003, 005, 007, 009*]—so called because of their much prized green fat—are also considered a flavorsome delicacy. The sailors of Old England, weary of eating tongue-blistering "salt junk," would rejoice at the capture of these remarkable vegetarians, drooling at the prospect of fresh meat. Their flesh is still highly prized throughout the world.

The turtles survived the catastrophes that caused the downfall of the dinosaurs —but today, all of the species shown in this book face extinction. They are victims of pollution; boat collisions; persecution for their flesh, shells, or fat; and destruction of their egg-laying habitat.

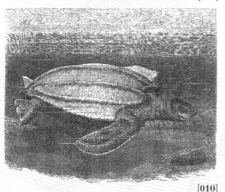

[010]

Subphylum	VERTEBRATA
Superclass	AMNIOTA
Class	REPTILIA
Order	CROCODYLIA/SQUAMATA

[013]

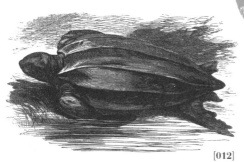

[012]

"'Come hither, Little One,' said the Crocodile, 'for I am the Crocodile,' and he wept crocodile-tears to show it was quite true."

RUDYARD KIPLING (1902)

Crocodiles, Snakes & Lizards

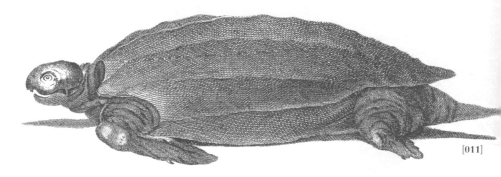

[011]

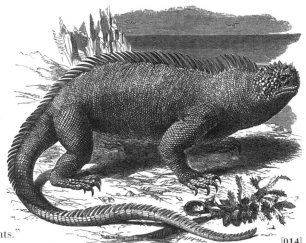

[014]

THE HARMLESS VEGETARIAN marine iguana [*014*] was rather unkindly described by Charles Darwin in his *Voyage of the Beagle* as a "hideous-looking creature, of a dirty black color, stupid and sluggish in its movements." The word "stupid" appears to have referred to their trusting reluctance to bite or run from humans and refusal to bolt into the sea. After millions of years of their evolution in the absence of land predators but persecuted by sharks in the sea, Darwin himself admits some wisdom in their approach.

Sea snakes have flattened tails for swimming and can swallow fish up to twice the diameters of their necks! They have venomous bites but are able to withhold their venom, and bites are thus rarely fatal.

Crocodylus is an adaptation of Greek *kroko-drilos*, meaning "pebble worm." The terrifying saltwater crocodile, found in Southeast Asia and northern Australia, is the largest surviving reptile, weighing in at more than 1½ tons [*015*].

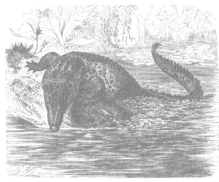

[015]

011 Leatherback turtle—*Dermochelys coriacea*
012 Leatherback turtle—*Dermochelys coriacea*
013 Sea snake
014 Marine iguana, Galapagos iguana—
 Amblyrhynchus cristatus
015 Saltwater crocodile—*Crocodylus porosus*

Birds *Chordata*

The birds are vertebrates—that is to say, animals with backbones. They are the only animals to possess feathers. The feathers not only help them to fly but are also important in helping the birds to regulate their body temperature. In this way, birds, like mammals, can be considered to be warm-blooded. Birds do not have teeth but have a beak or bill made of bone with a smooth, cornified covering. The legs are also covered with a cornified covering that resembles scales. The skeleton is strong but light, and inside the hollow bones there are crossbraces to increase the strength of the skeleton. Unlike mammals, birds do not give birth to live young; all birds reproduce by laying eggs. Birds have highly developed voice, hearing, and sight. The ancient Greek word for "bird," *ornis*, gives rise to the name for the study of birds: ornithology.

The largest living birds are the condor and the ostrich, and the smallest is the hummingbird. Differences between bird species are adaptive, so that each bird occupies a different role in the environment.

Colored feathers are used either for camouflage or for sexual signaling. Female birds select the males with the most intense colors and/or song.

Many species of birds migrate over long distances, guided by a combination of instinct and navigational cues such as the stars. Birds usually travel to warmer regions in winter.

On the temperate seashore, there are three major groups of birds. First, there are the birds that live permanently on the shore, including the auks such as the puffin, the gulls such as the black-backed gull, and the ducks such as the eider. Second, there are the birds of passage that are traveling through, such as the waders, exemplified by the redshank. Third, there are the particularly marine birds such as the petrel and the albatross, which spend most of their lives out on the open ocean.

There are many orders of birds, ranging from the ostriches (Struthioniformes) through the penguins (Sphenisciformes), the albatrosses (Procellariiformes), and the ducks (Anseriformes), and many more.

Penguins, Divers, Grebes & Ducks

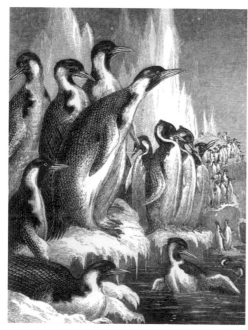

[001]

[002]

[003]

[004]

PENGUINS ARE FLIGHTLESS BIRDS in which the wings are modified into paddles and the bones are compressed. Small scalelike feathers cover the body, the feet are webbed, and there is a thick layer of fat under the skin. There are about 20 species, restricted to the southern oceans.

Grebes are aquatic birds of quiet freshwater or ocean margins. They are infrequent fliers but expert divers.

The teal is a duck normally associated with inland waters. It flies low, quickly, and erratically, in compact flocks.

The great northern diver swims with only the head above water and dives quickly when alarmed. The eider is a heavy-billed diving duck.

[005]

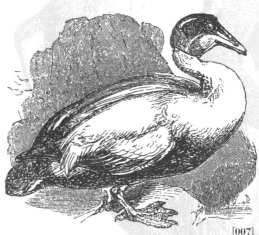

[007]

[006]

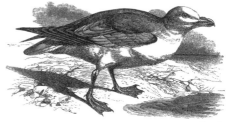

[009]

Petrels, Pelicans & Darters

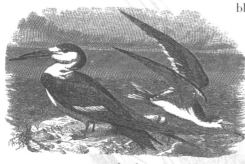

[008]

008 Black skimmer, razorbilled shearwater—*Rhynchops nigra*

009 Petrel—*Fulmarus glacialis* ♙

010 Storm petrel—*Hydrobates pelagicus*

011 Seagull colony

012 White pelican—*Pelecanus onocrotalus*

013 Frigate bird—*Fregata minor* ♙

014 Snakebird, black-billed darter, anhinga—*Plotus anhinga*

015 Red-billed tropic bird—*Phaeton aethereus*

THE LOWER MANDIBLE of the skimmer [*008*] fits into the upper like a penknife and its blade. In inland and coastal waters of the tropics these birds skim over the water surface, feeding on aquatic life.

Pelicans use the gular pouch (which acts as a dipnet) to hold fish scooped from the water.

In a process of kleptoparasitism, the frigate bird forces other fish-eating birds to regurgitate their prey and takes the food in the air. Frigate birds display their gular pouch at mating times to attract females. The healthiest birds have the reddest pouches.

The darter is a pelecaniform fishing bird found along the banks of rivers and on coastal marshes in Africa and America.

Rev. Wood (1863) noted that the feathers of the coast-dwelling tropic bird were "used by South Pacific natives in the war head-dress and worn as a decoration in battle."

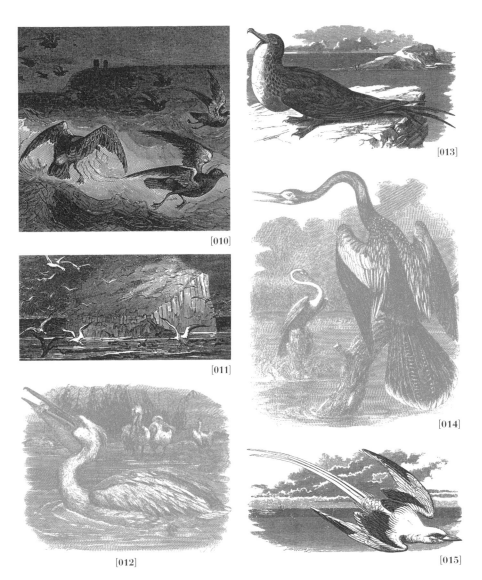

[010]

[011]

[012]

[013]

[014]

[015]

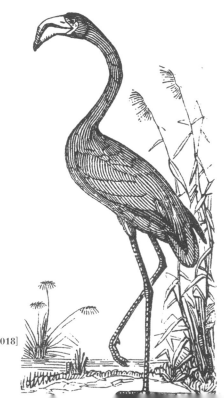

[017]

Gannets &
Cormorants

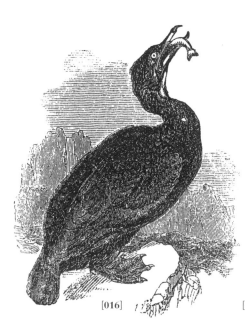

[016]

[018]

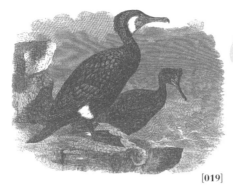

[019]

[020]

[021]

GANNETS ARE LARGE, strictly marine birds that breed in dense colonies on steep cliffs. Although they are often seen far out to sea, they can sometimes be seen fishing in surf close to the shore. They wheel in the air when feeding, then plunge vertically up to 100 feet to take fish under the surface. By contrast, cormorants are near-shore birds that are now extending their range up rivers. In Southeast Asia, fisher-men put a ring around their necks to stop them eating the fish, then train them to fly freely and catch fish.

The slender white and rose-pink barnacle goose lives in America and Europe, migrating south in winter. In 1636 Gerard, confused by the migratory habits of this bird, claimed that the early part of its life cycle was spent as a goose barnacle (*see Crustaceans, pages 52–81*) before it developed into the adult bird.

016 Cormorant—*Graculus carbo* ⇄ *Phalacrocorax carbo*
017 Gannet—*Sula bassanea*
018 Flamingo—*Phoenicopterus ruber*
019 Cormorant—*Phalacrocorax carbo*
020 Barnacle goose—*Bernicla leucopsis* ⇄ *Branta leucopsis*
021 Lapwing—*Vanellus cristatus* ⇄ *Vanellus vanellus*

Shore Birds

[022]

[023]

[024]

[025]

THE AVOCET is a relatively large bird (18 inches) that feeds on worms and crustaceans in estuaries of Europe and Africa. The eggs are laid in a depression. Like the lapwing, disturbed adults feign lameness in order to draw away intruders.

The red-backed sandpiper, in Europe known as the dunlin, lives on coasts in winter but on moorland in summer. It adopts a characteristic hunched posture when it is feeding.

The curlew is a large wader with a long, down-curved bill and characteristic bubbling call throughout the year.

Like the dunlin, the sandpiper migrates to the coast in winter. where it constantly bobs the head and tail while feeding in sand and mud.

Unlike the heavier scavenging black-backed gull, terns are small graceful birds that plunge from a characteristic fluttering flight in order to feed on fish.

[026]

[027]

[028]

[029]

Subclass	NEORNITHES True birds
Order	CHARADRIIFORMES
Family	ALCIDAE Auks and Puffins
Order	PROCELLARIIFORMES Albatrosses, Fulmars, and Petrels

Albatrosses, Auks & Choughs

[031]

[030]

[032]

[033]

[035]

[034]

030 Puffin—*Fratercula arctica*
031 Black guillemot—*Cepphus grylle*
032 Guillemot—*Uria aalge*
033 Albatross—*Diomedea exulans*
034 Great auk—*Pinguina impennis*
035 Chough—*Pyrrhocorax pyrrhocorax*

AUKS ARE SMALL BIRDS that "fly" under water to catch fish. They live in dense colonies on sea cliffs or in burrows. The puffin has a serrated tongue that allows it to hold its catch while it fishes again.

The flightless, penguinlike great auk was exterminated in 1844 and exists only as museum material. In the text accompanying the illustration shown here, Wood (1863) writes in the present tense: "It breeds principally on the shores of Iceland and Spitzbergen laying one large egg on a cleft of a high rock. The eggs are extremely scarce and fetch a very high price among collectors."

The albatross is an oceanic, marine fish-eating bird with an enormous wing span of 10 feet.

The chough, a crowlike bird, lives on sea cliffs and rocky uplands.

Seals, Sea Lions & Walruses *Chordata*

Soon after the amniotes evolved in the Carboniferous period, they diverged into two great branches: one forming the reptiles and birds, the other ultimately resulting in the mammals. The earliest records of true mammals date back 210 million years to the late Triassic, which means that they shared the first two-thirds of their evolution with the dinosaurs. During that time, they rarely reached the size of a beaver— but the demise of the dinosaurs, 65 million years ago, allowed these terrestrial animals to evolve into a vast array of shapes and sizes. Some became adapted for a marine existence, and about 25 to 30 million years ago, the first pinnipeds appeared in the fossil record. Today these include three families: the earless or "true" seals (Phocidae), the eared fur seals and sea lions (Otariidae), and the walruses (Odobenidae). Conventional wisdom suggests that the eared seals and walruses evolved from a bearlike ancestor 30 million years ago whereas the earless seals

evolved independently from an otterlike animal in the North Atlantic about 20 million years ago. However, recent DNA studies suggest that they share a common ancestor (probably bearlike), and that the walruses may be more closely related to the "true" seals than the eared seals. The debate continues.

Taxonomists disagree over the origins of the seals, but the Inuit Eskimos have no doubt. Their folklore tells how Nuliajuk (also called Sedna), a little orphan girl, was left behind when the people of her village left to find food in time of famine. She tried to jump onto their raft but was thrown into the water. Desperately, she tried to climb aboard but the people cut off her fingers, which fell into the water and became seals. Nuliajuk sank to the bottom of the ocean where she became a powerful and vengeful spirit, the mother of the sea and ruler of all beasts.

Superclass	AMNIOTA
Class	MAMMALIA
Order	CARNIVORA
Suborder	PINNIPEDIA

001 Skeleton of a common seal, *Phoca vitulina*, showing adaptation of the pectoral and pelvic limbs
002 Hind flippers of seal
003 Skull of walrus

Seal Anatomy

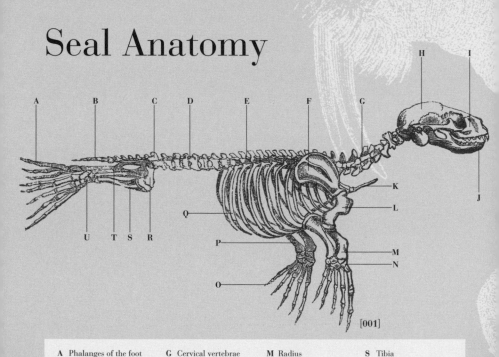

[001]

A Phalanges of the foot	**G** Cervical vertebrae	**M** Radius	**S** Tibia
B Caudal vertebrae	**H** Skull	**N** Carpal bones	**T** Fibula
C Pelvis	**I** Superior maxilla	**O** Digital phalanges	**U** Tarsal bones
D Lumbar vertebrae	**J** Inferior maxilla	**P** Ulna	
E Thoracic vertebrae	**K** Sternum	**Q** Ribcage	
F Scapula	**L** Humerus	**R** Femur	

A As spread when in use
B Closed

[002]

PINNIPEDIA IS FROM THE LATIN, meaning "feather-footed," describing the fact that all four feet have evolved into webbed flippers. However, pinnipeds still form limbs that enable the animals to move on land, albeit inelegantly. This, coupled with the fact that they have fur, separates them from whales and manatees, which have sacrificed all of these attributes during their evolution. Unlike the eared seals, the true seals have moved further toward a marine lifestyle, having hind limbs that are swept back behind the remnants of their tails. They have also lost some movement in the pelvis, elbow, and wrist. Only the shoulder remains mobile, but they swim powerfully through the water by undulating their hind limbs. The eared seals, as the name suggests, have obvious earflaps, and hind limbs that can move away from the tail and allow "walking" movements. Walruses and eared seals swim with their front limbs, but the former have no earflaps.

A Cranium
B Orbit
C Maxilla
D Upper canines (tusks)
E Dentary
F Occiput

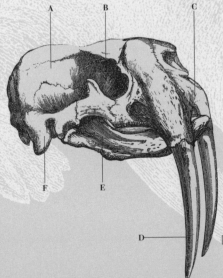

[003]

Superclass	AMNIOTA
Class	MAMMALIA
Order	CARNIVORA
Suborder	PINNIPEDIA

[005]

Earless or Hair Seals *1*

004 Harp seal with walrus—*Pagophilus groenlandicus*
005 Harp seal—*Pagophilus groenlandicus*
006 Common seal, harbor seal—*Phoca vitulina*
007 Gray seals—*Halichoerus grypus*
008 Hooded seal—*Cystophora cristatus*
009 Elephant seal (bull)—*Mirounga angustirostris*

[004]

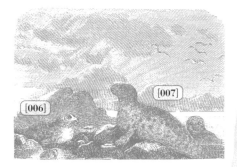

A RECENT ESTIMATE SUGGESTS that there are about 50 million pinnipeds in the world, of which approximately 90% are from the family Phocidae. This remarkable group of animals can also, rather confusingly, be called "true," "hair," or "earless" seals. Most phocid species are found in the Northern Hemisphere, but the largest population is that of crabeater seals in the Antarctic, numbering about 30 million! With the exception of the walruses, the phocids are the only seal species occupying the polar regions. Fewer representatives of the family are found in warmer climes, examples including the Mediterranean and Hawaiian monk seals, both of which are endangered, having populations of only 500 and 1,500 respectively. Their close relative, the Caribbean monk seal was declared extinct in 1986.

The common or harbor seals shown here [*006*] are from the genus *Phoca*, derived from the Greek word *phoke*, meaning "seal."

Superclass	AMNIOTA
Class	MAMMALIA
Order	CARNIVORA
Suborder	PINNIPEDIA

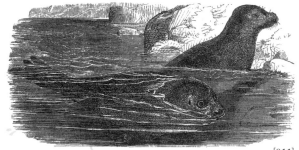

[011]

Earless or Hair Seals 2

010 Leopard seal—*Hydrurga leptonyx*
011 Common seal, harbor seal—*Phoca vitulina*
012 Harp seal—*Pagophilus groenlandicus*
013 Common seal, harbor seal—*Phoca vitulina*
014 Elephant seal—*Mirounga angustirostris*

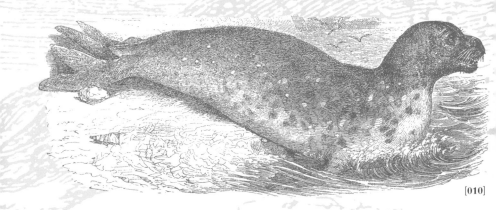

[010]

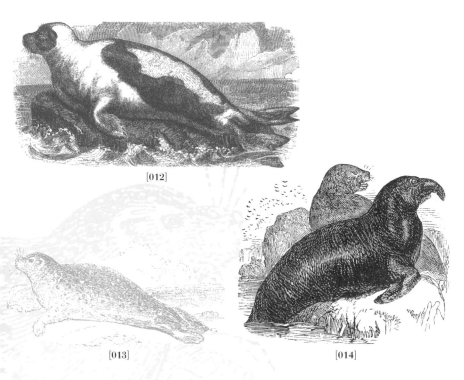

[012]

[013]

[014]

ALL SEALS ARE CARNIVORES, feeding on fish and on invertebrates such as mollusks and crustaceans. Their appetite for fish and the high quality of the fur on the young pups has meant that phocid seal populations in the Northern Hemisphere have been the target of fishermen and fur traders for centuries. In 2001 it was claimed that the 100,000-strong population of gray and common seals [*007, 011*] ate 15,000 tons of cod per year in British coastal waters. However, gray seals were the first mammals to be protected by modern legislation (the Gray Seals Protection Act, 1914). A more recent act prevents culling between September and December, but conservationists express concern at the lack of scientific justification for culls. Even more controversial has been the practice of clubbing seal pups to death during culls in order to preserve the quality of the pelt.

Superclass	AMNIOTA
Class	MAMMALIA
Order	CARNIVORA
Suborder	PINNIPEDIA

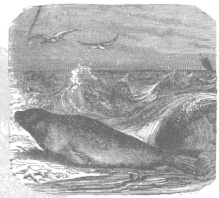

[016]

Earless & Eared Seals

[015]

SOME PHOCID SPECIES are relatively small, monogamous creatures, but the elephant seal [015] bears neither of these traits. So called because of its huge size and the elongated nose of the males, a single bull elephant seal can measure 20 feet and weigh up to 3 tons! From this immense body, up to 1 ton of oil can be extracted from the thick layer of blubber beneath the skin. For this reason, seals were highly sought after in the early 19th century—so much so that the huge numbers found in the Southern Hemisphere at that time were almost annihilated.

Other than by humans, seals are preyed upon by killer whales, their distant cousins the polar bear (*page 262, 030*), and by large sharks, such as the great white (*page 150, 022 and 023*).

The eared seals from the Otariidae include the endearing and intelligent sea lion [*018*].

[017]

[018]

019 Californian sea lion, with elephant seals (cows)—
 Zalophus californianus with *Mirounga angustirostris*
020 Steller sea lion—*Eumetopias jubatus*
021 Group of seals
022 Northern fur seal—*Callorhinus ursinus*
023 Northern fur seal—*Callorhinus ursinus*

[019]

Eared or Fur Seals

EARED SEALS DIFFER from their earless cousins in a number of ways. Apart from the anatomical differences described on pages 236–237, they are generally smaller (though may still reach 13 feet), tend to occupy the more temperate regions, and nurse their young for longer periods. Most species occur in the Southern Hemisphere. They are sometimes grouped in two subfamilies by taxonomists, including the sea lions and the fur seals or sea bears. The latter belong to the genus *Arctocephalus*,

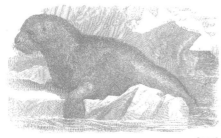

[020]

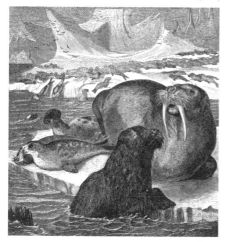

[021]

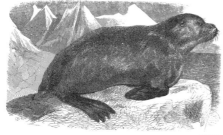

[022]

from the Greek, *arktos* "bear," and *kephale* "head," whereas the former are so called because of the hairy mane found on the adult males of most species.

Sea lions [*019*] have magnificent silvery whiskers, and these were greatly prized by the Native Americans of British Columbia, being used as ornaments on the headdresses of the chiefs. The young braves vied among themselves for deeds of daring and skill in spearing these intelligent creatures.

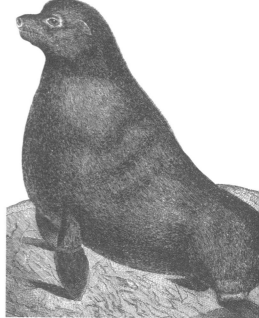

[023]

Superclass	AMNIOTA
Class	MAMMALIA
Order	CARNIVORA
Suborder	PINNIPEDIA

THE MIGHTY WALRUS (of the family Odobenidae), immortalized in Lewis Carroll's poem for its collusion with the Carpenter in deceiving the Oysters, is the second-largest of the seals. A full-grown male can reach almost 12 feet and weigh up to 1½ tons. These once trusting creatures are now wary of humans, having been extensively hunted for the fine ivory in their tusks, for their oil, and their tough skin—much prized for harness-making. They have a fearsome appearance and

"'The time has come,' the Walrus said,
'To talk of many things:
Of shoes...and ships...and sealing-wax...
Of cabbages...and kings....'"

LEWIS CARROLL (1865)

Walruses

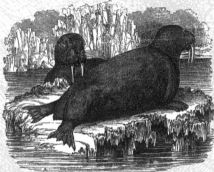

[025]

024 Walrus or morse—*Odobenus rosmarus*
025 Walrus or morse—*Odobenus rosmarus*
026 Walrus or morse—*Odobenus rosmarus*
027 Walrus or morse—*Odobenus rosmarus*

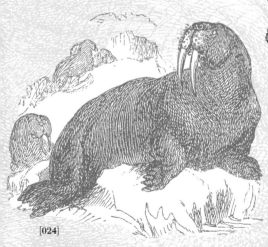

[024]

have been known to fight off polar bears. However, the Rev. J. G. Wood states that "they seldom, if ever, commence an attack" but are "most furious when opposed or wounded." These gentle giants use their whiskers to help them find their food in the bottom sediments, mainly mollusks (clams, snails, and octopus), krill, crabs, worms, and the occasional fish. Rev. Wood describes one "remarkably gentle" animal that was trained to catch fish for its master!

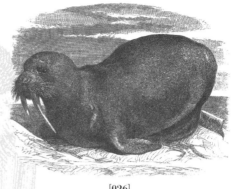

[026]

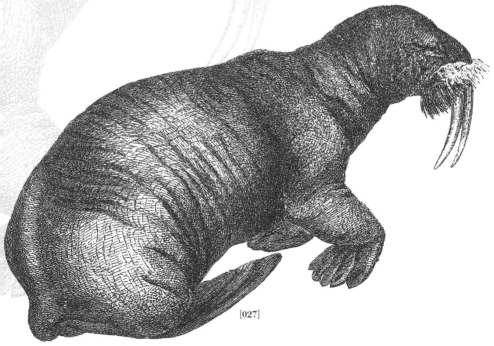

[027]

Whales *Chordata*

The human race has the privilege of sharing planet Earth with the largest animals that have ever lived here—the whales (order: Cetacea). It also bears the shame of driving several species of these huge intelligent creatures to the edge of extinction, and another—the North Atlantic gray whale—to oblivion. Since the 17th century, whales have been hunted for meat, oil, and whalebone with a ruthless, ever-increasing efficiency until, in 1946, catastrophically declining catches forced a group of wealthy nations to form the International Whaling Commission (IWC). Little action was taken for some time, despite growing evidence of declining stocks. However, no other issue captured the minds of the people like the "Save the Whale" campaign instigated by Greenpeace in 1975, which brought graphic images of whale slaughter to millions of people and helped to force a global whaling moratorium in 1986. Both Japan and Norway refused to honor the ban and still lobby for restrictions to be lifted. Today, the populations of some species are recovering, but many species remain on the endangered list.

Whales have a rich fossil record that began about 55 million years ago. Darwin, in the first editions of *On the Origin of Species*, argued that they had evolved from bears. However, Flower in 1883 suggested that they had features in common with hoofed animals, and by 1966 paleontologists believed that they had evolved from a group of extinct hoofed, wolflike carnivorous mammals called the mesonychians.

Recent studies on the DNA and proteins of existing species suggest that whales are more closely related to the artiodactyls (cloven-hooved or even-toed animals such as pigs, hippopotamuses, camels, and cattle). In fact, based on the molecular evidence, hippopotamuses have the closest relationship to whales. However, some argue for cetacean origins.

There are two main suborders of cetaceans: the Mysticeti and the Odontoceti. The Mysticeti are the baleen whales, which include the right whales, rorquals, and gray whales. The Odontoceti are the toothed whales, which include the sperm whales, killer whales, porpoises, and dolphins.

Subphylum	VERTEBRATA
Superclass	AMNIOTA
Class	MAMMALIA
Order	CETACEA

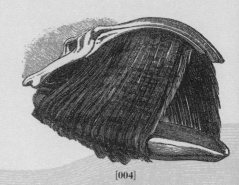

[004]

Whale Anatomy

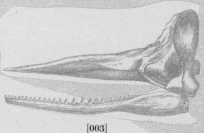

[003]

[002]

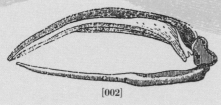

[001]

A Caudal vertebrae
B Lumbar vertebrae
C Thoracic vertebrae
D Whalebone or baleen
E Upper jaw
F Lower jaw

G Scapula
H Humerus
I Radius and ulna
J Carpal bones
K Digital phalanges
L Ribs

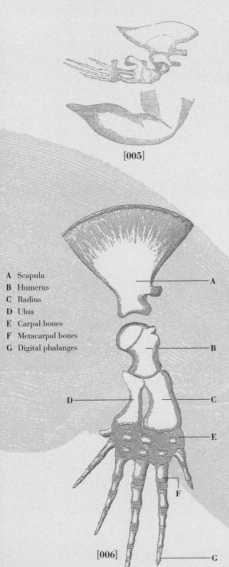

[005]

A Scapula
B Humerus
C Radius
D Ulna
E Carpal bones
F Metacarpal bones
G Digital phalanges

A

B

C

D

E

F

G

[006]

ARISTOTLE FAILED TO RECOGNIZE cetaceans as mammals, and it was not until 1693 that naturalist John Ray argued their mammalian lineage. The debate then switched to whether they were the ancestors of terrestrial mammals or vice versa. Flower's work on their anatomy in the 1880s settled most arguments when he showed that some species have the remnants of land-mammal features, for example, reduced, nonfunctional hind limbs. Additionally, the fossil record shows an unusually clear progression to this state. Unlike most other aquatic vertebrates, whales swim by up-and-down movements of their powerful tail flukes. During the evolution of their streamlined bodies, the neck has vanished, and in some species, seven of the cervical vertebrae (which in the giraffe are as long as 6 feet) have fused into a single disk. The dorsal fin, if present, is a fold of skin not supported by bone. The nostrils are located on the top of the head, forming the blowhole.

007 Right whale

008 Right whale

009 Greenland whale, bowhead whale—
Balaena mysticetus

010 Greenland whale (*Balaena mysticetus*) being
attacked by killer whales—*Orcinus orca*

011 Northern right whale—*Eubalaena glacialis*

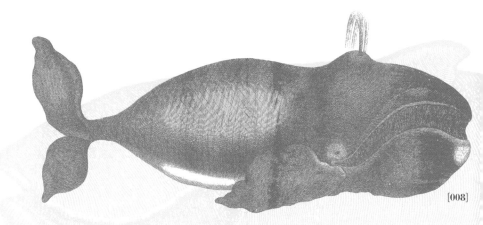

[008]

Right Whales

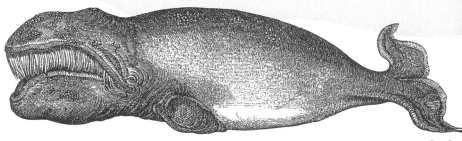

[007]

[009]

[010]

THERE ARE NEARLY 80 SPECIES of cetaceans that can be classified in two groups: the Odontoceti (toothed whales) and the Mysticeti (whalebone or baleen whales). The latter are subdivided into the right whales (Baleanidae), the rorquals (Baleanopteridae), and the gray whales (Eschrichtidae). The Mysticeti have huge mouths, lined with plates of baleen (also called whalebone) which take the place of teeth (*see page 250, 004*). In an adult Greenland whale [*009*] there may be 300 plates, each 3 to 6 feet in length and composed of agglutinated hairs. To feed, the whale drives with open mouth into the shoal of prey (shrimplike animals called krill or other small plankton), engulfing them by the million before closing its mouth and forcing the water out through the baleen. The remaining prey is then swallowed and the process repeated. In this way, an adult whale may ingest up to 10 tons at one feeding.

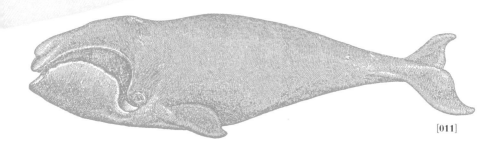

[011]

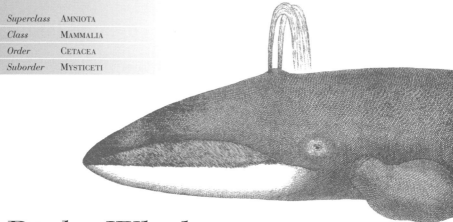

Superclass	AMNIOTA
Class	MAMMALIA
Order	CETACEA
Suborder	MYSTICETI

Right Whales
& Rorquals

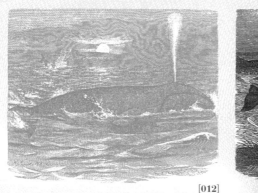

[012]

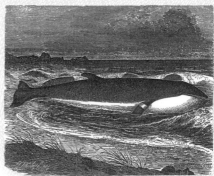

[013]

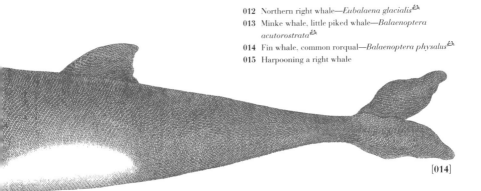

[014]

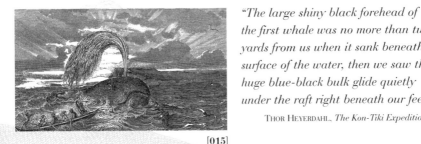

[015]

"*The large shiny black forehead of the first whale was no more than two yards from us when it sank beneath the surface of the water, then we saw the huge blue-black bulk glide quietly under the raft right beneath our feet.*"

THOR HEYERDAHL, *The Kon-Tiki Expedition* (1950)

REV. WOOD, WRITING IN 1863, tells us that the Greenland right whale was found in "great abundance," and that it reached 60 to 70 feet in length. He also states: "Its character…is inoffensive and timorous…It is a very affectionate animal, holding firmly to its mate and protecting its young with a fearlessness that is quite touching to anyone except a whaler." In 1998 it was estimated that there were about 8,000 of these gentle giants

left, placing the Greenland right whale firmly on the endangered list.

Rorquals can be distinguished by the presence of a dorsal fin and grooves on the throat, neither of which is found on the right whales. In general, they have smaller heads and are more streamlined than right whales, making them faster and hard to catch. Indeed, the fin whale [*014*] grows to 75 feet but is called the "ocean greyhound" because of its speed.

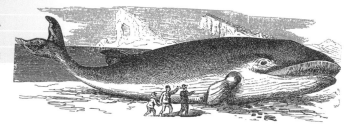

[017]

Rorquals *1*

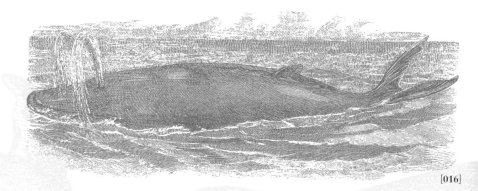

[016]

THE NATURALIST DR. G. HARTWIG admitted in 1873 that "our knowledge of the Cetaceans is still very incomplete." Indeed the term "rorqual" (from the Norwegian, meaning "whale with folds") seems to have been used for a range of species, including blue and finback whales. The Victorian whalers' preferred victims were the right whales because of their superior oil yield. By contrast, the rorquals were hated by fishermen and whalers alike, the former because they consume fish as well as plankton, the latter because of the relatively poor yield of oil and the whales' reputation for fearless aggression once harpooned. At that time, the unfortunate

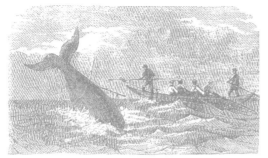

"Oh, the rare old Whale, mid storm and gale
In his ocean home will be
A giant in might, where might is right,
And King of the boundless sea."

Nantucket Whale Song (Traditional)

[018]

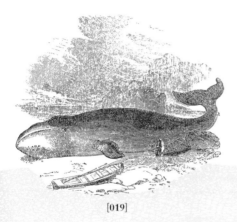

[019]

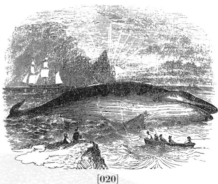

[020]

animals were hunted from small boats by whalers using hand-held harpoons [*018*]. If a rorqual was harpooned by mistake instead of a Greenland whale, Rev. J. G. Wood informs us, "in many cases the aggressors have paid dearly for their error by a crushed boat and the loss of several lives."

016 Humpback whale—*Megaptera novaengliae*
017 Humpback whale—*Megaptera novaengliae*
018 Harpooned whale plunging
019 Beached whale
020 Humpback whale—*Megaptera novaengliae*

Superclass	AMNIOTA
Class	MAMMALIA
Order	CETACEA
Suborder	MYSTICETI

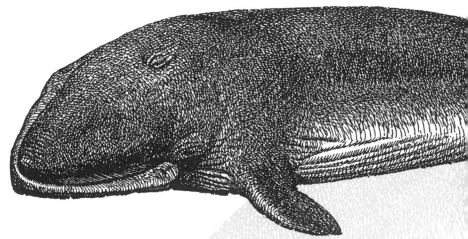

Rorquals 2

*"The gulfing whale was like a dot
 in the spell.
Yet look upon it, and 'twould size
 and swell
To its huge self, and the minutest fish
Would pass the very hardest gazer's wish,
And show his little eye's anatomy."*

JOHN KEATS, Endymion, Book III

[021]

[022]

WITH THE ADVENT OF SAFER WHALING methods in the early 20th century and, later, declining right whale populations, the whalers' attention turned to the rorquals. By 1965, blue whales had become so scarce that the combined fleets of the entire world could capture only 20 of these animals in a whole season. In that year, this giant of all giants was protected by the IWC and remains so today. Population estimates suggest that there are still only between 400 and 1,400 of these leviathans in existence today.

Victorian marine biologists knew that whales could communicate with each other from several miles away. The discovery of the beautiful and haunting song of humpback whales toward the end of the 20th century led to intensive research on their "language." We now know that if they "sing" at depths of 3,000 feet or more, the sounds can be heard by whales hundreds of miles away.

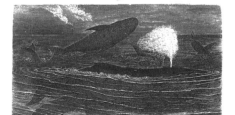

[023]

[024]

021 Minke whale, little piked whale—*Balaenoptera acutorostrata*

022 Finback whale—*Balaenoptera physalus*

023 Finback whale, common rorqual—*Balaenoptera physalus*

024 Humpback whale—*Megaptera novaengliae*

Superclass	AMNIOTA
Class	MAMMALIA
Order	CETACEA
Suborder	ODONTICETI

Toothed Whales *1*

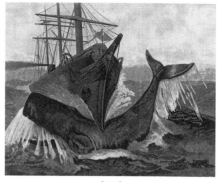

[026]

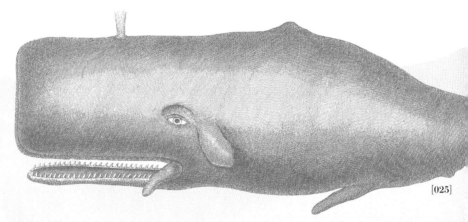

[025]

THE ODONTICETI OR TOOTHED WHALES differ from the Mysticeti in having only one nostril (blowhole) and true teeth instead of baleen (*see page 250, 004*). The cachalot or spermaceti whale (now usually called the sperm whale) is the largest of this group [*025–029*]. Males can grow to 65 feet, but females grow to 35 feet at most. They live in small herds of 15 to 20 females and a single male. Sperm whales were as avidly hunted as right whales by the early whalers, the huge head yielding up to 100 barrels of oil and 24 barrels of valuable spermaceti—a highly prized wax

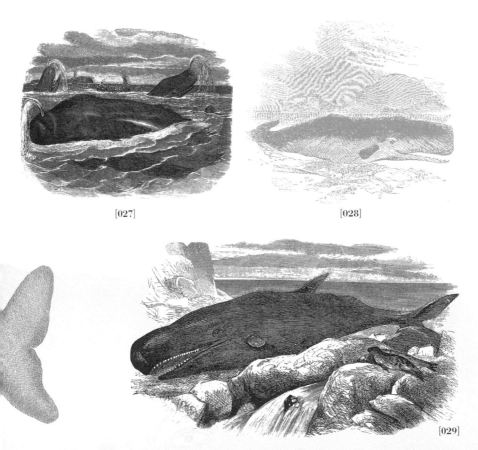

[027]

[028]

[029]

for candlemaking. As a bonus, whalers occasionally found ambergris in the intestines—a waxy substance much cherished as a base in perfumery. Old sea tales such as Herman Melville's *Moby Dick* have given the species an unequaled reputation for aggression and shipwrecking.

025 Sperm(aceti) whale, cachalot—*Physeter catodon*
026 Sperm(aceti) whale, cachalot—*Physeter catodon*
027 Sperm(aceti) whale, cachalot—*Physeter catodon*
028 Sperm(aceti) whale, cachalot—*Physeter catodon*
029 Sperm(aceti) whale, cachalot—*Physeter catodon*

Superclass	AMNIOTA
Class	MAMMALIA
Order	CETACEA
Suborder	ODONTICETI

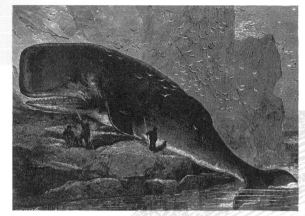

[031]

Toothed Whales 2

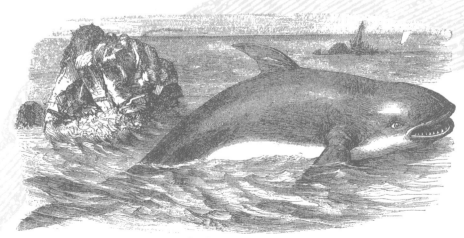

[030]

THE SPERMACETI IS FOUND in liquid form in a huge receptacle, termed "Neptune's chair" by whalers, at the front of the enormous and curiously formed head of sperm whales. The function of this organ is still the cause of speculation, but in the males it seems to be important as a battering ram in male-male contests (and ship sinking) and for the protection of the females and young. It is also implicated in buoyancy control and the production of its voice—a series of clicks that travel huge distances, and may be used for communication or as a sonar device to help catch their prey of squid and cuttlefish in the dark depths to which they dive (up to a mile beneath the surface). The grampus, killer whale, or orca [030] shared a reputation for aggression similar to that of the sperm whale, but enhanced knowledge of its behavior and films such as *Free Willy* have done much to improve its image.

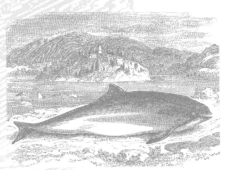

[032]

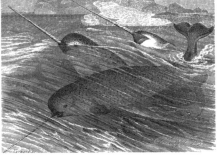

[033]

030 Killer whale, grampus—*Orcinus orca*

031 Sperm(aceti) whale, cachalot—*Physeter catodon*

032 Porpoise—*Phocoena phocoena*

033 Narwhal—*Monodon monoceros*

034 White whale beluga –*Delphinopterus leucas*

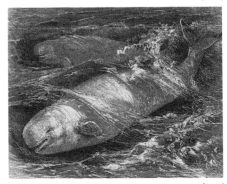

[034]

Superclass	AMNIOTA
Class	MAMMALIA
Order	CETACEA
Suborder	ODONTICETI

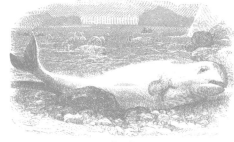

[036]

Toothed Whales *3*

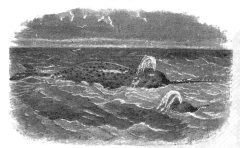

[035]

"But the whale has his diminishers as well as his magnifiers, and his bigness cannot save him from destruction."

E. FORBES, Posthumous publication (1859)

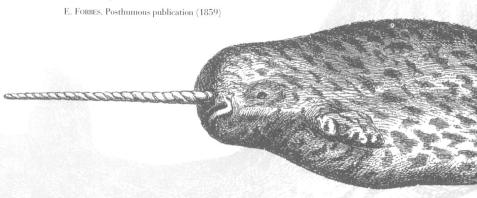

ONE OF THE MOST EXTRAORDINARY of toothed whales is the narwhal (from the Old Norse meaning "corpselike whale") [*035, 037*]. It is sometimes called the sea unicorn, because of the spectacular tusk on the upper jaw that some claim to be the origin of unicorn legend. The tusk, found almost always on the males, is actually a tooth that grows through the upper lip, reaching lengths of up to 9 feet. Its function remains controversial but seems to be mainly that of a jousting weapon as used by courting males. During the Middle Ages the tusk was believed to be a unicorn horn that supposedly disarmed all poisons. This quality was "a great recommendation in days when the poisoned chalice crept too frequently upon the festive board; and a king could receive no worthier present than a goblet formed from such material" (Rev. J. G. Wood).

The beautiful blue-eyed white whale, or beluga [*036*], like the narwhal, lives in Arctic waters in small herds.

[037]

[039]

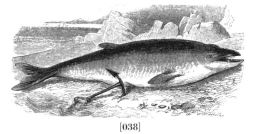

[038]

Superclass	AMNIOTA
Class	MAMMALIA
Order	CETACEA
Suborder	ODONTICETI

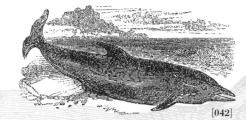

[042]

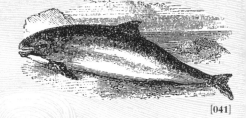

[041]

Porpoises
& Dolphins

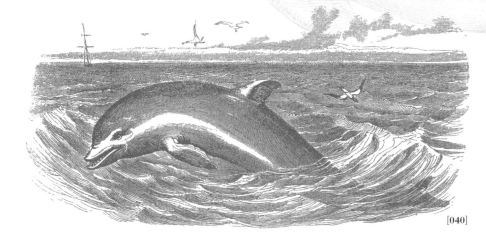

[040]

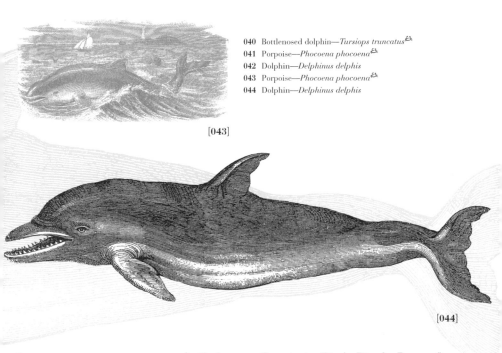

040 Bottlenosed dolphin—*Tursiops truncatus*

041 Porpoise—*Phocoena phocoena*

042 Dolphin—*Delphinus delphis*

043 Porpoise—*Phocoena phocoena*

044 Dolphin—*Delphinus delphis*

[043]

[044]

LAST, BUT FAR FROM LEAST of all the animals in this book, come the porpoises and dolphins. Embedded in human folklore, they were worshiped by the ancient Greeks and protected by their law. These intelligent, boisterous, and inoffensive animals have such an infectious zest for life that people suffering from depression and other mental disorders now benefit routinely from swimming with them in the wild. Moreover, the dolphins seem to realize this, and some individuals—such as Fungie in Eire's Dingle Bay—often swim with humans. Pliny the Elder (AD 23–79) gives an account of how dolphins helped fishermen to catch gray mullet, and many tales tell of how they rush to rescue humans in difficulties. These wonderful creatures have an almost universal appeal with their vivacious leaps, complex language, and playful characters.

In 2003 researchers estimated that 800 whales, dolphins, and porpoises died every day, trapped in fishing nets.

Seaweed *Algae*

Sea plants mainly comprise the protistans, ranging from tiny single-celled organisms such as the diatoms through macrophytes (*macro* "large," *phyt* "plants") such as the 100-foot-long fronds of the kelp forest just off the California coast.

In their natural element, seaweeds possess a beauty that cannot possibly be imagined by those who only see dried, twisted specimens washed up on the strandline of the seashore.

The Victorians appreciated the beauty of seaweed. It used to be an accomplishment of Victorian womanhood to make a seaweed herbarium. This was done by taking a frond of seaweed and floating it in water. A piece of white card was then slid under the seaweed and the seaweed was carefully lifted out of the water on the card. After being left to dry naturally, the dried seaweed card would be annotated with its name, date, and location of collection, and stored with other specimens in the herbarium.

Seaweeds can be classified into the green algae (Chlorophyta) including sea lettuce, the brown algae (Phaeophyta) including the kelps and wracks, and the red algae (Rhodophyta) including the edible dulse.

Seaweeds reproduce asexually by having mobile reproductive cells, called zoospores. The zoospores are shed into the plankton from a mature plant called the sporophyte. The zoospores sink and develop into either male or female plants called gametophytes, since they produce gametes (sperm and eggs). When mature, the male plant releases sperm that swim to the female plants and fertilize the female sex cells. The embryo then develops into a full-sized plant.

The life-cycle oscillation from sporophyte to gametophyte forms an "alternation of generation." It has different emphasis in different algae. Sporophyte and gametophyte thus look completely different in oarweeds, but their appearance is similar in sea lettuces.

Domain	EUKARYA
Kingdom	PLANTAE
Class	CHLOROPHYTA

001 Russian soldiers collecting algae on the shores
 of the North Pacific (Hartwig, 1873)
002 *Enteromorpha compressa*
003 *Cladophora arcta*
004 *Bryopsis plumosa*
005 Green laver—*Ulva latissima*

Green Algae

[001]

FRONDS OF EDIBLE GREEN LAVER are prepared by stewing, and eaten with condiments either alone or with vegetables. For example, it may be boiled with vinegar for several hours, after which, on cooling, it forms an olive-green jelly that can be spread on bread.

Although it looks completely different from *Ulva*, recent studies in molecular biology suggest that *Enteromorpha* and *Ulva* are merely different forms of the same species. *Enteromorpha* is most frequently found where there is some freshwater input to the seashore. It thus occurs on estuaries and in splash pools on rocky shores.

Cladophora and *Bryopsis* species are small, opportunist plants growing on rocky shores. *Cladophora* forms dense green tufts in damp places on rocks and under large brown seaweeds; it looks soft but feels wiry. *Bryopsis* has the appearance of a green fan, and grows in deep, shaded pools.

[003]

[002]

[004]

[005]

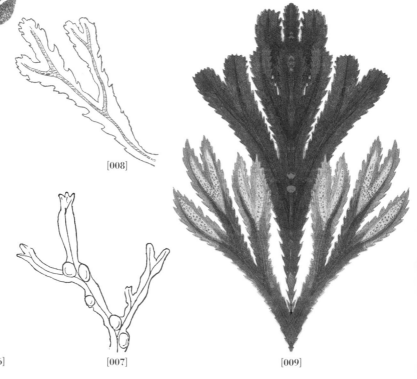

Domain	EUKARYA
Kingdom	STRAMENOPILA
Phylum	PHAEOPHYTA Brown algae

006 Bladderwrack—*Fucus vesiculosus*
007 Bladderwrack—*Fucus vesiculosus*
008 Toothed wrack, sawedged wrack—*Fucus serratus*
009 Toothed wrack, sawedged wrack—*Fucus serratus*
010 Irish moss, carrageen moss—*Chondrus crispus*
011 Podweed, sea oak—*Halidrys siliquosa*
012 Channeled wrack—*Pelvetia canaliculata*
013 Red seaweed—*Chondrus* sp.

Brown Algae *1*

[008]

[006] [007] [009]

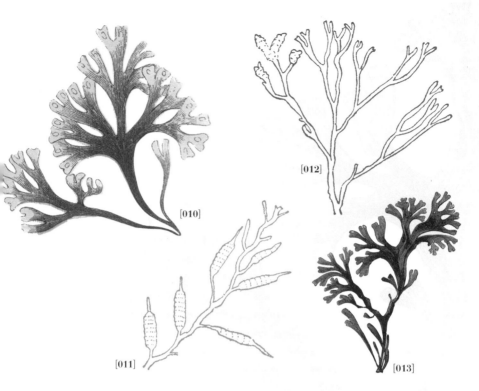

[010]

[011]

[012]

[013]

BLADDERWRACK ATTACHES to hard surfaces on the middle shore and is covered each day by the tides. Its brown fronds dominate the shore, shading out other algae. However, it begins life as an embryonic gametophyte (*see page 269*); tiny gametophytes are an important source of food for creatures that graze over the rock surfaces. So, when the grazers are removed by pollution or harvesting, a population explosion of bladderwrack follows.

Toothed wrack lives submerged in deeper, calmer waters but is exposed at low tide. Where the shore is sheltered—for example, in fjords and salty estuaries—it can occur farther up the shore.

Channeled wrack occurs on the upper shore and is particularly resistant to desiccation. Podweed has a Latin name that means "sea oak." *Chondrus* is a red seaweed that can appear brown, red, yellow, or white, depending on its state of health.

[016]

Brown Algae 2

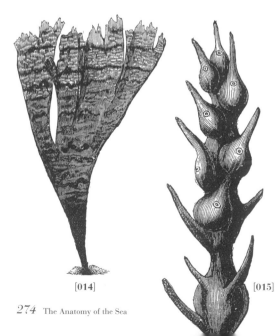

[014]

[015]

[017]

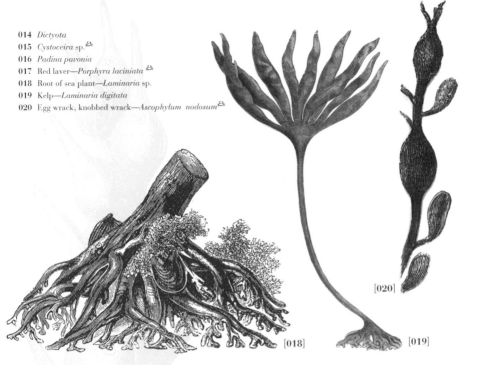

[018]

[020]

[019]

DICTYOTA HAS A THIN, limp, and slightly spotted frond with blunt final divisions. Its thin holdfast attaches the algae to rocks and small stones.

Cystoceira has fronds that are 1–2 feet in length, with a rather crowded appearance. It has what appear to be short spines and occurs on rocky shores and gravelly flats.

Padina pavonia lives on the lower shore and has a very distinctive rounded 6-inch frond.

In Swansea and Llanelli in Wales, *Porphyra* is eaten as a delicacy, fried with bacon or rolled in oatmeal. Like *Ulva* (*see page 271*) this is referred to as "laver bread." *Porphyra* is found on rocks and stones at most levels on exposed shores.

Laminaria digitata is a kelp, permanently submerged on the lower shore but often deposited on the upper shore by storms. It has holdfasts, not true roots. The holdfast shelters small animals, and has no special absorption capability

Red Algae

[021] [022] [023]

THE DEEP PINK *DELESSERIA* has a much-branched stem with wavy, undivided edges. Like many of the red algae, it tends to occur lower down the shore than the other seashore algae and is widely distributed in deep, shadowy pools.

Polysiphonia urceolata is tufted red algae that often grows on the main fronds of egg wrack (*see page 275*). In spring, the latter produce fruiting bodies like stalked yellow-green raisins. When these bodies have dropped off, *Polysiphonia* attaches and grows into dark red tufts.

Nitophyllum punctatum has thin, delicate branching fronds with a bunched appearance. Although it is pinkish red, the

[024]

[025] [026]

[027]

frond tips create an iridescent blue reflection. It lives on seaweeds and in pools on the middle and lower shore.

Corallina officinalis forms short, tufted, pink calcareous fronds and is easily mistaken for a coral. However, corals are animals (*see page 24*), and this is quite definitely a plant.

021 *Delesseria hypoglossum*
022 Sea beech—*Delesseria sanguinea*
023 *Polysiphonia urceolata*
024 Group of sea plants
025 *Nitophyllum punctatum*
026 Coral weed—*Corallina officinalis*
027 Ashleaved seaweed—*Wormskioldia sanguinea*

Glossary

ABDOMEN: in a crustacean, this is the hindmost of the three main body sections. It contains most of the digestive organs and the reproductive organs. The abdominal segments also bear the swimmerets (swimming legs or pleopods).

AMBULACRA: zone of dense tube feet on the surface of an echinoderm.

ANADROMOUS: describes fish that migrate from salt water to freshwater to spawn.

ANTENNA: (plural antennae) sometimes called the "feelers." The sensory organs on the heads of arthropods that are responsible for smelling, temperature perception, or touch.

ANTENNULES: second pair of antennae, diagnostic of the crustaceans.

ANTERIOR: the front end of an organism.

APERTURE: in a snail shell, this refers to the large opening.

APPENDAGE: something that protrudes from the body, e.g., an arm, leg, or jaw.

ARISTOTLE'S LANTERN: jaw apparatus of a sea or heart urchin.

ARTHROPODA: phylum containing the insects, crustaceans, spiders, scorpions, and centipedes. All groups are characterized by having segmented bodies and jointed legs.

ASYMMETRICAL: not the same in all directions.

BILATERALLY SYMMETRICAL: like the body of a fish, where the right side mirrors the left side.

BIVALVE: two-shelled mollusk such as a clam.

BUDDING; TO "BUD OFF": form of reproduction by cloning from the main body of an organism.

CALCAREOUS: made of lime (calcium carbonate).

CALYX: apical part of a radially symmetrical organism

CARAPACE: outer shell covering the thorax and head in crustaceans. See also cephalothorax.

CATADROMIC: describes fish that migrate from freshwater to salt water to spawn.

CEPHALOTHORAX: describes the foremost body compartment of crustaceans where the head and thorax are indistinguishable from each other. Often covered by a carapace.

CHELICERAE: the first pair of fanglike appendages in arachnids and some other arthropods, modified as pincerlike jaws.

CHELIPED: leg of a crustacean bearing claws or pincers.

CILIA: tiny, beating, hairlike filaments that are used to move an organism through water, or move water over part of an organism.

CLASPER: specially modified part of the ventral fin in male elasmobranchs, which serves as a copulatory organ.

CLASS: category within the Linnaean classification system describing a group of closely related orders. May be further divided into subclasses and divisions.

COELOM: fluid-filled body cavity containing internal organs of higher multicellular organisms such as worms, mollusks, and vertebrates.

CONVERGENCE: process of descent by natural selection whereby two quite different species, inhabiting the same environment, gradually come to resemble each other.

CYPRIS LARVA: settling stage of a barnacle, so called because its body is enclosed in a bivalve shell, closely resembling ostrocod crustaceans from the genus *Cypris*.

CYTOTOXIC: kills cells; usually refers to drugs that kill harmful cells but could also refer to venom.

DETRITUS: dead organic material that can be broken down by bacteria or other organisms.

DIVISION: category within the Linnaean classification system that, for animals, describes a sub-group of closely related orders.

DORSAL: of or pertaining to the upper side of an animal with bilateral symmetry (cf. ventral), e.g., dorsal fin.

EPIBIONT: an organism that lives on the surface of another.

EXHALANT: an organ that is used for exhalation.

EXOSKELETON: external skeleton of an animal, serving to protect its softer parts and as an attachment for muscles. Examples include the hard shell of a crab or lobster, or the shell of a clam or whelk.

FAMILY: category within the Linnaean classification system describing a group of closely related genera.

FLAGELLUM: a motile, whiplike projection from a cell or appendage (e.g., antennal flagellum).

GAPE: the opening between the two valves of a bivalve mollusk.

GASTROPOD: snail or slug.

GENUS: (plural: genera) category within the Linnaean classification system describing a group of closely related species.

GILL: organ for extracting oxygen from water.

GIZZARD: part of a digestive system, coming after the esophagus, which mechanically breaks down food.

GONAD: the part of the sex organs that produces sperm or ova.

GUT: the alimentary canal from the mouth to the anus.

HERMAPHRODITE: an animal normally having both male and female organs, e.g., many mollusks, annelids, and some crustaceans.

HETEROCERCAL: describes a tail with the upper lobe larger than the lower, and with the vertebral column prolonged into the upper lobe.

HINGE: articulation between the two shells of a bivalve.

INHALANT: an organ that is used for inhalation.

INTERAMBULACRA: zone between the ambulacra of an echinoderm.

INVERTEBRATE: animal without a backbone, e.g., starfish, crustaceans, worms, jellyfish, etc.

KINGDOM: category within the Linnaean classification system that describes a group of closely related phyla.

LATERAL LINE: a system of organs in fish sensitive to pressure changes and vibrations.

LIVERFLUKE: a parasitic worm, often spread to humans by aquatic mollusks.

LOPHOPHORE: crown of tentacles of a bryozoan (Greek *lophos* "crest," *phor* "carry").

MADREPORITE: sievelike organ connecting open seawater with the water system of an echinoderm.

MANDIBLE: jaw of a crustacean or other member of the Arthropoda.

MANTLE: fleshy lobe that surrounds the body of all mollusks.

MAXILLIPEDS: limbs modified for feeding in crustaceans.

MEMBER: a projection from the body, such as an arm or a leg.

METAMORPHOSIS: change from one life stage to another in which a substantial alteration in morphology is involved.

Morphology: the structure of an organism.

Nacreous, or nacre: glossy, hard, smooth inner surface of many mollusk shells.

Nauplius: the first larval stage in many crustaceans, characterized by an unsegmented body with a dorsal shield, a single central eye, and three pairs of legs.

Nictitating membrane: third or inner eyelid that can be extended across the eye of a shark to protect it from sand, grit, etc.

Notochord: stiffening-rod, equivalent to a backbone, in chordates.

Operculum: various structures covering or closing an aperture, e.g., the bony flap covering the gills of a fish or the calcareous, horny, or fibrous plate secreted by some gastropod mollusks, serving to cover the opening of the shell when the animal is retracted.

Order: category within the Linnaean classification system that describes a group of closely related families and/or superfamilies.

Orifice: a hole.

Ossicle: part of a calcareous skeleton, for example in the echinoderms.

Ovum, ova: unfertilized egg, eggs.

Paleontologist: one who studies fossils and extinct species.

Paleozoic: the period of multicellular life before the dinosaurs took over the earth: from 580 to 200 million years ago.

Parasite: an organism that spends all or part of its life feeding on another species, usually much larger than itself, and giving nothing in return.

Pectoral: of or pertaining to the chest or thorax, e.g., pectoral fin.

Pedicellariae: tiny pincerlike projections from the surface of an echinoderm, used to keep the body surface clear of detritus.

Pelagic: inhabiting the surface waters of the sea.

Pellucid: transparent.

Pelvic fin: ventral fin of a fish supported by the pelvic girdle.

Pelvic girdle: framework formed by the bones of the pelvis, which supports the hind limbs.

Pereiopods: the paired appendages arising from the thorax of a crustacean that may be specialized for walking, feeding, or swimming.

Phyllosoma: transparent larval stage of the spiny lobsters and other closely related species. Also known as glass crabs.

Phylum: category within the Linnaean classification system describing a group of closely related classes.

Physiologist: one who studies the functions of organs, tissues, and cells within an organism.

Pinnules: side branches of a tentacle.

Plankton: floating or drifting organisms that occur at various depths in aquatic environments and are unable to determine their destination.

Pluteus: larva of a brittle star.

Polyp: an individual in the phylum Cnidaria.

Posterior: the back end of an organism.

Progenesis: larva displays features of the adult, for example, sexual maturity.

Radially symmetrical: like the flower of a daisy.

Radula: long rasping tongue of a snail or slug. The radula is covered in thousands of rows of renewable teeth.

Ray: the arm of a starfish; or a kind of flattened shark.

Rostrum: beaklike projection on the front of the head of a crustacean or other arthropod.

Sedentary: fixed to a solid surface.

SEGMENT: each of a series of similar anatomical units of which a body and its appendages are formed in some animals, especially the annelids and crustaceans.

SIPHON: tube that lets water into and/or out of an organism.

SPICULE: an organic needle made of lime or silica, usually embedded in the skin of an organism; millions of spicules help support the body structure of animals such as sponges or starfish.

SPIRE: the apical, pointed part of a snail shell.

SUBPHYLUM: category within the Linnaean classification system ranking between a phylum and a class.

SUBSTRATUM: a solid surface on which an organism lives, such as sand, rock, and mud, though in some cases, such as epibionts, it could be another living organism.

SUPERCLASS: category within the Linnaean classification system describing a group of closely related classes.

SUPERFAMILY: category within the Linnaean classification system describing a group of closely related families.

SUPERORDER: category within the Linnaean classification system describing a group of closely related orders.

SWIM BLADDER: a gas-filled sac in the body of a bony fish by which buoyancy is maintained.

SWIMMERETS: the paired appendages arising from the abdomen of a crustacean that may be specialized for swimming or retaining eggs.

SYMBIOTIC, OR SYMBIOSIS: mode of life in which two different species cooperate so that they are physiologically dependent on each other.

TAXON: (plural: taxa) unit within a classification system (e.g., family or genus).

TAXONOMIST: person who studies the classification of organisms.

TAXONOMY: process of, or system of, classification of organisms.

TELSON: the last segment of the abdomen or an appendage to it, e.g., the middle plate of a lobster's tail fan or the tail spine of a horseshoe crab.

TENTACULAR CROWN: U-shaped group of tentacles of an individual animal in the Bryozoa.

TEST: an external cover, or thick "skin," covering an organism.

THORAX: the section of the body between the head and abdomen. In the case of crustaceans and other arthropods, the thorax usually

carries appendages specialized for locomotion or feeding.

TORNARIA: larva of a protochordate.

TROCOPHORE: larva of a worm.

TUBE FOOT OR FEET: tiny mobile appendage on the surface of an echinoderm, used for walking and for forcing open its prey.

TUBERCLE: projection from the surface of a skeleton.

TUNICA: gelatinous "coat" of a sea squirt or salp.

UMBO: apex of the shell of a bivalve mollusk.

UROPODS: appendages on the side of the telson in the tail fan of a crustacean.

VALVE: shell of a mollusk.

VENTRAL: of or pertaining to the underside of an animal with bilateral symmetry (cf. dorsal).

VISCERAL MASS: the main soft body of a mollusk, containing digestive gland, gut, and gonad.

ZOECIA: the individual animal in a sea mat colony.

ZOOID: general term for an individual in a colonial animal; usually used for the phylum Cnidaria.

ZYGOTE: fertilized egg at the earliest stage, usually a single-celled embryo.

Additional Information

BOOKS

BARNES, R., CALOW, P., OLIVE, P., GOLDING, D. & SPICER J. *The Invertebrates—A Synthesis.* 3rd Ed. Blackwell Books, Oxford, 2001.

BARRETT, J. & YONGE, C. *Pocket Guide to the Sea Shore.* Collins, London, 1964.

BYATT, A., HOLMES, M. & ATTENBOROUGH, D. *The Blue Planet.* BBC Consumer Publishing (Books), London, 2001.

COUSTEAU, J. *The Ocean World.* Harry N. Abrams Inc., New York, 1998.

COWARDINE, M. & WATTERSON, K. *The Shark Watcher's Handbook: A Guide to Sharks and Where to See Them.* BBC Consumer Publishing (Books), London, 2002.

CROTHERS, J. & CROTHERS, M. *A Key to the Crabs and Crab-Like Animals of British Inshore Waters.* Backhuys Publishers, Leiden, Netherlands, 1988.

DARWIN, C. *The Voyage of the Beagle.* Wordsworth Editions Ltd, Ware, 1997.

ERWIN, D. & PICTON, B. *Guide to Inshore Marine Life.* Immel Publishing, London, 1995.

GIBBONS, B., OVENDEN, D., SENIOR, H., & PERKINS, M. *The Concise Guide to Seashore Life.* New Holland Publishers, London, 1991.

GOSSE, P. H. *The Romance of Natural History.* James Nisbett & Co., London, 1886.

HARTWIG, G. *The Sea and Its Living Wonders.* Longmans, Green & Co., London, 1873.

KARLESKING, G. *Introduction to Marine Biology.* Thomson Learning, London, 1997.

KURLANSKY, M. *Cod: A Biography of a Fish That Changed the World.* Vintage UK, London, 1999.

RIEDMAN, M. *The Pinnipeds: Seals, Sea Lions & Walruses.* University of California Press, Berkeley, 1992.

WOOD, J. G. *Wood's Natural History.* London, Routledge, Warne and Routledge, 1861.

WOOD, J. G. *The Illustrated Natural History: Birds.* Routledge, Warne and Routledge, London, 1863.

WOOD, J. G. *The Illustrated Natural History: Mammals.* Routledge, Warne and Routledge, London, 1863.

WOOD, J. G. *The Illustrated Natural History: Reptiles, Fishes & Molluscs.* Routledge, Warne and Routledge, London, 1863.

WOOD J. G. *Half Hour Library; Half Hours in the Deep.* James Nisbett & Co., London, 1885.

WOOD, T. *Nature and Her Servants.* Society for Promoting Christian Knowledge, London, 1886.

WURTZ, M. & REPETTO, N. *Whales and Dolphins: A Biological Guide to the Life of the Cetaceans.* The Crowood Press, Marlborough, 1998.

USEFUL WEBSITES

American Museum of Natural
History, New York
http://www.amnh.org/
Accessed 4/20/04

Aquascope—Learn more about
the sea!
**http://www.vattenkikaren.gu.se/
defaulte.html**

Biotic Database of Indo-Pacific
Marine Mollusks—US Academy
of Natural Sciences
**http://data.acnatsci.org/obis/
index.html**
Accessed 4/20/04

Bivalve Classification—Archerd
Shell Collection
**http://nighthawk.tricity.wsu.edu/
museum/ArcherdShellCollection/
BivalveClassification.html**
Accessed 4/20/04

CIESM Atlas of Exotic Species
in the Mediterranean Sea
http://www.ciesm.org/atlas/
Accessed 4/20/04

Conchologists of America
http://coa.acnatsci.org/conchnet/
Accessed 4/20/04

Echinoderm Classification
**http://www.calacademy.org/research/
izg/echinoderm/classify.htm**

Encyclopedia of Marine Life
of Britain and Ireland
**http://www.habitas.org.uk/marinelife/
index.html**
Accessed 4/20/04

Hardy's Internet Guide to Marine
Gastropods
**http://www.gastropods.com/
index.html**
Accessed 4/20/04

IT IS (Integrated Taxonomic
Information System):
http://www.itis.usda.gov
Accessed 4/20/04

Lahontan Audubon Society
Bird Species Classification and
Representative Species
**http://www.nevadaaudubon.org/
BirdSites/SpeciesClass.htm**
Accessed 4/20/04

Marine Biological Laboratory,
Woods Hole, Mass.
http://www.mbl.edu/marine_org
Accessed 4/21/04

The Marine Life Information
Network
http://www.marlin.ac.uk/
Accessed 4/20/04

National Institute of Water &
Atmospheric Research, New
Zealand
**http//www.niwa.co.nz/pubs/bu/03/
bryozoan.htm**
Accessed 4/20/04

National Museum of Natural
History, Smithsonian Institution,
Washington, DC
http://www.mnh.si.edu/
Accessed 4/20/04

National Oceanic and
Atmospheric Administration—
Ocean Explorer
**http://oceanexplorer.noaa.gov/
welcome.html**
Accessed 4/20/04

Natural History Museum, London
http://www.nhm.ac.uk/
Accessed 4/20/04

ReefQuest Centre for Shark
Research
http://www.elasmo-research.org/
Accessed 4/20/04

Royal Society for the Protection
of Birds
http://www.rspb.org.uk/
Accessed 4/20/04

Seafriends—Marine Conservation
in New Zealand
http://www.seafriends.org.nz/enviro/
Accessed 4/20/04

The Tree of Life Web Project
http://tolweb.org/tree/
Accessed 4/20/04

UCMP Berkeley—Discover the
History of Life
**http://www.ucmp.berkeley.edu/
historyoflife/histoflife.html**
Accessed 4/20/04

US Geological Survey—
Nonindigenous Aquatic Species
http://nas.er.usgs.gov/queries/
Accessed 4/20/04

Index

Acknowledgments

We thank Glenis Lambert and Dr. Jacqueline
Trigwell for their helpful suggestions and the
loan of several invaluable books. Likewise
Mildred Warner for the loan of *Mrs. Beeton's
Book of Household Management*.

David Ponsonby

Special thanks are due to Vivienne Ponsonby,
not only for her patient support during the
writing of this book but also for her considerable
contribution to it, including many hours of
background research, the scripting of numerous
pages, and her critical review of substantial
sections of the manuscript. Thanks are also due
to Caroline and Hayley Ponsonby for their
cheerful forbearance and helpful suggestions.

Georges Dussart

Many thanks to Molly Dussart for her
patience and good humor during the
preparation of this book.